D1555899

Vitalizing Memory

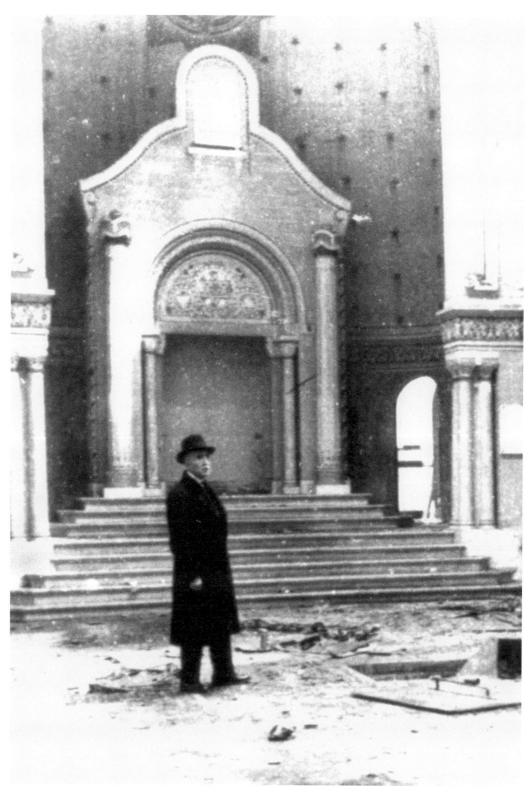

The president of the Sephardic Synagogue in Antwerp, October 1944.

Courtesy of the Jewish Museum in Belgium.

Vitalizing Memory

INTERNATIONAL PERSPECTIVES ON PROVENANCE RESEARCH

AMERICAN ASSOCIATION OF MUSEUMS

1575 Eye St. N.W., Suite 400, Washington, DC 20005

Vitalizing Memory: International Perspectives on Provenance Research

The essays in this publication originally were presented at the International Provenance Research
Colloquium, Nov. 15-16, 2004, Washington, D.C. The colloquium was organized by the American
Association of Museums; funding was provided by the Getty Grant Program, the Commission for Art
Recovery of the World Jewish Congress, and the Samuel H. Kress Foundation.

The opinions expressed in this book are those of the individual authors and are not to be taken as
representing the views of any institution or organization, including the American Association of
Museums.

Design: Polly Franchini

On the cover: *Limbo* by Harland P. Nasvik. The Minneapolis Institute of Arts, gift of the artist.

Library of Congress Cataloging-in-Publication Data

Vitalizing memory : international perspectives on provenance research.
 p. cm.
 "The essays in this publication originally were presented at the International Provenance Research
Colloquium, Nov. 15-16, 2004, Washington, D.C. The colloquium was organized by the American
Association of Museums."
 Includes index.
 ISBN 1-933253-02-9
 1. Art--Provenance--Congresses. 2. Art treasures in war--Europe--History--20th century--Congresses.
3. World War, 1939-1945--Art and the war--Congresses. I. American Association of Museums. II.
International Provenance Research Colloquium (2004 : American Association of Museums)

N3999.V58 2000
707.2'2--dc22

2005029287

Contents

Nancy H. Yeide

PROVENANCE research is an international discipline, just as the art and cultural property it traces are international in origin and influence. Through the ages art has crossed borders, winding up in the most unexpected places. This fluidity of movement is paralleled in the records that document transfers of ownership, as these, too, are often subject to dispersal and relocation. Provenance research means transcending geographic boundaries, in real and virtual terms.

International meetings concerning the ownership of art and cultural property have not been lacking in the last 10 years. Likewise, scores of academic conferences related to the history of collecting have been held during this same period. Somewhere between policy and scholarship, encompassing aspects of each, is the domain of provenance research. However, until recently, this domain, whose importance has been recognized by its neighbors, has not been the subject of dedicated professional conclaves.

The goal of the International Provenance Research Colloquium was an exchange of information on the general topic of provenance research, with an emphasis on World War II provenance issues. While an increasing number of provenance researchers have been working independently in the United States and in Europe, this colloquium was convened to bring together specialists from both sides of the Atlantic. The inspiration behind the colloquium was the German Arbeitskreis Provenienzforschung, which began with a handful of provenance researchers meeting in Hamburg in 2000 and has continued, without institutional funding, to grow and meet at irregular intervals since then. More structured and much larger meetings were held in Cologne in 2001 (Museen im Zweilicht) and Hamburg in 2002 (Die eigene Geschichte).

Although a few Americans have been cordially invited to attend the meetings of the Arbeitskreis when possible, for the most part the participants were European. Close relationships have been forged between the original (German) founding members and their colleagues in German-speaking Europe, i.e., Austria and Switzerland. The Arbeitskreis is a peripatetic forum, with meetings held in Berlin, Frankfurt, Vienna, and Hamburg. It is also diverse by nature, bringing together the perspectives of researchers in museums and the art market as well as those working independently. This openness and mutual respect enables members (and guests) to share information and resources in a field that is characterized by the sensitivity of its main subject, i.e., World War II-related provenance research.

In the United States the venues for provenance researchers to meet and share information have been sponsored almost entirely by the American Association of Museums, in the guise of panels at annual meetings from 1999-2005 and seminars conducted at the National Archives in 2002 and 2003. While tremendously useful in establishing a national network to exchange research strategies and resources, these meetings have lacked an international perspective.

Originally envisioned as a meeting between Germans and Americans, the colloquium was

expanded to include colleagues from Austria, Belgium, Canada, Czech Republic, Poland, Switzerland, and the United Kingdom. Museum affiliations were not required nor was the subject matter limited to research relating to World War II, although that period clearly dominated the program, just as it continues to dominate museum provenance research for the foreseeable future. In all, some 70 individuals attended over two days, and half of the participants presented papers. We were extraordinarily fortunate to have as our keynote speaker, Lynn H. Nicholas, renowned author of *The Rape of Europa*, whose remarks energized colloquium participants. She reminded us of the remarkable progress made in researching World War II provenance issues over the past few years, just as the papers presented later made clear how much was yet to be accomplished.

The colloquium was conducted in sessions reflected in the organization of these published proceedings. The first session made it clear that provenance research is recognized at a national level as vital not only to art historical scholarship but as a fulfillment of principles adopted in response to ownership issues that have arisen in recent years. Subsequent sessions moved the focus from the macrocosm of guidelines to the microcosm of current research. Topics included the exegesis of collections of the Nazi elite, the recreation of historic family collections, case studies of specific object provenance, the presentation of lesser known archival resources, and observations concerning the art trade in the 20th century.

Several themes emerged over the course of the colloquium. Foremost among them was the importance of communication among researchers. For example, during the colloquium international connections were made that would lead to more efficient research paths and discoveries as participants pool resources and knowledge.

While the majority of the colloquium participants were most familiar with researching the fine arts, specialists in other disciplines reaffirmed that provenance research covers much more than paintings. There is an emerging awareness of the need to uncover the fate of, and reassemble where possible, libraries and Judaica dispersed during World War II. Unlike their fine art counterparts, which were owned in most cases by individuals, these objects were often community property, and reassembling them is part of the task of recovering communal memory.

This conference highlighted the significant strides made in provenance research resources and methodology since the discipline has moved from the bastion of a specialized few to the concern of a great many. However, it also illuminated the amount of work yet to be done in this arena, the number of different sources that may have to be consulted to clarify the provenance of any one object, and the very real logistical barriers that must still be hurdled. The International Provenance Colloquium represents another step in a long journey, one that is best made with cooperation and communication between colleagues worldwide.

National Perspectives

U.S. Museums and the Nazi-Era Assets Issue

Helen J. Wechsler

OVER the last decade American museums—like their counterparts in Europe—have become increasingly involved in the issue of assets looted during the Nazi era. However, there are a few obvious but important differences between the situations of museums in the United States and those in Europe.

The first difference has to do with organizational structure. Unlike museums in many other countries, American museums are not under the auspices of a federal ministry of culture. About 70 percent are nonprofit organizations, governed by a voluntary board of trustees, accountable to the public, and subject to rules for tax-exempt charitable organizations under U.S. law.

While U.S. museums must comply with applicable laws, they are not overseen by any governmental regulatory agency. Rather, the standards and practices for the field are determined voluntarily by the museum community itself, through the mechanism of its professional associations—in the case of art museums, the American Association of Museums (AAM) and the Association of Art Museum Directors (AAMD).

Self-regulation (that is, standards developed by the members of a profession for the profession itself) is a desirable goal pursued vigorously by professional associations in the United States. Through self-regulation, associations hope to avoid or reduce regulation by the government with its attendant costs, common misunderstandings, and sometimes unfavorable publicity.

This is not to say that the nonprofit sector has nothing to do with the government. Actually, we often work very closely together; the topic of Nazi-era assets represents a good example of this cooperation.

The second difference is the nature of the collections in U.S. museums, which were not the repositories of objects recovered after the war. Rather, looted objects may have entered our collections via the robust post-war art market and a series of good-faith purchases and donations.

The U.S. museum community has been struggling with this issue now for about seven years. It has been a learning experience. I will present our challenges and accomplishments chronologically to show how our approach has developed and changed over the years.

During the past decade museums have become more aware of Nazi looting and its possible impact on their collections. Lynn Nicholas's 1994 book, *The Rape of Europa*, gave the subject a popular profile, and a 1995 conference called The Spoils of War brought interested parties together for the first time to address the topic in a public forum. Increasingly, U.S. museums began to recognize that objects unlawfully appropriated during the Nazi era had entered the international art market and may have made their way into their collections.

In 1997, three court cases placed this issue firmly on the agenda of the U.S. art museum community. The cases also rocketed this topic to the front pages of newspapers, and the press was not always kind to museums.

Apparently, our government officials also read the papers. Within nine months in 1998,

hearings were held in Congress, a presidential commission was formed, and the Department of State hosted an international governmental conference on the subject of Holocaust-era assets.

The hearings were held in February 1998. Congress wanted to know what museums in the United States were doing about potential Nazi-era looted assets in their possession. The law-makers heard testimony from five museum directors, who stated strongly that museums do not wish to possess stolen art, that they were sensitive to the tragic circumstances of the losses in question, and that the museum community was coming together to begin the development of guidelines on the topic (i.e., self-regulation). Members of Congress were gracious and congrat-ulated the museum directors on their good faith, their efforts, and their willingness to confront the problem directly. To the association world, Congress's interest was a clear indication that if we didn't handle this issue effectively within our profession, the lawmakers would do it for us.

In June 1998, President Clinton appointed a commission to study issues relating to Holocaust victims' assets in the United States. A large component of the commission's work was devoted to cultural assets. That November, the Department of State and the U.S. Holocaust Memorial Museum co-hosted the Washington Conference on Holocaust-Era Assets, an international gathering of government delegations and non-government organizations. This conference resulted in a document outlining 11 principles to help resolve issues relating to Nazi-confiscated art.

Using the Washington Conference Principles as well as AAMD's 1998 report on the spoli-ation of art during World War II, AAM created a working group of museum professionals to draft a set of guidelines calling on museums systematically to research their collections, make information about their collections accessible to the public, and address claims of ownership openly and responsively. These three things—provenance research, making information acces-sible to the public, and dealing with claims—were the portions of the Washington Conference Principles that museums felt they could best address.

The guidelines were distributed for comment to important sectors within the museum com-munity. By the time they were issued in late 1999, American museums were committed to adopting them.

In implementing the guidelines involving claims of ownership, U.S. museums face far fewer barriers than many of their European counterparts. Following AAM's guidelines, the decision to return objects or negotiate a financial settlement is handled independently by the nonprofit museum's governing body—without government restrictions. Museums' stewardship duties and their responsibilities to the public require that any decision about the resolution of a claim be taken only after the completion of appropriate steps and careful consideration. But the decision is the museum's to make. The guidelines encourage museums to avoid litigation—in fact, very few cases have gone to court—and to even consider waiving certain legal defenses, such as statute of limitations in Nazi loot cases.

Regarding the provision about researching collections, those guidelines instruct museums to identify objects with incomplete or uncertain provenance. Most U.S. museums began to survey their collection for objects with gaps in their provenance for the years 1933-45. They also looked for names in provenances of collections known to have been looted or dealers known to have handled looted works.

In an effort to be as open as possible regarding collections information, many U.S. museums began posting their "gap lists" on their individual websites. AAM maintained a list of links to these museums on its site as well. However, each of these sites had a different interpretation of what constituted incomplete or uncertain provenance. In addition, as provenance researchers gained experience in examining works in their collections, they learned that the appearance of

a suspicious name in a provenance or gaps in ownership histories were not always reliable indicators of a troubled past. Instances arose in which objects with incomplete or uncertain provenance were cleared of suspicion and others with apparently complete ownership histories turned out to be problematic.

These lessons led AAM to begin thinking about standards and best practices to help museums identify which works in their collections should be listed and what level of information should be provided. Meanwhile, the presidential commission also was studying this issue and was eager to recommend its own standards for museums.

In late 2000 the museum associations and the commission collaborated to develop a new standard. In summary, the standards changed from instructing museums to publicize information about objects whose Nazi-era provenance was incomplete or uncertain to recommending that they make public information about all objects transferred in continental Europe between 1933 and 1945, regardless of completeness of provenance. This standard is less ambiguous and relieves museums from having to make judgments about their collections. The AAM and AAMD guidelines subsequently were amended to reflect this new standard.

Another of the commission's recommendations was the creation of a searchable central registry of the museum-provided information, in accordance with the new standard. This dream of a centralized search tool also had been articulated in the Washington Conference Principles and in a declaration issued following the Vilnius Forum on Holocaust-era cultural assets. AAM's list of museum websites was not searchable; it merely pointed claimants to the museums with online information.

AAM took on the task of figuring out how to create such a searchable registry. We assembled a task force of museum professionals, representatives of the claimant community, and government representatives. We had two primary goals:

1. To help museums fulfill their responsibility to make Nazi-era provenance information accessible.
2. To provide researchers and claimants with a central location from which to begin their research.

In determining how best to achieve these goals, the task force faced competing pressures. Claimants needed centralization, consistency, and usability so they were not forced to approach and search each museum's website. Task force members also felt that it was important to have a description field, because claimants may remember the content of a painting rather than its title or artist. Providing images of objects was important as well. Seeing a picture of an object is the quickest way to eliminate false positives or to make an initial match.

Museums wanted to ensure that they would retain institutional control of the presentation and maintenance of information about objects in their collections. Not every museum would have complete information about objects in its collections. Since the guidelines recommend that museums make public currently available information and update that information as research continues, the records would be continually changing, ultimately containing a significant amount of detailed information. Maintaining and updating this information in two locations—the museum and any centralized database—would require an inefficient duplication of effort.

In the end, the task force struck a balance. Museums would be responsible for populating the database with a basic set of unchanging information about objects in their collections and would retain control of that information at all times. Searching this set of information would provide a researcher with a powerful tool for narrowing fields of inquiry. For detailed informa-

tion about an individual object, including images, the Nazi-Era Provenance Internet Portal (as it came to be called) would link researchers to individual museums to continue their inquiries.

It is important to note that we set the bar for museum participation in the Portal very low. All a museum needs to get started is a list of objects in its collection that may have changed hands in continental Europe between 1932 and 1946. For museums to move beyond this to undertake serious provenance research, however, they must overcome two major challenges: training and resources. To address the training problems in 2001 AAM published *The AAM Guide to Provenance Research*, written by three experienced researchers, Nancy H. Yeide, Konstantin Akinsha, and Amy L. Walsh, and organized provenance research seminars in 2001 and 2003. While we have been able to meet some of the training needs, funding provenance research is still a struggle for most museums.

To build the Nazi-Era Provenance Internet Portal (www.nepip.org) we relied on generous outside funding from the Institute of Museum and Library Services, Getty Grant Program, Commission for Art Recovery of the World Jewish Congress, Conference on Jewish Material Claims Against Germany—Rabbi Israel Miller Fund for Shoah Research, Documentation and Education, Samuel H. Kress Foundation, and the Max and Victoria Dreyfus Foundation.

The Portal opened to the public in late 2003, with 66 museums participating and 5,700 objects registered in its database. After one year of public operations, museum membership grew to 117 and the number of objects registered rose to 13,665. The Portal continues to enroll new museums and add new objects.

Public use of the Portal also has been very gratifying. During its first week of public use the Portal received 22,819 hits on its home page and executed 24,637 searches for objects against its database. Use has stabilized at 80 home-page hits and 70 to 80 searches per day.

Participation in conferences like this one and the willingness of researchers to share their knowledge moves us closer to understanding the complex histories of some of the objects in our collections. Ultimately the Portal is only as good as the research to which it provides access.

Spoliation Research in Museums and Galleries in the United Kingdom

Marina Mixon

THE TASK of identifying artifacts in public collections in the United Kingdom that might have been spoliated in the period from 1933 to 1945 has been mainly promoted and coordinated by the National Museums Directors' Conference (NMDC), an organization representing museums and libraries funded by the British government. In June 1998 the conference set up the Spoliation Working Group under the chairmanship of Sir Nicholas Serota, director of the Tate, to examine issues arising from the spoliation of works of art and other cultural artifacts during the Holocaust and World War II. The group was also required to draw up a Statement of Principles and proposed action for member institutions.

The statement was adopted by the NMDC in November 1998 and presented at the Washington Conference on Holocaust-Era Assets that December. It recommended that each national museum, gallery, and library in the United Kingdom should instigate a program of provenance research relating to the question of spoliation. The purpose of this research was to establish, through a fairly swift audit, which works, if any, had periods of uncertainty in their history during the years 1933-45. The aim was to bring these uncertainties more openly into the public domain, rather than actively to search for suspicious names; having said this, such names were to be investigated if found. However, it should be stressed that the exercise was based on an assessment of available information rather than a hunt for particular problems. A neutral assessment of the facts has remained the guiding principle over any assumptions. This approach is reflected in the information published on the NMDC website, http://national museums.org.uk, which lists the provenance histories of works with "gaps in the operative period" and identifies and comments on any problems.

In 1999, the scope of the project was extended to include the non-national museums, mainly local authority and university museums, and, as a consequence, representatives from the non-nationals joined the working group. Progress made by the group is reviewed by an external advisory committee, chaired by a High Court judge, Sir David Neuberger, and has benefited from the assistance of a number of organizations, including the Commission for Looted Art in Europe. At an early stage, it became clear that many of the non-national museums were dismayed at the scale of the task they faced. While the national museums with relatively large staff and state funding had at least a basis for undertaking the required research, many representatives of the non-national museums doubted their capacity to investigate the history of their collections without extra staff and special funding.

In 2001, the Spoliation Working Group engaged me to assist curators in the non-national museums with provenance research and to coordinate and supervise reports with the aim of publishing them on the conference website. The position is funded by the Museums, Libraries and Archives Council, a government-funded agency. Initially, 22 non-national museums agreed to nominate an in-house contact who would be responsible for investigating their collections

for possible spoliation problems. The differences between the participating museums made it difficult to set cast-iron guidelines for what portion of the collection should be researched, apart from requesting that each museum should investigate an area or areas where spoliation might be a problem and where research was feasible. For the most part, English watercolors were regarded as an area of low risk, while prints and coins were set aside as areas of intractable difficulty. Such exclusions are specified on each institution's list on the NMDC website. Most of the reports concentrated on European paintings, Old Master drawings, sculpture, and the decorative arts.

The quality of provenance information available to the museums varied widely. In general, the museums with the poorest resources for undertaking work of this kind were also those with the least adequate provenance records. Work was undertaken, on occasion, by staff who did not have expertise in specialized provenance research. Curators also pointed out the difficulty of undertaking research of this kind without ready access to the libraries and archives in London. I undertook to refine the reports submitted in the first draft through research in the British Library, the Imperial War Museum, the Witt Library, the Warburg, and the Wiener Institute. Anomalies, inconsistencies, and the occasional absurdity were removed to the extent possible with the assistance of a panel of advisers from the participating museums.[1]

The first version of the reports, uniformly formatted and combining submissions from the national and non-national museums, was published on the conference's website. In the areas indicated by each museum, the lists contain details of all artifacts whose history between 1933 and 1945 is unknown or uncertain. It is not a provenance index *per se* and, for the most part, it excludes information that is not relevant to the issue of spoliation. To a large extent, the index is no more than a reflection of our ignorance in an area fraught with difficulties for researchers. Unfortunately this point was missed by some members of the British press, who ran scare stories implying that thousands of works of art in U.K. museums may have been spoliated in the 1930s and 1940s. On the contrary, by continental or American standards, museums in the United Kingdom are at low risk in this area.

The website has generated a great deal of interest but few claims. The purpose of the exercise has been to encourage museums to take the initiative in uncovering problems and, if possible, in contacting potential claimants. The strategy is one of openness, as the website makes the most up-to-date information publicly available. All formal claims for the restitution of artifacts have been instigated, so far, by claimants or their representatives.

In assessing these claims, museums and claimants in the United Kingdom may apply to a Spoliation Advisory Panel, set up by the government on the recommendation of the NMDC, under the chairmanship of a High Court judge, Sir David Hirst. The Hirst Panel exists to consider claims from anyone, or from the heirs of anyone, who lost possession of a cultural object between 1933 and 1945. While the panel may consider the question of legal title, it bases its decisions primarily on the difficult question of moral right. Its findings are not legally binding, and it does not constitute a court of law. But it also doesn't require the structure (and expense) of full legal submissions. There is, however, an expectation that museums should agree to the submission of claims to the panel and should abide by its recommendations.

As of November 2004, the Hirst Panel has made only one ruling. This is in the case of a painting of Hampton Court by the 17th-century artist Jan Griffier the Elder, which is in the Tate collection. It is worth summarizing the case and the panel's findings, as the report gives a clear idea of how the panel works and the difficulties of adjudicating in an area where the evidence is uncertain. The claim was presented formally in June 2000 and the findings published in January 2001. Among the panel's primary tasks were, first, to "evaluate, on the balance of

probabilities, the validity of the claimant's original title to the picture and the validity of the institution's title thereto"; and, second, to "give due weight to the moral strength of the claimant's case, and to consider whether any moral obligation rests on the institution."[2]

The painting was acquired from Gallery Stern in Dusseldorf in the early 1930s by the claimant's father, a local Jewish banker. The claimant remembered the picture hanging on the wall of the dining room in the family home and produced a photographic negative showing the work there, which was examined by the V&A and authenticated as being 1930s in origin. In 1933, the claimant's father was dismissed by the Nazis from his position as a partner in a private bank and was shot in 1937. After sending her children abroad, the claimant's mother fled with her paintings to Belgium in 1939 and, after the German occupation in 1940, she remained in hiding, selling paintings to live. She survived, but told the claimant that she only received enough "for an apple and an egg" for the Griffier.

The painting re-emerged in 1955, when it was auctioned at the Kunsthaus Lempertz in Cologne. It was bought by Roland, Browse & Delbanco, and sold to the Friends of the Tate Gallery in 1961 for donation to the Tate. Subsequent inquiries, by all parties, to the auctioneers only established that the previous owner was "a serious private collector in South Germany."

As far as the history and legal ownership of the work was concerned, the panel found that the claimant's mother's account "lacked precision." However, they acknowledged that their Terms of Reference, following the 1998 Washington Declaration, required them "to recognise the difficulties of proof after the destruction of the period." Taking into account the general conditions in Occupied Belgium and the reappearance of the work in Germany, they were inclined to believe the account, accepting it as "tantamount to a forced sale for an undervalue," one of the qualifications within their remit. As to a legal claim, however, the panel took advice as to the position in Germany, Belgium, and England and concluded that "The claimant's title was . . . extinguished in 1967, thus clothing the Friends, and thereafter the Tate themselves, with an unassailable title."

In evaluating the moral issues, the panel took as its guide the 1943 *Inter-Allied Declaration against Acts of Dispossession Committed in Territories under Enemy Occupation or Control.* This wartime document set out the Allies' intention, where possible, to return art spoliated during the period to its original owners. While finding no grounds for criticizing either Tate or Roland, Browse & Delbanco, the panel—guided by this principle—upheld the claim of ownership on moral grounds.

The panel is empowered to advise the government on what action should be taken and had several options. It could have recommended the return of the work, although this would have raised difficulties that I shall come back to, and in any event the claimant explicitly sought compensation. The second option was to recommend the payment of compensation but, as the claimant had been found to have no legal title, the panel considered it inappropriate to award compensation "in the legal sense." As a result, it proposed a combination of two further options, recommending that an *ex gratia* payment be made, based on the work's market value (in this case of £125,000), and that the Tate should display alongside the painting an account of its provenance with special reference to the claimant and his family.

The panel's position as adviser to the secretary of state meant it could recommend that the *ex gratia* payment be made by the British government. In so doing it acknowledged that the Tate should not pay, being "free both of any legal liability and of moral blame." Instead, the panel argued that payment should be borne by the taxpayer both because "the public has had the benefit of access to and enjoyment of the picture" over 40 years and because the government

had declared its determination "to set an example of how a civilised society should behave." The government and the gallery agreed and complied with the findings of the panel.

As this abbreviated account indicates, while the findings of the Hirst Panel in the Griffier case set a precedent for a satisfactory resolution of a claim, each case necessarily will be shaped by different circumstances. More generally, it is possible to foresee that a difficulty in implementing any future recommendations of the Hirst Panel may stem from the provisions of the statutes of the United Kingdom's national museums and galleries. The boards of trustees of these institutions are bound to act in accordance with the terms of these statutes and the general charity laws of the United Kingdom. For instance, the Board of Trustees of the British Museum is required by its governing statute to keep the objects vested in the collection for public enjoyment. Its powers of disposal are extremely limited and have no obvious application in the event that the Hirst Panel were to recommend the return of an object on the grounds that it had been spoliated. In view of this anomaly, the museum has in the past indicated that it would support proposals to enable national museums and galleries, in appropriate circumstances, to deaccession objects that are proven to have been spoliated.

Since the spoliation section of the Conference's website went online, we have added new information and extended its scope. Often new details are added to the histories of particular works, found either through continued research or through public responses to the website. Some works may be removed from the listings as a result of new research, but more commonly the updates see the arrival of new banks of lists as research reaches hitherto unresolved areas or collections. Provenance researchers have received generous and time-consuming help from Sotheby's and Christie's, whose auction rooms, in dozens of cases, represent the earliest known stage in the history of an artifact. The auction houses also have given us valuable access to their databases and files on spoliated collections.

We have had useful exchanges with similar research teams in the Netherlands, the United States, and Austria. As the person through whom this information is channeled to the museums, I also have become involved in providing general advice on spoliation issues—in particular, on the question of lending works of art in the "at-risk" category to foreign exhibitions. Museums are nervous about accepting assurances regarding exemptions from legal actions such as seizure. This nervousness reflects a reluctance to enter into legal procedures rather than any desire to obstruct valid claims.

Despite our best efforts, we have not uncovered a massive problem as a result of the spoliation research undertaken in museums and galleries in the United Kingdom. It may well be that the section of the Conference's website will generate more claims in the years ahead. Should we place a time limit on future claims? This is not a problem that affects only the United Kingdom but one of several issues that should be discussed by everyone working in the field of spoliation and provenance research. The Washington Conference urged us to take action on a national basis. Now, six years down the line and when the Washington Principles and those of our own National Museums Directors' Conference have been largely implemented, it may be time to proceed to a further stage with renewed international cooperation.

Notes

1. Dr. Jon Whiteley of the Ashmolean, Oxford; Dr. Mark Evans, Victoria & Albert Museum; and David Scrase of the Fitzwilliam in Cambridge.

2. All quotes from "Return to an address of the Honourable Sir David Hirst The House of Commons Dated 18th January 2001 for the "REPORT ON THE SPOLIATION ADVISORY PANEL IN RESPECT OF A PAINTING NOW IN THE POSSESSION OF THE TATE GALLERY," The Right Honourable Sir David Hirst, Ordered by the House of Commons to be printed 18th January, 2001.

Germany's Coordination Office for Cultural Losses

Michael Franz

NATIONAL activities, current German research, the collections of the National Socialists, archives, the art trade, and case studies are among the many interesting topics discussed under the heading "international provenance research." As experts on looted and trophy art, some of us already are aware of select facts; nevertheless, we can learn new information as well. This is precisely because as experts we can specialize only in a small part of a complex subject, which means we have to neglect a wide range of related issues.

As a starting point, permit me to define the goals of my own work and the point of view taken by my office, Koordinierungsstelle für Kulturgutverluste (Coordination Office for Lost Cultural Assets, hereafter referred to as "the Office"). Our aim in operating www.lostart.de— Germany's central and publicly accessible database for looted and trophy art on the Internet— is to provide and collect information that will help locate and identify cultural assets in order to return them to their rightful owners.

To do so, and to deal with an overabundance of information online, I consider it imperative to pool existing data and make it freely accessible to interested parties worldwide. This will create the best possible basis for identifying and restituting these assets.

This paper is divided in two parts. The first focuses on the Office's mission and achievements. The other outlines the two initiatives designed to encourage a flow of transparent information from public databases and international cooperation among database operators.

Koordinierungsstelle für Kulturgutverluste: Mission and Achievements

The Office's tasks are defined by national and international agreements and declarations. Following the adoption of the well-known Washington Principles in 1998, the German federal government, the German federal states, and the central organizations of the country's local communities passed in 1999 the so-called Gemeinsame Erklärung (Joint Declaration) to find and return Nazi-confiscated art, particularly works formerly in Jewish possession. This Joint Declaration calls on German institutions that hold cultural assets to continue the search for looted art in their collections and report the results to the Office.

Against this background, the Office has grown from an institution financed in 1994 by only a few German states (and documenting exclusively trophy art from the German federal states) into an institution financed by the federal government and all 16 federal states. The Office now collects national and international queries for missing art and notifications of discoveries regarding looted art and trophy art and makes them available on the Internet via www.lostart.de. It also conducts public relations work to this effect and serves, since July 2003, as the Office for the Beratende Kommission im Zusammenhang mit der Rückgabe NS-verfolgungsbedingt entzogener Kulturgüter, insbesondere aus jüdischem Besitz (Advisory Commission on the return of cultural assets seized as a result of Nazi persecution, particularly those cultural assets removed from Jewish ownership).

The Office's development reflects the importance Germany places on the difficult questions regarding trophy art and looted art. That the Office's existence has been extended for five more years, from 2005 to 2009, speaks for itself and suggests that its services will remain necessary for years to come.

Here is a summary of our achievements to date:

Concerning documentation, www.lostart.de now contains over 80,000 lost-and-found reports and more than 8,000 illustrations. Information has been received from over 400 national and international institutions and nearly 300 individuals at home and abroad, with most data relating to 62,000-plus search reports for trophy art originating from Germany and other countries, for example, the Ukraine. For looted art, over 2,300 search queries have been reported by over 120 individuals. More than 4,700 items with provenance gaps have been reported by nearly 60 institutions and 20 individuals from both home and abroad, including those in Germany, Austria, Finland, and elsewhere, while over 110 institutions have sent negative reports to date.

There are two kinds of *intersections* in which a single object listed in www.lostart.de can be subject to more than one type of confiscation: For example, objects could have been taken away from former Jewish citizens and then seized again as so-called "degenerate art." Or they could have been taken away as looted art and then later became trophy art by being transported some years later to, for example, the former Soviet Union.

The *technical presentation* within www.lostart.de is improved continually. For example, you now will find new ways to search for artists whose works have been listed on the site.

It is gratifying to see that www.lostart.de has helped *identify and return* several works of art over the last few years. As an example, a painting by Adriaen van de Velde from the Remaining Stock CCP—the Central Collecting Point in Munich, otherwise known as the "Linzer Liste"—was identified and returned in 2001. That same year, the database aided the restitution of two paintings by Lucas Cranach the Elder. In early 2002, Berlin's Jewish Museum was offered *Jerusalem*, a painting by Lesser Ury; with the help of www.lostart.de, the museum identified it as being relocated from Görlitz, Germany, during World War II. In mid-2002, a painting by Dujardin was returned to the State Art Collections in Dresden, Germany. In 2003 a painting by Franz von Lenbach and a wooden statue of St. George dating from the 15th century were restituted to the heirs of a former Jewish citizen.

More cases are currently under negotiation. I can only report the following cases anonymously because they have not yet been resolved. In the spring of 2004, a painting registered as trophy art on www.lostart.de resurfaced during the well-known international art fair in Maastricht, where it was offered for sale. When it was identified as a loss from a German museum, the possessor of the painting took it back to the United States where it will be examined within the next few months. A painting from the 17th century registered in www.lostart.de as trophy art from a German museum was sold in the summer of 2004 by a German auction house to Italy; the next few months will reveal the results of this case, too.

Between November 2004 and July 2005, further restitutions have taken place. In February, the painting *Prinzessin zu Sayn-Wittgenstein-Sayn* by Franz von Lenbach, which had been seized from Bernhard Altmann in Vienna in 1938, was identified and restituted with the help of www.lostart.de. Two months later, the painting *Reiterschlacht*, which has been registered in www.lostart.de for some time due to its provenance gaps, was returned from Germany to Russia.

To encourage a steady influx of reports to www.lostart.de, the Office undertakes intensive *public relations* work to make lost art a point of continued discussion among the general public and experts at home and abroad. We have placed repeated appeals for contributions to the website in national and international media. We launched a series of publications in 2001, of which two volumes have appeared so far; volumes 3 and 4 are scheduled for publication in 2005. Brochures listing looted and trophy art have been designed and distributed. Since 1995 we have distributed an international newsletter titled *Spoils of War,* which is also available at www.lostart.de. We started an advanced training program titled Verantwortung wahrnehmen (Accept Responsibility). It covers all German states and encourages those in charge of cultural assets to deal with the topic of looted art within their possession. Furthermore, the Office is partnering on conferences such as the international meeting on questions of restitution in September 2004 in Berlin and the May 2005 conference on aspects of looted art and books in Hanover.

Germany's Advisory Commission was founded in July 2003 to deal with restitution cases from a moral point of view. It operates from the Office and concerns itself with the return of cultural assets confiscated as a result of Nazi persecution, particularly those from Jewish owners. Where this creates differences of opinion between public institutions and former owners or their heirs, the Advisory Commission will make recommendations if requested to do so by both sides. The commission is chaired by Jutta Limbach, former chief judge at the German Federal Constitutional Court. Members include Rita Süssmuth, former speaker of the German Bundestag (Federal Parliament), and Richard von Weizsäcker, former president of the Federal Republic of Germany. The Office prepares the commission meetings and handles inquiries.

Since the International Provenance Research Colloquium, the Advisory Commission has issued its first recommendation. At a Jan. 12, 2005, meeting in Berlin, the commission advised the German federal government to return three paintings by Karl Blechen and a watercolor by Anselm Feuerbach to the heirs of Julius and Clara Freund. This recommendation rested on the following facts: Julius Freund, persecuted by the Nazi regime because he was Jewish, owned a large art collection, including said paintings. At the end of 1933, he took his collection to Switzerland to protect it from the Nazis' greedy hands. In 1939, financially ruined as a result of Nazi persecution, Freund and his wife Clara emigrated to London. Following Julius Freund's death in 1941, economic circumstances forced Clara to auction the collection through the Fischer gallery in Lucerne. The works of art mentioned above were bought by Hans Posse, Hitler's special commissioner in charge of the establishment of the so-called Führermuseum in Linz.

After the war, the paintings were secured by the Allies and loaned to German museums because at the time it was impossible to allocate them. Later, to find legitimate claimants, they were displayed as lost art in the www.lostart.de database. Julius Freund's heirs requested the return of the four works of art, stating that they were sold solely for economic reasons due to Nazi persecution. The competent Bundesamt zur Regelung offener Vermögensfragen (Federal Office for the Settlement of Open Property Issues) rejected the return because it did not see any connection between Nazi persecution and the paintings' sale.

Initiatives

Following this general introduction to our work, permit me now to introduce the two initiatives I mentioned earlier.

Provenance Research Module

Recently media in Germany and elsewhere have reported a certain loss of interest in looted art objects and have criticized German museums for not contributing sufficiently to provenance research. There also have been complaints about provenance research "know-how" being drained by the expiration of contracts with workers active in the field. Others have complained about a perceived lack of research tools, including for instance a central database listing dealers and collectors who had handled such art. To respond to these criticisms, I believe one first needs an understanding of who is responsible for what in the provenance research field. Here the responsibilities are quite clear. Institutions such as museums, libraries, and archives are obliged to identify works of unclear provenance and report them to the Office, which in turn is responsible for documenting the findings at www.lostart.de.

Institutions

Institutions are free, of course, to decide the extent of the provenance research, if any, they wish to undertake.

The first task of provenance research is therefore a question of setting priorities; this question must be decided by each institution itself. Two years ago, I described to a provenance research conference in Hamburg two alternative approaches institutions have taken when searching their collections for looted art.

On one hand, some institutions seek to investigate the provenance of each individual work until the provenance becomes clear. This requires a high labor input, is costly and time-consuming, and—due to that lengthy internal research—can withhold partial but important information from those concerned until the research is deemed complete. After all, claimants who could recognize and identify works once owned by their families and have proof of such ownership are growing older from day to day. In the words of Monica Dugot, formerly of the Holocaust Claims Processing Office, this is truly a "race against time."

Other institutions pursue provenance research by first surveying entire stocks groups of objects to identify works in question. This survey is followed by immediate publication at www.lostart.de. This approach saves time, can be handled relatively speedily by existing personnel, and makes the facts known almost at once. The institution also may receive new information about the works as a result of going public.

In my opinion, these two methods must be combined, particularly because the return of assets may be delayed by investigating their provenance at length before publishing it. When dealing with German establishments, we therefore routinely demand publication—as early as is feasible—of as many suspected assets as possible on the Internet, bearing in mind the spirit of the Joint Declaration and the rationale behind www.lostart.de.

Koordinierungsstelle für Kulturgutverluste

Regarding the work of the Office, I would like to announce the addition of a provenance research module to www.lostart.de. In the course of our work during the last 10 years, we have acquired information that goes beyond mere reports of lost and found art. This information includes data on claimants, dealers, auctions, etc., which on principle lends itself to the organization of individual lists to support research. These lists, which can be searched electronically, contain names of claimants; details of what is known about Jewish auctions; lists of storage places outside museums; lists of archivists, collectors, people who delivered assets, art dealers, auction houses, etc.; stamps and collector's marks on paintings; sources, finds, and auxiliary tools, links, etc. As you can see, such material touches on most of the aspects discussed at this

conference. Extracts that can be used as tools by German museums have been incorporated into the module.

After an introduction to the subject of provenance research, the provenance module provides basic information on how to detect looted art, accompanied by listings of suspect names, including owners, dealers, collectors, auction houses, and the like. Another section of the module deals with specific indicators relating to the object, such as the circumstances of acquisition and marks and pointers on the work itself, etc., followed by lists of domestic and foreign sources subdivided into archives, libraries, etc. Finally, the user will find reports on provenance research at home and abroad, along with a detailed bibliography on looted art, provenance research, case studies, and restitution.

This arrangement facilitates the search for specific data, and users will not have to read lengthy texts to find the information they seek. Provenance research thus will benefit from reports to our Office, which in turn will facilitate restitution in accordance with the objectives of the Joint Declaration.

In keeping with the concept of www.lostart.de as a service database to which third parties may contribute, the provenance module will accept material offered by informed parties at home and abroad (workers in the field of provenance research, art historians, scientists, etc.). Information gathered from outside will complement information already available from the Office and provide a better tool for use by institutions conducting provenance research. This should help mitigate concerns about expert knowledge being drained from the field.

I would like to see continued use of www.lostart.de on your part and invite you to submit contributions to the provenance research module.

Metasearch

Finally, here are some thoughts on the second initiative, which deals with ways of promoting international cooperation among database operators.

The international conference organized by the Office in Magdeburg, Germany, in November 2001 was devoted to the subject "Database-assisted documentation of lost cultural assets: Requirements, tendencies and forms of cooperation." The conference is documented with selected papers in a special edition of the *Spoils of War* newsletter, available at www.lostart.de.

Participants from the United States, the Netherlands, France, Austria, Britain, the Czech Republic, Russia, and Germany discussed aspects of possible cooperation between database operators. They also agreed that tools to guide users through a steadily rising flood of data were necessary so that information could be found more easily. Conference attendees suggested that a metasearch system would provide the required degree of clarity, while preserving the desirable autonomy of national databases that might be lost in any attempt to establish one central system.

Since then, as you all know, the Nazi-Era Provenance Internet Portal (www.nepip.org) has been developed by AAM and presents nearly 14,000 objects from 115 American museums. From my point of view, the Portal is a very important and, without any doubt, valuable addition to the available provenance research tools.

With regard to similar European activities and as a follow-up to the Magdeburg conference, the prototype of a European metasearch engine already has been developed jointly by Magdeburg's Otto-von-Guericke University, the Office, and the Czech and Dutch operators of Internet databases. Encouraged by the conference and the fact that we now have the prototype, I would be very pleased if, in addition to the Netherlands, the Czech Republic, and Germany,

other partners would join this metasearch project in the future. Therefore, we will continue to invite all international database operators to take part in the project.

Prospects for the Future

Now and in the future our efforts will be aimed at providing free access to information on an international scale as the necessary first step to identifying and returning looted and trophy art to its rightful owners. As this is a cross-border issue, I believe that international cooperation is imperative. I would therefore be glad to see you use www.lostart.de very actively in the future. However, I also would like to enlist your support in extending this website and promoting cooperation of all kinds among databases dealing with these issues. Such supranational collaboration and sharing of information is the only way to make progress on the difficult road to restitution now and in the years to come.

Author's note: Parts of this text have been published previously.

Looted, Lost, and Recovered: Poland's Restitution Efforts

Boguslaw W. Winid and Anna A. Pankiewicz

Looting of Polish Cultural Property

All restitution efforts of art looted from Poland during and in the aftermath of World War II should be seen against a historical background.

On Sept. 1, 1939, Poland was invaded by German forces; on Sept. 17 it also was invaded by Russian troops. After five weeks of fighting, Polish forces were defeated and the two powers occupied the country. Both the Nazis and the Soviets committed plunder, confiscations, and coercive transfers of cultural property on a massive and unprecedented scale. The looting started almost on the very first day of the invasion—even in the opening weeks of the war German units did not spare the priceless collections of the Czartoryski family gathered in their castle in Sieniawa, destroying *inter alia* the entire collection of royal memorabilia.

After the occupation of 1939, planned, systematic confiscation started. In this respect the situation in Poland was unique, as there was a formal decree on Dec. 16, 1939, issued by Hans Frank, Nazi general governor of Poland, which prohibited anyone living in occupied Poland to possess any works of art created before 1850. Anyone in possession of such objects was to report this fact directly to the government of the occupying forces. It goes without saying that not many Poles volunteered to obey this law. Yet the decree provided a legal basis for Nazi confiscation—in other words, it legalized the looting. It is also worth noting that in 1941 the German authorities published a catalogue of looted art (*Sichergestellte Kunstwerke im Generalgouvernement*), known as the "catalogue of plunder." This infamous catalogue consisted of 521 most splendid objects that had been stolen from public and private collections. Postwar Polish restitution efforts resulted in the recovery of roughly 55 to 60 percent of these masterpieces; other objects are still missing. Probably the most precious painting still missing is the famous *Portrait of a Young Man* by Raphael, looted from the Czartoryski collection in Kraków.

It should be mentioned that in occupied Poland—just as in France—various German authorities competed with each other for stolen objects. On the one hand there was Hans Frank, the general governor, who was convinced that everything looted in central Poland belonged to him. On the other hand, other Nazi institutions favored the transfer of certain objects to Berlin or to Linz. Robbery by the German army was initially carefully planned. Long before the war German art historians had compiled lists of the most valuable pieces from Polish collections. These included, among others, the case of Albrecht Dürer drawings, stolen in 1939 by the Austrian art historian Josef Mühlmann—brother of Kajetan Mühlmann, responsible for the looting in Poland on behalf of the Reich—from the collection of the Warsaw University Library. The three magnificent pen-and-ink drawings by Dürer never returned to Warsaw.

In the eastern part of Poland, the Soviets plundered Polish cultural property with a brutality equal to that of the Germans. Entire art collections were confiscated. In addition to direct plunder, the Soviet military forces also captured in 1944 and 1945 some of the Nazi reposito-

ries containing works of art looted not only from Poland but from other European countries as well and subsequently transferred them to Moscow. Thus, objects that should have been treated as wartime losses to be made good through repatriation were confiscated as war trophies for the Soviet state.

In 1944 two further tragic cultural losses occurred in Warsaw. During the Warsaw Uprising of 1944, the National Museum was almost completely destroyed and organized looting gave way to uncontrollable plunder by individual soldiers. Then, after the capitulation of Warsaw in November 1944, the German Brandkommando burned down the entire collection of the National Library of Warsaw. Thousands of rare books, old books, and manuscripts were intentionally destroyed, without any military or strategic justification.

The end of war in 1945 did not bring peace to Poland. The country came under the Soviet influence. To put it in the words of Jan Ciechanowski, former Polish ambassador to the United States, Poland faced "a defeat in victory." For the next three years Poles struggled against the growing Soviet domination. Finally the communist forces supported by the Soviet NKVD prevailed and crashed the opposition. The communist system was established in Poland.

Restitution Efforts

The most significant restitution activity occurred in the years immediately following World War II (1945-47), mostly from the American-occupied zone in the western part of Germany. These efforts were led by Prof. Karol Estreicher, who as early as 1944 edited a publication registering Poland's wartime losses (*Cultural Losses of Poland, Index of Polish Cultural Losses during the German Occupation 1939-1944*). However, with the sovereignty of Poland limited by the Soviet presence, the pace of restitution quickly slowed. For purely political reasons the communist authorities never seriously attempted to recover any objects of art. In 1951 the Bureau for Restitution and Compensation was dissolved. Except for several instances of restitution from Russia in the late 1950s, the issue of Polish cultural losses was more or less abandoned for the next several decades.

In 1989 Poland regained its sovereignty and it became possible once again to engage in restitution work. Two special bureaus were established, one in the Ministry of Culture and another in the Ministry of Foreign Affairs, to deal with the issue of looted cultural property. As part of the restitution efforts Poland initiated talks with Germany, Russia, and Ukraine. To show the scale of wartime losses and aid in identifying specific objects, the Ministry of Culture published a series of five catalogues on lost cultural property. These catalogues are available as books, CD-ROMs, and online on the website of the Polish Embassy in Washington, D.C., www.polandembassy.org. The series encompasses the following volumes: *Polish Painting, Foreign Painting, Ancient Art, Numismatics,* and *Jacob Kabrun's Collection.* This last volume illustrates the fate of the famous collection from the City Museum in Gdansk. One should bear in mind, however, that these publications present only a small percentage of lost works of art. This is mainly due to the lack of written or visual documentation.

Recent Restitution Cases

Some recently resolved cases illustrate the restitution efforts now being made by the Polish government:

Flowers in a Glass Vase by the Dutch painter from Amsterdam Jacob van Walscapelle (1644-1727), looted from the National Museum in Warsaw in 1944, was returned to its original location in April 2001.

The Holy Trinity, attributed to Georg Pencz (c. 1500-50) of Nuremberg, stolen from the

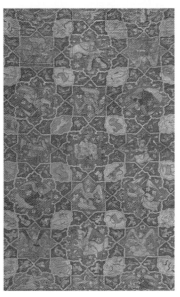

Above: *Holy Trinity* by Georg Pencz. Right top:*The Dead Christ* by Albrecht Dürer; from the Lubomirski collection, currently housed by the Cleveland Museum of Art. Right above: Persian tapestry (detail).

National Museum in Warsaw in 1944, was recovered from the Viscaya Museum and Gardens in Miami, Fla., in January 2002.

The Los Angeles County Museum of Art returned in April 2002 a 16th-century Persian tapestry, looted from the Czartoryski collection in Kraków.

In July 2002 a New York art gallery owner returned a marble *Head of a Youth* by Giovanni Maria Mosca, known as Padovano (1493-1574), to its rightful owner, the National Museum in Warsaw.

Peasants in an Inn by the Dutch painter Adriaen Brouwer (1605-38) was returned by the English art dealer Johnny van Haeften.

Woman in an Armchair by Charles François Hutin (1715-76) was restituted from France by the Tajan auction house. This painting was one of the 521 masterpieces included in the above-mentioned Nazi catalogue. It was returned to the Potocki family in Warsaw. This recovery would not have been possible without the involvement and active support of the Art Loss Register.

It was also thanks to the engagement of the Art Loss Register that we learned that yet another painting, duly registered as a wartime loss, was put up for sale at Sotheby's auction

house in London. The case of the 19th-century painting by Wojciech Gerson (1831-1901) remains unresolved.

There has been only one recent case of an official restitution from Germany. The object in question—an Etruscan mirror—was returned from Hamburg to the Czartoryski collection at the Goluchów castle. The only other instances of recovery involved individual German citizens, former soldiers, who decided to return once-stolen pieces.

In November 2004 the Museum of Fine Arts in Boston returned a 15th-century *Madonna with Child*, originally the central panel of a triptych, to its rightful owner in Poland. Both parties expressed their satisfaction that the matter was resolved amicably, in accordance with AAM's *Guidelines Concerning the Unlawful Appropriation of Objects during the Nazi Era*.

In this context it is worth noting that Polish museums also are engaged in investigating the provenance of their own collections, systematically checking the collections for objects that might have ended up in Poland in the turmoil of the war. In 2001 a set of Judaic liturgical objects was located in the National Museum in Warsaw and subsequently handed over to Michael Schudrich, chief rabbi of Poland. The ceremony took place at the Warsaw Synagogue.

Polish authorities currently are engaged in several other restitution matters. The most famous case relates to the Lubomirski Dürers, which before the outbreak of World War II were a part of the splendid collections of the Ossoliński National Institute in Lwów. The recently published book *The Fate of the Lubomirski Dürers: Recovering the Treasures of the Ossoliński National Institute* presents in a comprehensive way the tragic wartime history of the once most treasured artifacts in Poland. The publication includes a section with selected legal documents that should prove useful in illuminating this fascinating yet complex case.

Current German Research

The Implementation of the Washington Principles in Germany:
Some Legal Aspects

Harald König

GERMAN museums and public authorities use provenance research as a tool for uncovering factual material concerning the whereabouts of works of art and to establish their legal owners between 1933 and 1945. Complemented by historical knowledge about the Nazi regime in Germany and the occupied countries, this factual material provides a basis for the handling of claims for compensation or restitution. Therefore provenance research must consider the rules, standards, and guidelines that govern the handling of such claims.

The principles adopted during the Washington Conference on Holocaust-Era Assets call for a "just and fair solution" in cases where former owners of works of art confiscated by the Nazis can be identified. The relevant authorities in Germany—the Federal Government, the Lands (i.e., the federal states), and the Communities and Cities (i.e., local authorities)—affirmed their willingness to meet these standards in a declaration published in 1999.[1] This declaration, however, emphasizes that the relevant German legislation "finally and comprehensively provide[s] for issues of restitution and indemnification of Nazi-confiscated art, especially from Jewish property." It goes without saying that the German legislature intended nothing else but a just and fair solution when enacting those laws and regulations that are known as the German Wiedergutmachungsrecht.

Apparently, the just and fair solution envisioned by the Washington Principles and the German declaration affirming them has a counterpart within the German legislation,[2] and it becomes necessary to distinguish between the two just and fair solutions. First of all, neither the Washington Principles nor the above-mentioned German declaration of 1999 establishes enforceable legal grounds for a claim. Therefore requests for restitution made under the Washington Principles (or the corresponding German declaration of 1999) need not be established within certain time limits. The German (Wiedergutmachungsrecht) legislation, by contrast, requires that specific deadlines be observed if claims are to be enforceable.

German legislation covering legal claims of Holocaust victims can reach only as far as the territorial sovereignty of the German legislature. Hence, objects dispossessed or confiscated in foreign countries occupied by Nazi Germany cannot be claimed under German legislation unless these objects were subsequently transferred to Germany. In contrast, the Washington Principles do not impose such territorial limitations.

According to German legislation, claimants qualify for restitution if their claims comply with the specific requirements laid down in the restitution laws. In particular, property lost during the Nazi era can be claimed only in cases where Nazi persecution caused the loss. If property was sold under duress or force, a direct link between the pressure exerted on the victims by Nazi persecution and the decision to sell off their property must be established. For the benefit of Jewish owners, however, German restitution laws contain a refutable presumption of this direct link. In contrast, the Washington Principles do not establish such specific requirements.

The principles merely recognize that the solution to be found "may vary according to the facts and circumstances surrounding a specific case."

Although German restitution laws specify the prerequisites for restitution and compensation, the relevant provisions cannot anticipate every possible circumstance and thus leave space for interpretation by implementation. The vaguely formulated just and fair solution prescribed in the Washington Principles also must be determined by interpretation. As regards German restitution laws, an extensive body of case law demonstrates how these provisions have been implemented in large numbers of individual cases.[3] When courts in Germany reviewed thousands of decisions made by the competent government authorities, the primary objective was a just and fair solution to each individual case. In almost the same manner as provenance research produces the relevant factual material needed for the handling of claims, German authorities and courts reveal the relevant facts of each individual case in preparation for their decision.

The body of case law dealing with the issue of restitution and compensation of Nazi confiscated assets is still growing. The Property Settlement Law of 1990[4] covers claims of victims who lost their property in the course of the Nazi persecution in East Germany between 1933 and 1945. The competent authority in Germany is still handling these claims. In its decisions this agency—the agency I work for—makes reference to this existing body of case law.

Under these circumstances, it seems reasonable that the government authorities handle requests for restitution under the Washington Principles through procedures analogous to the procedures and the material conditions laid down in German restitution laws, complemented by the existing body of case law. Thereby, equal treatment is guaranteed for those who request restitution of works of art with reference to the Washington Principles and those who lodged their (legal) claims under German restitution laws. However, the abandonment of time limits and territorial restrictions within the Washington Principles distinguishes the handling of requests for restitution according to the principles from legal procedures according to German restitution laws. Nevertheless, a just and fair solution according to the Washington Principles should consider compensation payments that already have been made according to German restitution laws.

Among the general principles that govern German restitution laws, the refutable presumption for the benefit of Jewish victims plays an important role. Accordingly, "any transfer or relinquishment of property made by a person who belonged to a class of persons which . . . was to be eliminated in its entirety from the cultural and economic life of Germany by measures of the State or the NSDAP for reasons of race, religion, nationality, ideology or political opposition to National Socialism shall be presumed an act of confiscation."[5] There exists an extensive body of case law that illustrates the variety of individual cases in which this provision became relevant and had to be interpreted by the judiciary.

Recently, a claim concerning two Waldmüller paintings that once formed part of Hitler's so-called Linz collection was brought forward. The federal agency in charge of the remaining part of this collection had to handle the claim. The Jewish former owner of these paintings lived in Austria until 1939. Before he left Austria, he transferred the ownership of these two paintings to his wife. His wife, who was not considered Jewish according to Nazi legislation, remained in Austria and put the two paintings on sale after her husband had left the country. In early 1940 the couple divorced. Finally, one of Hitler's agents responsible for the planned museum in Linz (Austria) bought the two paintings on behalf of the German state.

One of the key issues discussed with the claimants was the question of whether the non-Jewish spouse belonged to the "class of persons which . . . was to be eliminated in its entirety

from the cultural and economic life of Germany by measures of the State or the NSDAP" for the reason of race. As the circumstances of the transaction did not indicate a forced sale, the question of whether or to what extent the presumption for the benefit of those who belonged to the class of persons that was to be eliminated is applicable in this individual case became relevant.

In 1950, the United States Court of Restitution Appeals in Germany held that "in many instances . . . the attitude of the Aryan spouses and/or the measures taken against them did place such persons . . . within the meaning of having been deprived of their property for reasons of race or religion or nationality. When an Aryan elected to stand by her Jewish help-mate, she often shared his fate, insofar as being forced to sell their property was concerned."[6] In subsequent decisions German courts subscribed to this view and made clear that non-Jewish spouses could benefit from the presumption of confiscation as long as they shared the fate of their Jewish spouse. However, a non-Jewish spouse who separated from or divorced her Jewish spouse could not benefit from this presumption.[7] Accordingly, the transaction in dispute in the discussed case could not be considered a forced sale.

The question concerning the circumstances under which a former owner may benefit from the presumption of confiscation according to the definition given in the restitution laws became relevant in another case concerning works of art that formed part of Hitler's so-called Linz collection. In this case the Jewish former owner transferred his collection of works of art to Switzerland in 1933. In 1939, he left Germany with his family and moved to the United Kingdom. After his death his legal heirs decided to auction off the collection of works of art in Switzerland. Again, one of Hitler's agents bought several paintings for the Linz collection on behalf of the German state.

The heirs of the former owner argue that Nazi persecution causally determined their emigration and their financial difficulties which induced them to sell off these paintings. Furthermore, it has been brought forward that the family belonged to "the class of persons which was to be eliminated in its entirety from the cultural and economic life of Germany by measures of the State or the NSDAP."

On the other hand, the paintings were offered for sale in a foreign country at a time when the family had escaped from Nazi persecution. Therefore, it has been argued that a direct link between the persecution in Germany and the sale of the paintings in Switzerland is missing. Furthermore, "measures of the State or the NSDAP" taken to eliminate all Jews "from the cultural and economic life of Germany" could reach neither person nor property located outside the German state or the countries occupied at the time.

These two cases may serve as illustrations of the handling of claims or requests made with reference to the Washington Principles. In almost a dozen other cases, the German authority charged with handling these claims decided in favor of restitution. In all cases research conducted prior to the decision included the factual material concerning the provenance of the paintings as well as the existing case law.

Notes

1. Statement by the Federal Government, the Laender (federal states), and the national associations of local authorities on the tracing and return of Nazi-confiscated art, especially from Jewish property, Dec. 14, 1999, available at www.lostart.de.

2. The legislation providing for the restitution of identifiable property within the three western occupied zones had been enacted by the occupying Allied Powers.

3. Thirty volumes of the (monthly) law journal *Rechtsprechung zum Wiedergutmachungsrecht* (RzW) give an account of this case-law.

4. *Gesetz zur Regelung offener Vermögensfragen* (VermG).

5. Cf. Art. 3, Law No. 59 Restitution of Identifiable Property, Military Government–Germany, United States Area of Control; Law Gazette of the Military Government–Germany, United States Area of Control, Nov. 10, 1947, vol. G, p. 1.

6. Reports/United States Court of Restitution Appeals of the Allied High Commission for Germany, U.S. High Commission for Germany, 1951, case 131, p. 399 [400].

7. ORG Berlin RzW 1955, 286; BGH RzW 1958, 110; BVerwG NJW 2001, 87.

Cases and Results of Provenance Research
at the National Gallery, Berlin

Friedegund Weidemann

FOR YEARS, the National Gallery of State Museums in Berlin has been pursuing provenance research to a certain degree in conjunction with cataloguing its inventory. As early as 1959-60 Jewish property was returned to its rightful owners, for example, to the heirs of the Cassirer family. Following the resolutions of Washington and Berlin, the focus again turned to the acquisitions of the gallery between 1933 and 1945. Therefore, in 2003 I was assigned to conduct the Provenance Research of the National Gallery, in view of the fact that I am a long-standing employee of the National Gallery and that I had a substantial part in cataloguing the inventory of the 20th-century paintings.

As a first step, I examined around 500 acquisitions of paintings and sculptures that took place during the period 1933 to 1945, registering them in a file. Documents in the central archive of the State Museums in Berlin laid an essential and unique groundwork for provenance research, providing an exact register of the National Gallery's files from 1933 to 1945. Research into acquisitions after 1945 will follow later. That period likely includes some problematic cases, such as a gift by the government of the Polish Republic to the German Democratic Republic (GDR) in 1953, or a transfer of objects for the Gallery of 20th Century by the Berlin Magistrate to the National Gallery in 1951.

Through the examination and appraisal of the acquisitions of the period 1933 to 1945—127 of which are recorded as lost during the war and through the "degenerate art" operation— Jewish property also was found. This property reached the National Gallery in different ways.

There are works sold by the persecuted owners themselves until 1937 and then inventoried.

There are works that were transferred to the National Gallery by the National Socialist authorities starting in 1937-38, often with unidentified ownership.

There is also confiscated property transferred to the National Gallery by the National Socialist state. These works were often only partially inventoried at the time, or were inventoried after the war.

There are some works of art that owners were compelled to turn over, in person and at their expense, to the National Gallery. These have not been inventoried.

Another problem, not yet completely resolved, is the purchase of works of art from property pawned with the Dresdner Bank by the Prussian State in 1935, some of which were transferred to the collections of the State Museums and, therefore, also to the National Gallery. The archive of the Dresdner Bank—as far as it was made available for my research—contained no detailed reference to the previous owners for these works of art. But there is no indication of illegitimate property.

Also, the purchases from galleries and auction houses have to be investigated regarding pre-

vious ownership. This investigation often proves to be difficult and lengthy, since the art dealers, or rather their successors, and their files after the war can no longer be found—a problem with which all provenance researchers are familiar. These approximately 140 works of art have been categorized as "incomplete provenance."

Nevertheless, the majority of the acquisitions of paintings and sculptures between 1933 and 1945 by the National Gallery are legally and morally indisputable and could be classified as "secure stock." The former directors, Alois Schardt (1933), Eberhard Hanfstaengl (until 1937), and Paul Ortwin Rave (until 1949), deserve our gratitude for being first and foremost dedicated to their museum work, despite the fact that they were civil servants. For the most part, these directors managed to keep a certain distance from the operations of the National Socialist state. For example, in 1933 all works of modern art that had been on loan to the museum were returned from the Kronprinzen-Palais (Crown Prince's Palace) to the owners to protect them from the imminent grasp of the state.

I would like to relate three examples of works of art from Jewish ownership that ended up at the National Gallery in East Berlin until the German Reunification. I will only briefly mention the most spectacular case, whose restitution in 2003-04 you surely know from the press: Caspar David Friedrich's painting *Der Watzmann*. Painted in 1824-25, this high mountain landscape of the "Berchtesgadener Land" was purchased by then-director Hanfstaengl from Martin Brunn of Berlin, on Feb. 19, 1937, and inventoried with the number A II 895. At a purchase price of 25,000 Reichsmark (RM), it was probably the National Gallery's most expensive acquisition between 1933 and 1945. Hanfstaengl, a specialist on romanticism, had appraised this major work as being from the middle of the artist's creative period and one of his very rare large-size paintings, and had ascribed it to C. D. Friedrich, which until then had not been certified. Since the National Gallery had a tight acquisition budget even then, it had received a grant of 10,000 RM from Hitler's special budget for this purchase.

Martin Brunn and his wife immigrated to the United States in 1941 after sending their children to Great Britain for their protection in 1939, a time when Brunn was unable to travel due to illness. This past year, the painting was restituted to his descendants. Thanks to the help of the DekaBank, which purchased the painting in 2004 from the heirs and made it available to the National Gallery as a permanent loan, it has remained in-house without interruption. It was on display at the Old National Gallery until Jan. 30, 2005, as part of a special exhibition within its temporal context and with other landscapes, such as its pendant *Ice-Sea* and an interpretation of the *Watzmann* by Ludwig Richter, from which Friedrich got his inspiration.

My second example describes a very moving case of a Jewish owner of four paintings who was not able to emigrate. On Dec. 9, 1940, in Berlin Mrs. Frida (Sara) Levy was forced to personally hand over to the National Gallery one painting by Hans Thoma titled *Sunflowers*, painted in 1909, as well as three other paintings—two flower representations and a painting titled *Wildflowers*—by Thoma's adopted daughter and student, Cella Thoma. The reason behind this forced donation was the "security order," dated July 12, 1940, against Mrs. Levy, confiscating her property according to article 59 of the currency law for the "protection of German cultural goods against emigration." A letter dated Oct. 24, 1940, from the financial president informed the officiating director of the National Gallery, Paul Ortwin Rave, of this fact. Mrs. Levy inquired of Rave on June 7, 1941, if the National Gallery might be interested in acquiring the Thoma painting. Rave responded on June 25, 1941, that the painting "could not be considered for acquisition by the National Gallery" because the Gallery already had a large stock of Thoma's works at its disposal. After the war, Rave intended to return the paintings, which had not been inventoried, to Mrs. Levy and wrote in a letter dated Aug. 2, 1946, that the paint-

ings survived the war without damage. The letter was returned on Aug. 15, 1946, marked "addressee moved; no return address," as were most letters addressed to members of the Jewish community in Berlin after the war. On Oct. 14, 1946, Rave turned to Dr. Grumbach, a Berlin attorney. On Nov. 26, 1946, Dr. Grumbach reported to Rave about his investigation: Mrs. Frida Levy had been arrested by the Gestapo and did not return. He was not sure if she was killed and he recommended that Rave keep the paintings until Mrs. Levy or her heirs got in touch with him, or an agency for "ownerless Jewish property" was established. (I found out from the Centrum Judaicum that in 1942 Mrs. Levy was deported to Riga and killed.) In response to Rave's inquiry, the counsel of the State Museums informed him that no law existed yet dealing with former Jewish property, and he recommended leaving the works in the National Gallery and resubmitting the problem from time to time. The division of Germany and the Cold War helped to keep the artworks at the Gallery. After the reunification the Prussian Cultural Heritage looked for the heirs with the aid of the Red Cross. Now the restitution to the heirs in Israel is currently ongoing.

During my research at the central archive of the State Museums and at the main archive of the state of Brandenburg, I came across a very progressive and culturally and socially engaged personality of the Weimar Republic, whom I would like to present to you as my last example: Hugo Simon. His property was confiscated in two operations—in 1933 for political reasons and in 1937 for racial reasons. In 1938 the National Gallery received works from the second expropriation, whose restitution to the grandchildren has now been initiated.

Hugo Simon lived in Berlin until 1933. A teacher's son of Jewish descent, he was born Sept. 1, 1880, in Usch near Posen. Trained as a bank official, he was a founding member of the banking house Carsch, Simon, & Co. in 1911, which in approximately 1922 was renamed Dr. Bett, Simon & Co., on Mohrenstrasse in Berlin, near Friedrichstrasse. Early on he joined the SPD (Social Party of Germany) and from 1917 to 1919 he was a member of the USPD (Independent Social-Democratic Party of Germany). On Nov. 14, 1918, after the November revolution, he became the first finance minister of the Hirsch Cabinet of the young Weimar Republic, and six weeks later on Jan. 3, 1919, he left the Cabinet together with all the other USPD members. In his novel *November 1918*, Alfred Döblin described him as a "farmers' minister." His friends included the brothers Thomas and Heinrich Mann, Albert Einstein, Stefan Zweig, Ernst Rowohlt, Samuel Fischer, Harry Count Kessler, and Kurt Tucholsky, who had worked at the bank as a trainee and, for a short period, even as Simon's private secretary. Membership in the League for Human Rights also connected Simon to Tucholsky.

Simon's house on Rauchstrasse, at the corner of Drakestrasse, in Berlin-Tiergarten was remodeled under the direction of Paul Cassirer and decorated with artworks such as a mural painting by Max Slevogt in the winter garden. It served as a meeting place for the contemporary political and artistic avant-garde. Simon not only sponsored art and artists but was also a member of the board of the "Association of friends of the National Gallery." From 1924 until 1933 he kept an account for the children's relief organization, "children's hell."

In his autobiographical novel *Silkworms*, Simon described his life and work before 1933. A pacifist by conviction, he reluctantly retired early from politics around 1930 and established the Experimental Estate Oderbruch (at the site of the former Swiss House) on 400 acres of land in Seelow, in Mark Brandenburg, as a social and ecological project. He had main roads constructed in Seelow at his own expense. His residence there also held an art collection.

According to the law of revocation of naturalization and the deprivation of German nationality dated July 14, 1933, Simon's entire fortune, including the art collection, was declared to be the state's property in an announcement dated Oct. 26, 1937, published in the *Deutscher*

Reichsanzeiger on Oct. 27, 1937. He and his family already had been dispossessed according to the law of confiscation of communist fortunes, dated May 26, 1933. The estate was confiscated on that date by the district leader of the NSDAP (National-Socialist German Workers Party) and collected by the government president of Frankfurt/Oder on Oct. 5, 1933. (The confiscated estates were assessed at an appraised value of 405,000 RM, with additional assets at 2,400 RM, which was offset by a so-called mortgage as well as tax debts from the year 1932 in the amount of 610,000 RM.) On March 27, 1933, after a warning from friends, he and his wife, Gertrud (née Oswald), successfully emigrated via Switzerland and Amsterdam to Paris. Their two daughters were already abroad. Dr. Bett, the co-owner of the bank, traveled to Amsterdam on June 1, 1933, and again in October 1933, and convinced Simon to withdraw from the bank house (registered in the trade register on Nov. 9, 1933). From 1935 until the German occupation, Simon lived in Paris's second district. He founded a new bank house, financed the *Pariser Tageblatt/Pariser Tageszeitung* (a daily newspaper), and supported numerous immigrants through the Baron de Rothschild Committée in the Democratic Refugée Aid. In 1940-41, the family fled via Marseille to Brazil with the aid of Czech passports. Hugo Simon died there in 1950 and his wife in 1964.

The starting point of my research, which led me to this impressive biography, was a collection of four paintings in the inventory A II at the National Gallery with the remark "transferred by the government president Frankfurt/Oder from the confiscated collection of the bank director Simon in Seelow." On Dec. 27, 1937, the general director of the State Museums had received an offer from the government president of Frankfurt/Oder to come to the local police president's office and examine 40 listed paintings confiscated from Simon in the name of the Prussian state and decide which of them could be considered for transfer to the collections of the museums. The remaining works of art would be "sold by an appropriate art dealership." On Feb. 1, 1938, Dr. Wolfgang Schöne, an employee of the National Gallery, travelled to Frankfurt by order of Director Rave and chose four paintings, one watercolor, and 24 graphics. The graphics—22 reproductions after H. Daumier and two lithographs by O. Kokoschka—were handed to the Museum of Prints and Drawings on March 16, 1938. They, as well as the watercolor titled *Huge Landscape with Figures* by French expressionist Jean Lurcat, are among the war losses. The paintings—three from the 19th century, *Horseback Ride* by Rudolf Henneberg, *German Legend* by Julius Schnorr von Carolsfeld, and *Landscape with Oaks* by Georg Heinrich Crola, as well as *Snow Landscape* by the German expressionist Hermann Max Pechstein— remained after the division of Germany at the National Gallery in East-Berlin. Their restitution is now in process.

The president of the Prussian Cultural Heritage Foundation (Stiftung Preußischer Kulturbesitz) has actively pursued the return of illegitimate property, with the awareness that we have to take responsibility for our history.

Author's note: A longer version of this article is featured in the 2005 *Jahrbuch Preußischer Kulturbesitz*, published by the National Gallery of State Museums in Berlin.

Special Considerations Concerning Provenance Research in Eastern Germany

Ursula Köhn

PROVENANCE research in eastern Germany, the former territory of the German Democratic Republic (GDR), is generally difficult because the original file materials are no longer accessible. For one, the files of the Staatliche Kunstsammlungen Dresden (SKD) were not maintained properly during World War II. In addition, files from Dresden's council administration [city hall], town archive, and museums either were burned in the bombing attack on Feb. 13, 1945, or lost during the resulting fire and rescue efforts.

Under the GDR government, only high-ranking officials had access to archival and museum files concerning art recovered from castles after the war. This was also true of the records of items left behind by refugees from the GDR and the subsequent sale of those items by government agencies. Finally, many essential aspects concerning the handling of these artworks were not written down; instead, much was done through unrecorded private meetings, oral agreements, etc.—a characteristic of the totalitarian system that ruled the GDR.

In this essay I will give a brief introduction to some special topics of provenance research in the former GDR, with a focus on Dresden. These topics and collections, little known outside of the GDR for so long, now can be made known to a broader community.

The Führermuseum in Linz

The city of Dresden held a special position in the National Socialist (NS) art-transfer system because of the connection between gallery directors Hans Posse and Hermann Voss and Hitler's planned Führermuseum in Linz, which was to be located on the Danube. Posse and Voss served successively as "special representatives" of the Führermuseum in charge of planning for and acquiring works. It is important to note that artworks that passed through Dresden under the auspices of the office of the special representative were not intended for city but for exhibition in the Führermuseum or other museums.

The works of art were accounted for on arrival and departure by the gallery director's office manager and the accounting manager in the office of the special representative, Fritz Wiedemann. Processing for the Führermuseum took place in the Dresdener Gemäldegalerie (Dresden's painting gallery). Photographs were taken by Alfred Loos or Hans Willy Schönbach. The painting restorer Fritz Unger was commissioned when his services were needed.

Initially, notes were made on handwritten cards. Later, between Aug. 12, 1942, and June 4, 1945, Wiedemann maintained a list. A copy of this list has always been in the archive of the general administration. The original can be found in the national archive in Berlin; it has been available as a resource for all researchers since May 2004.

The records concerning the storage facility, Castle Weesenstein, refer to "card boxes Linz." We know that these card boxes are still in Moscow today. Unfortunately they have not yet been made available for examination.

Losses Due to War: Search for Missing Paintings in the Erzgebirge (Ore Mountain Range)

Dr. Hans Ebert was the representative of the general director of the SKD from 1960 to 1967. In the mid-1960s he initiated a limited search in the Erzgebirge region for paintings lost from Dresden during the war. Karl Brix also took part in the search; he was an expert on Schmidt-Rottluff and director of the art collection of Karl-Marx Stadt, the city that today is known once again as Chemnitz. The goal of this search was to recover some of the lost paintings by seeking help from the inhabitants of the region where the works were kept during the war. The undertaking was a success, at least in part: all in all, 27 paintings and 30 drawings were given back to museums and exhibited in August 1966 in Karl-Marx Stadt. Press coverage of the search also made it possible for the subject of "war losses" to be discussed more openly within the GDR.

Ebert's 1963 publication, *Kriegsverluste der Dresdener Gemäldegalerie* (War Losses of the Dresden Painting Gallery), has received much praise and is internationally known. However, the actual search for the lost paintings in the Erzgebirge (southwest of Dresden) in the mid-1960s has not received much public attention. To my mind, this regional undertaking is just as important. I spoke with Ebert, then director of the Berlin Kupferstichkabinett, about this in 1969, during my work there to classify prints of the Berlin ornament engraving collection, returned to the GDR as a "gift" from the Soviet Union 10 years earlier.

The subject of Dresden's war losses is by no means closed. A catalogue of the artworks from the city's museums that went missing or were lost due as a result of the war is being prepared for publication in 2005.

Land Reform Assets and Items Taken from Castles

This category of confiscation and movement of art objects is unique to the eastern part of Germany, and arose from the state custody of art assets left in deserted castles and manors following land reforms in 1945. Museum staff and monument caretakers transported to nearby museums or council houses valuable and portable furnishings that people had left behind. In Saxony, the Albertinum was used by the SKD as a main collection point. In this way a significant number of items recovered from the castles ended up in the SKD museums.

The administration called cultural items of this category "stored assets in governmental possession." In the museums they were simply called "land reform assets." Apart from some leftover items, these objects were given to the SKD under the compensation and settlement law of 1994 (EALG). The terms "land reform assets" and "items recovered from castles" have an ideologically shaped ambivalence: they speak of saving and rescuing but do not judge the degree to which these actions were legal theft. The land reform act of 1945 was enforced without any resistance after the owners were driven out of their places, interned, and dispossessed. The "possessionless" properties were distributed to farmers and new settlers, who were forced to manage the land for the next 20 years as "LPG" (Landwirtschaftliche Produktionsgenossenschaft) or large-scale collectivized farmland.

An entire study waits to be done concerning these and other issues of museum politics under the Soviet occupation, which lasted from 1945 until the foundation of the GDR in 1949. For example: Order No. 85, dated Feb. 10, 1945, from the Soviet Military Administration in Germany (SMAD) regulated the inventorying and protection of all museum treasures and the repositioning of museums in the Soviet-occupied zones in Germany. This order was promulgated despite the fact that works of art were transported from East German museums to Russia through the Soviet Union's Trophy Commissions—which were established to look for Russian cultural art stolen by the Nazis but took other items as well—that operated at the same time.

Foreign Possession and Refugee Assets: The Berlin Jewish Art Collection in the Storage Facility, Konsul Vollmann

Under the GDR, works of art were placed in museums by offices of finance and/or the local authority, with the charge "to securely store" the objects. This happened on a regular basis when a citizen of the GDR moved to West Germany without being "deregistered" by the police. The individual was deemed a fugitive from the republic and was prosecuted under criminal law. In addition, the government confiscated all valuables that had been left behind; works of arts were handed over to the museums. This procedure also was used to deal with disliked art dealers, who were accused of tax evasion and pressured to apply for emigration to West Germany; and their property was confiscated. The GDR government passed regulations that were used to legitimize in 1952 the transferral of such property into public custody, and in 1958 the confiscation of such works of art and their future fiduciary administration by the state.

As a rule, in the states of the former GDR, a restitution claim under the assets law and the compensation and settlements law may be forwarded from one of the ArOVs—the Amt zur Regelung offener Vermögensfragen (Office for the Regulation of Estate Questions)—to a museum for investigation. The claim is investigated to determine if the applicants are the actual legal heirs. In addition, the states determine the legal standing of claimants in light of the whereabouts of the works of art.

The fate of the artworks from the Konsul Vollmann collection presents a special case. In this case, the responsible ARoV did not recognize the works of art as connected to the NS persecution during the war but rather as GDR confiscations. As a result, it denied the claims registered on behalf of the Conference on Jewish Material Claims against Germany (JCC) and stopped processing according to the burden equalization or assets law through the ARoV. But the Konsul Vollmann collection was actually the collection of Fanny Steinthal, a Jewish resident of Berlin. Vollman was the executor of Steinthal's estate; he emigrated to West Germany after the end of the war, abandoning his possessions in Saxony. The Steinthal collection stayed in his house in Dresden. It was officially confiscated and in 1953 was handed over to the SKD for storage.

For 50 years the artworks were stored in the depots of the Kupferstichkabinett, under lock and key in the Gallery of the New Masters. This story has a conclusion that seldom is seen in provenance research: the restitution of 69 works of art. Steinthal's heirs organized an exhibition titled "Max Steinthal: A Banker and His Paintings" (including a booklet, *Proprietas Verlag* 2004) and people were able to see the works in the Jewish Museum in Berlin in 2004.

Conclusion

It is logical to assume that the generations born in the GDR before 1945 were manipulated by the government and encouraged to assume that all property belonged in the "hands of the people" and was therefore "public property." That was thought to be true of possessions belonging to the general public and museums, and especially works of art. Because this was the prevailing attitude in the GDR, it is possible that East German museums sold works of art in the marketplace. And some of those sales could have included works of art whose labels, if they were not removed, might connect them to the NS confiscations. (From what I have observed, curators in the GDR do not pay attention to works of art without clear origin, even those suspected to have been confiscated by the NS, unless they are of artistically historical importance. However, provenance research is an important part of art history. The curator and the provenance researcher have similar goals and should collaborate rather than work against each other.)

The research into NS-confiscated cultural items continues. At the Gemäldegalerie Alte

Meister (Old Masters Picture Gallery) a complete catalogue is being produced. In the Skulpturensammlung (Sculpture Collection) a volunteer is researching the provenance of a sculpture on the Wiedemann list. A report about museum-initiated art sales was given to the SKD administration by a group of staff members in 1989 (just before the Berlin wall fell). This report circulated internally as a special edition and also was printed in *Kunstchronik* 43, no. 12 (December 1990), 637ff. But this topic should be revisited as part of the research into the institutional history of the SKD.

Nazi Collectors



The Hermann Göring Collection

Nancy H. Yeide

IN 2001 the *Washington Post* identified Hermann Göring as an "art thief and leading Nazi,"[1] an iteration of crimes that even the least historically minded likely would consider inverse in terms of magnitude. But the depiction is evidence of a continuing fascination with Göring, not just as a war criminal but as a character, larger than life in psychological terms (and nearly so in the physical as well). His excesses in costume, his morphine addiction, his elaborately staged hunting parties, his pathologically driven art collecting—all of these contribute to a fascination that persists to this day.

There are many biographies of Göring, ranging from early breathless accounts of his World War I exploits, propagandistic presentations during the Nazi period, and post-war analysis of his role in the Third Reich, to more recent considerations. These publications have mainly focused on his political life, of course, particularly his place as second-in-command in Nazi Germany. Almost all make some reference to his art collection, usually within the context of a larger desire for ostentatious consumption and presentation. Through these accounts we have a good idea of his approach to collecting, the staff he employed, his acquisition methods, and, of course, his residences, especially Carinhall where the majority of the collection was displayed. By the end of World War II, the "Contemporary Maecenas," as Göring called himself, possessed one of the largest and most important art collections in Europe. However, until now there has not been a systematic attempt to catalogue the contents of the entire collection, perhaps because no one definitive inventory exists. Gunter Haase presented a significant amount of information on the collection gleaned primarily from postwar investigations in *Die Kunstsammlung des Reichsmarschalls Hermann Göring* (2000), including reproductions of two partial inventories of the collection. However it would be misleading to suggest that these inventories are either authoritative or completely accurate; like all archival documents they must be reviewed critically and in context. Ilse von zur Mühlen's *Die Kunstsammmlung Hermann Görings: Ein Provenienzbericht der Bayerischen Staatsgemaeldesammlungen* (2004) is a catalogue of those paintings that had been returned to the Bavarian government, but includes by definition only 128 paintings, a small fraction of the original Göring collection. The current project is the first comprehensive catalogue of every painting known to be associated with Göring, based on archival research in repositories world wide.

My study has utilized these archival records to form a virtual recreation of Göring's collection. It has been instructive to compare these records, not only in terms of the collection, but also in terms of the records themselves. The temptation to place faith in the accuracy of records created close in time to the events they describe is compelling, but while the archival record is the most trustworthy written account of history, it is not infallible. People make documents; people make mistakes (present author included). The archival record may be incomplete or inaccurate, and the information found in archival documents must be carefully considered.

The photography studio of the Munich Central Collecting Point, with a painting by van Dyck that had been in Göring's collection, 1945. Craig Hugh Smyth Papers. National Gallery of Art, Gallery Archives.

The documents considered fall into two general categories: (I) those created by Göring, his staff, or other Nazi agents and (II) those created as part of the postwar restitution effort. The latter category includes records created by the Allies as they processed the vast quantities of art and cultural property recovered from Nazi repositories, records created in formerly occupied countries seeking the return of expropriated materials, and records of the postwar German government as it endeavored to complete the task of restitution. Because the documents in the latter category frequently refer to the earlier documents or to each other, errors in the former are carried over, adding a false authority to such information.

For example, in 1945 the Art Looting Investigation Unit (ALIU), a special component within the Office of Strategic Services, produced the *Consolidated Interrogation Report #2: The Göring Collection*, which relied in part on records of the Einsatzstab Reichsleiter Rosenberg (ERR), the Nazi organization that had carried out confiscations of cultural property in occupied countries. In 1952 the Treuhandverwaltung von Kulturgut, the entity of the reconstituted German government that continued the work of research into and restitution of looted art, made use of the *Consolidated Interrogation Report #2*, and any original errors were repeated yet again. The notion of generations of records might seem self-evident, parallel as it is to generations of secondary literature repeating the mistakes of the past. But when records lie dormant for 50 or 60 years, as have most of these documents, there is a tendency for researchers to regard them all with the same degree of confidence, especially as not all researchers have access to all generations of materials.

Archival documents may accurately reflect contemporary mistakes. As vast quantities of art objects were being relocated near the end of the war, it is inevitable that there was confusion, and that information in the documents can be wrong, even as it records correctly what occurred at the time. One example is from the Munich Central Collecting Point (MCCP), where a huge amount of recovered art was documented and processed. At the MCCP, inventory numbers were assigned to all incoming objects. No. 5879 referred to a Salomon van Ruysdael, previously titled *The Beach near Scheveningen* and now called *View of the Dunes near Zandvoort*. The picture is well documented as having come from the Goudstikker Gallery in Amsterdam, no. 2440. According to the notebook created in May 1940 by Jacques Goudstikker before he fled the

Netherlands—generally considered to represent the inventory of the contents of the Goudstikker Gallery at the time of its acquisition by Göring and Miedl in July of 1940[2]—no. 2440 came from the Otto Held collection and was acquired at his auction in Berlin in December 1929; it is reproduced in the sales catalogue. The Goudstikker notebook refers to the 1938 *catalogue raisonné*, no. 272, also with illustration.[3] The same illustration appears on the website Herkomstgezocht.nl, where those objects recovered after the war and still in Dutch state custody are presented. There the Ruysdael is assigned number NK2592, with the same Held/Goudstikker/Göring provenance. The picture itself was recovered with Göring's collection in 1945. When processed through the MCCP, its inventory card refers both to the Goudstikker number and to the *catalogue raisonné*. Thus all of these sources corroborate the history of this painting from Held to Goudstikker to Göring to the MCCP. However, the corresponding MCCP photograph for no. 5879 depicts a Ruysdael that was not part of Göring's collection but had come from the 1929 Held sale. It required multiple sources to clarify what was clearly an error made at the MCCP.

Another example is a Rubens painting titled *Henry IV Makes Peace*. This picture also passed through the MCCP and is recorded as having been recovered in Berchtesgaden, where most of Göring collection was discovered, organized, and shipped to Munich. Its number, 5233/11, is within the range used for the Göring collection (that is, roughly between no. 5000-8000). Based on these records, then, there is every reason to associate this picture with Göring. However, I never came across another reference to this picture in any of the Göring records I surveyed. In fact, this was not a Göring picture at all, but rather one acquired by the Sonderauftrag Linz and destined for the Führermuseum. It is published in Birgit Schwarz's *Hitlers Museum: Die Fotoalben Gemäldegalerie Linz* (Vienna, 2004), no. IX/25, and today is in the custody of the Bundesamt zur Regelung offener Vermögensfragen (BARoV). How it came to be catalogued at the Collecting Point with the rest of Göring's collection is anyone's guess.

Similarly, within the Munich inventory range for the Göring collection are some 30 paintings that actually were recovered at the National Socialist Party Buildings (Parteiforum) in Berchtesgaden. Although MCCP property cards identify these paintings as having been part of the Göring collection, which was shipped to the Collecting Point at the same time, there is no other evidence to support their being owned by Göring.

An additional difficulty in researching art objects is the inconsistent manner in which the same object is described, both in the art-historical literature and in archival documents. This has been particularly troublesome in sorting through the Göring records. The same painting has been attributed to different artists or called by different titles, and dimensions have been inconsistently recorded. It is only by going through all of the materials and comparing the information that one is able to link objects mentioned in various archival documents. Fortunately there exist a significant, but not complete, number of photographs to aid in identification. In the current catalogue every attempt has been made to include the varying attributions and titles found in the archival documents. While the connection between widely differing artists, varied titles, and inconsistent dimensions might seem improbable on first observation, the author has adopted Sherlock Holmes's strategy: when you have eliminated the impossible, whatever remains, however improbable, must be the truth.

A policy of inclusiveness has been adopted in the current catalogue. For example, objects that Göring traded from his collection are included, even those that he held only briefly. Most of the objects he traded in 1944 for the *Christ and the Woman Taken in Adultery*, supposedly by Vermeer, had been in his collection for several years and are of interest as a fundamental part of the collection as conceived by Göring or more likely, his curator Walter Andreas Hofer. The

current catalogue also includes paintings obtained via the ERR in France and traded immediately by Göring's intermediaries for objects preferred by the Reichsmarschall. Although these objects were never intended to be part of Göring's collection, they are a topic of great interest to researchers and their inclusion in the current project is a valuable contribution to scholarship. And although many of the impressionist ERR pictures were in fact traded for Old Masters, Göring did keep some for his own collection as well as retain a large number of earlier French, Dutch, Flemish, and Italian paintings from this source. For these reasons this catalogue includes all of the ERR pictures connected to Göring, rather than just the portion he retained. Similarly the relatively few pictures associated with Göring that had been deaccessioned from German state collections as part of the Nazi campaign against "Entartete Kunst" (Degenerate Art) are included, although they did not enter his collection *per se*.

In the catalogue I have made every attempt to reference any painting mentioned in available archival documents. Based on this survey, I have divided objects in the current study into four categories:

A. Definite: This is a uniquely identifiable object that had been in Göring's possession. In this category is any object with which an RM (Reichsmarschall) number is associated.

B. Probable: Almost certainly this is an object that had been in Göring's possession, based on references in contemporary documents, but some small degree of doubt remains or it is impossible to link the references with an actual object.

C. Unlikely: There is insufficient proof in the archival documentation that this is an object that had been in Göring's collection. Usually for this category there is only one archival reference that has not been corroborated elsewhere. It is very likely that the archival reference can be traced back to inaccurate information, such as incorrect recollections by those interrogated, or mistakes made in records created by Nazi agents. The archival reference also may be too vague to match to a specific, known painting in the collection as descriptions or images may be lacking.

D. Trade: Objects acquired purely for trade and never part of the Göring collection

The frequently cited number of 1,375 paintings in the Göring collection is an underestimation. Based on the above categories, it is my opinion that Göring's painting collection numbered at least 1,645 objects—that is, those paintings categorized as A or B. It is possible that some or all of those objects categorized as C should be added to this count, bringing the possible total up to almost 2,000 paintings. The objects categorized as D are included in the interests of thoroughness but should not be considered part of the collection itself.

Why the discrepancy between the current catalogue and earlier object counts? The number 1,375 comes from an inventory created by Hofer and transcribed by the Treuhandverwaltung von Kulturgut from a presumed lost original in Hofer's hand, although a few pages of the original are extant among MCCP files.[4] The last entry in the Hofer inventory dates from December of 1943; Göring, however, continued to acquire paintings practically until he evacuated Carinhall. The latest acquisition I have found took place in January of 1945. The final year of acquisitions has never figured in the count of the collection. Göring also actively traded and sold paintings, and anything he sold prior to 1943 is not included in the inventory. In addition, while most of the collection was recovered in Berchtesgaden, some was found at Göring's Castle Veldenstein, and many of these pictures, mainly by contemporary German artists, are not included in the Hofer inventory or its transcription. It is possible, although speculative, that the Hofer inventory was solely for the collection at Carinhall.

The virtual recreation of the Göring collection provides a unique opportunity to evaluate a

museum-quality collection assembled without monetary, geographic, practical, or legal limits. Previous misunderstandings of the actual size and scope of the collection have prevented it from being considered as a whole, and the limited commentary on it has been over-generalized. While the overall characterization of the collection presented in the scholarly literature is accurate, interpretations lack subtlety and are marred by a tendency to overestimate the artistic merit of Göring's collection. The opinion formed by post-war investigators, that "Göring had no real artistic judgment, and he knew it"[5] is confirmed by the collection itself, which contains an overabundance of mediocre pictures with a minority of genuine masterpieces. The best works in Göring's possession came pre-selected from the best sources, that is the great Parisian collections—various Rothschilds above all—or the first selections in Holland, before it became apparent to Dutch dealers that they could sell Göring practically anything with a known artist's name attached to it, however precariously. The sheer excess in the collection is staggering: over 60 works associated with Cranach, some 30 Ruysdaels and an equal number of Bouchers, over 40 van Goyens . . . the list goes on. Equally stunning are the overly optimistic, and subsequently downgraded, attributions. Quantity was very clearly more important than quality to the Reichsmarschall.

The intent of the current catalogue is to provide the first opportunity in 60 years to look at the painting collection as a whole, and to enable the evaluation of its place within Nazi art politics. Ideally the publication of the current catalogue also will result in the clarification of provenances of the objects contained herein and bring to light pictures whose histories and whereabouts have been hidden for too long.

This essay includes excerpts from the author's forthcoming catalogue of the Göring painting collection, in preparation with Akademie Verlag, Berlin.

Notes

1. Peter Finn, "Treasure Hunters Seek Light at Both Ends of Czech-German Tunnel," *Washington Post*, Feb. 1, 2001; p. C01.

2. Gemeentearchief, Amsterdam, access no. 1341.

3. Wolfgang Stechow, *Salomon van Ruysdael: eine Einführung in seine Kunst: mit kritischem Katalog der Gemälde*, Berlin, 1975.

4. For a complete history of this document, see Ilse von zur Muehlen, *Die Kunstsammlung Hermann Görings: Ein Provenienzbericht der Bayerischen Staatsgemaeldesammlungen*, Munich, 2004, p. 82. The extant pages can be found in RG260/Ardelia Hall/Records of the Munich Central Collecting Point/Restitution Research Files/Box 437, Folder 5, United States National Archives.

5. Art Looting Investigation Unit, *Consolidated Interrogation Report (CIR)* #2, *The Göring Collection*, p. 3, M1782, United States National Archives.

Birgit Schwarz

MY BOOK, *Hitler's Museum*,[1] deals with the so-called Führermuseum, which Hitler wanted to build in Linz, his hometown in Upper Austria. To be more exact, the book is dedicated to the centerpiece of the museum's collection, the gallery of paintings. The museum was never built, but an informal organization, the Sonderauftrag Linz, was set up to amass the collection. The Sonderauftrag was located in Dresden and consisted of art historians in the service of the famous Dresden Gemäldegalerie. The methods of acquisition employed by the Sonderauftrag ranged from confiscation to purchase, and included cases of forced sales.

It was generally thought that the Führermuseum was going to be the world's biggest museum, a giant that would gobble up Europe's artistic assets. This is a myth, perhaps stemming from knowledge of the so-called Führervorbehalt, a directive that reserved for Hitler the right of first refusal on all seized art assets. The directive gave rise to the idea that the National Socialists looted art primarily to stock the Führermuseum. This notion—which predominates to this day in the press and in publications—ignores the enormous political and geographic sweep of the art acquisition project. The Sonderauftrag Linz did not collect paintings solely for the Führermuseum, but also for other museums in the German Reich, especially in the eastern territories. The paintings would have been distributed to these museums after the war.

In my book, I've published 19 photograph albums, which were created by the Sonderauftrag between autumn 1940 and autumn 1944. The albums were presented to Hitler every Christmas and on his birthday and were delivered in shipments ranging from a minimum of one to a maximum of five volumes. In 1943 and 1944, additional deliveries were made on the ninth of November, the anniversary of Hitler's failed putsch of 1923.

Originally 31 volumes existed, but only 19 have been preserved; the surviving originals had been kept in the Oberfinanzdirektion Berlin and are now at the BARoV, Bundesamt zur Regelung Offener Vermögungsfragen. The extant volumes were sent via Munich to Hitler's Berghof residence near Berchtesgaden, where they were found by the U.S. Army in May 1945. The missing albums, volumes IX through XIX, were sent via Berlin to Hitler's Wolfsschanze headquarters in East Prussia. Their fate is unknown. I was able to reconstruct their contents because they are documented in an index of the first 20 albums, printed in 1943 and preserved in the Bundesarchiv in Koblenz.[2]

My book reproduces in facsimile the albums' pages of photographs. Each volume contains approximately 50 black-and-white photographs with handwritten annotations identifying artist, title, and, in most cases, dimensions. In my catalogue, I've tried to trace the provenance of the artworks from Hitler´s seizure to their restitution after World War II, and I have been successful in almost every case. Two inventory numbers are assigned for the identification of the paintings: first, the registration number of Hitler's Munich residence, the Führerbau—later called the "Linz number", which I call the F-number (F = Führerbau). In some cases the F-

numbers are missing. This fact indicates that the object was not transported to the Führerbau after acquisition. In particular, a lot of paintings confiscated in Vienna in 1938 remained in depositories in Austrian territory (e.g., Album I: 4, 7-10, 13-15, 24-28).

The second number is the Mü-number (Mü = München), the postwar inventory number of the Central Collecting Point in Munich. If this number is absent, the paintings did not pass through the Central Collecting Point. This could have been for several reasons. Some paintings remained in depositories in Austria (e.g., Album XXII: 50); some had been stolen (e.g., Album XXXI: 48); some had been confiscated by Soviet forces in the depository of Weesenstein near Dresden (e.g., Album XXVII: 9, 10); and others had been destroyed in the Dresden air raid (e.g., Album XXXI: 27).

Until now the Sonderauftrag Linz albums have been considered picture books intended to show Hitler a selection of masterpieces to be included in the future gallery. It is true that the albums present a selection of the Sonderauftrag's acquisitions—the selection for Hitler's museum. As a result they are much more than picture books; they are the most important historical and visual source relating to Hitler's museum. The albums show the gallery in the making and thus illuminate the history of the collection. They reveal that the idea that the Führermuseum was to be the world's biggest museum is in fact a myth.

Let me point out one of the main results of my study: I was able to distinguish two different phases of the Sonderauftrag. The first phase, under the directorship of Hans Posse, lasted from June 1939 to December 1942, when Posse died of cancer. Hitler had full confidence in Posse, who in turn believed in the Linz museum. He worked incessantly, always in close contact with Hitler, who approved his holding decisions.

Posse's 20 albums are documents of the intended gallery holdings.[3] Volume 20 is the only sculpture album and indicates a closure of an initial stage in the gallery's planning. Posse envisioned installing a few sculptures in each gallery room, a symbolic act of completion. Nevertheless, the first 20 albums—the nine volumes shown page by page in my book and the contents of the missing ones given as picture lists—represent the gallery in a provisional state. The quality of the holdings would have been improved over the course of time with future acquisitions—improved but not enlarged. The first 20 photograph albums give us an impression of the scope of the collection in 1942: approximately 1,000 paintings.

The second phase of the Sonderauftrag lasted from Posse's death in December 1942 until the last album was delivered in November 1944. Under the second director, Hermann Voss, things totally changed.[4] Voss started in March 1943, after the disaster of Stalingrad, the turning point of the war. He surely recognized the impending end of the Third Reich. Voss met Hitler only three or four times in 1943. Shortly after his appointment, he had a falling-out with Hitler, after which it didn't make sense to make joint decisions about the holdings anymore. Voss continued to purchase more paintings, as Posse had done, but created only six albums, due to the wartime lack of paper, leather, and other materials. Voss's albums present only a minor part of his total acquisitions.

Voss bought most of the art objects during the last year of the war, after the Allies had landed in France, thereby limiting opportunities to get art from the occupied countries. Despite this 1944 and 1945 saw an acquisition boom that may seem crazy. But there is a simple explanation for this paradox: by 1944 the Sonderauftrag had turned into a life-saving machine for the men involved. Working for the Sonderauftrag conferred "indispensable" status, including exemption from military service. Buying paintings therefore saved these men's lives. The more likely it was that they would be drafted, the more they bought and the quality of the acquisitions declined. That means that in 1944 the project went off course, diverted by the survival instinct of its staff.

Above: *Album III/8.*

Right: *Album I/8.*

Below: *Album V/33.*

Courtesy of Birgit Schwarz/Böhlau Verlag, Vienna.

After the war, the Art Looting Investigation Unit (ALIU) of the Office of Strategic Services was charged with investigating Nazi art-looting activities. Lane Faison, who was responsible for the report on the Linz museum, could not get access to the catalogue of the Sonderauftrag Linz because it had been confiscated by the Soviet forces. He therefore referred to the register of the Führerbau in Munich—up to then called Hitler's Collection—as the catalogue of Hitler's museum.[5] He called it the Hitler-Linz Collection. For a long time the Führerbau register was therefore believed to be the Linz inventory. In truth, this register comprises works of art acquired by the Sonderauftrag for Linz, but also pieces from other sources collected for other purposes.

As far as I know, there are two versions of this so-called Linz inventory in the National Archives II in College Park, Md.: one organized by entry and one by artist's name in alphabetical order.[6] There is also a version in the Bundesarchiv in Koblenz called the *Dresdener Katalog*, organized by entry and supplemented with additional provenance information."[7] There is some evidence that the real inventory of the Sonderauftrag, kept inaccessible in a Moscow archive, is a complete catalogue of the Sonderauftrag's holdings. This would mean that it does not distinguish between objects for the Linz museum and those designated for distribution.

I am convinced, however, that none of these catalogues represent the works actually selected for the Führermuseum. Hitler's photograph albums represent the only distinction ever made, and they alone are the decisive source for the gallery of paintings in the Führermuseum.

Notes

1. Birgit Schwarz, *Hitlers Museum: Die Fotoalben Gemäldegalerie Linz: Dokumente zum "Führermuseum,"* Vienna, 2004, cited as *Hitler's Museum*.

2. Bundesarchiv Koblenz, B 323/192: Gemäldegalerie Linz Inhaltsverzeichnis.

3. *Hitler's Museum*, pp. 28-31.

4. Ibid., p. 60ff. See also Birgit Schwarz, "Die Taktiken des Herrn Voss," *Frankfurter Allgemeine Zeitung*, Oct. 2, 2004, p. 35.

5. *Hitler's Museum*, p. 15ff.; Günther Haase, *Die Kunstsammlung Adolf Hitler: Eine Dokumentation*, Berlin 2002; and my review of this book in *Journal für Kunstgeschichte* VIII (2004), S. 53-56.

6. NARA RG260/Ardelia Hall Collection/Records of the Munich Central Collecting Point/Restitution Research Records/Boxes 428, 430, NARA location: 390/45/26/02. See Nancy H. Yeide, Konstantin Akinsha, and Amy L. Walsh, *The AAM Guide to Provenance Research*, Washington, D.C., 2001, pp. 61 (ill.) and 62.

7. Bundesarchiv Koblenz, B 323/45-51, 78-85; *Hitler's Museum*, pp. 20-21. See also Birgit Schwarz, "Der Dresdener Katalog im Bundesarchiv in Koblenz als Quelle der Provenienzforschung," *Kunstchronik* LVII, no. 8 (August 2004), p. 365–368.

Art and the Advantage of Living on the Border:
Managing Culture in the Rheinprovinz, 1933-1944

Bettina Bouresh

UNLIKE many of the other essays in this volume, this essay will not introduce new stories of looted pictures or the tragedies of the collectors behind them. Instead, I will offer an account of what we at the Archiv des Landschaftsverband Rheinland/ALVR/Rheinisches Archiv and Museumsamt have learned in our extensive research: the special role of the Rhineland, the region I come from, in the rape of art.

From the 1945 reports of U.S. officers who investigated the crimes of the war, we know that:

> This predominance of the Rhineland is not surprising since it is known from the Bunjes papers that a Rhineland-Gang consisting of Apffelstaedt and Bammann of Dusseldorf and Rademacher of Bonn was particularly active in taking advantage of the favorable currency situation to acquire works of art in France.[1]

Indeed, these three persons were more involved than anyone else in acquiring art for the Rhineland. The three of them, and especially Apffelstaedt, were the vanguard. What were the reasons for their special role?

I work at the Archiv des Landschaftsverband Rheinland/ALVR/Rheinisches Archiv and Museumsamt, a regional archive near Cologne. The geographic area covered by the archive is the most western part of Germany, identified by the blue line of the river Rhein, which has a long history as a border from Roman times to the 20th century.

Following the First World War, conserving cultural heritage became an important factor in maintaining the identity of the Rhineland. The desire to revive a Rhineland identity led to activity aimed at preserving the "native country" (Heimat)—not only arts and monuments, but also nature and landscape. Underneath these preservation impulses lay a strong interest in "gaining back" the border regions lost as a consequence of the First World War. The history of culture (language, architecture, monuments, etc.) was considered important evidence that these regions "had always belonged to Germany."

When the National Socialists (NS) took power in Germany in 1933, Rheinprovinz quickly adopted the "new spirit." Prussia's structure of self-government and provincial autonomy was struck down; administration of the province would now follow the guidelines coming from the Oberpräsident in Koblenz as representative of the state.

In the field of culture, it was not clear what could be expected from the new Dirigent der Kulturabteilung (leader of the department of culture), Dr. Hans Joachim Apffelstaedt, who was installed by the new NS Landeshauptmann (director of administration) Heinrich Heinz Haake in January 1934. In the traces he has left in the archival record, Apffelstaedt presents himself as an art expert on the one side and "a soldier of Hitler" on the other. Many documents show his intention to thrust the Rheinprovinz into a leading position in cultural affairs and, through that,

to secure a leading position for himself. Starting in a region with a well-developed cultural infrastructure, he developed big plans.

Part of his plan was to create a Gallery for Rhenish Art in Bonn. We know about his role in "collecting" works of art for this gallery from the archival record.[2] An incident described in a file in our archive called Rückforderung von Kulturgütern aus den westlichen Ländern (Reclamation of objects of art from the western countries)[3] shows how Apffelstaedt wielded the powers available to a leader at his level. Ordered by Apffelstaedt in his role as director of the department of culture and executed by the Institute of the History of Art in Bonn, it shows quite clearly how art-acquisition networks in the Rhineland were constructed and how they functioned.

To understand these networks, we must remember that during the First World War there were groups of German scientists (including some from the Rheinprovinz) "researching" works of art in the portion of Belgium, the Netherlands, and France located behind German lines. At the end of the 1920s the conservator of the Rheinprovinz, Paul Clemen, published an inventory of monuments of Eupen-Malmedy, a German region given to Belgium as reparations after the First World War. Clemen was succeeded as director of the Institute of the History of Art at the University of Bonn in 1935 by Alfred Stange, a specialist on medieval art. In the fall of 1939—which coincided exactly with the beginning of the Second World War—Stange started a seminar on "French Art Robbery in the Rhineland." The aim was to create a list of all works of art, handicrafts, and other items considered to have been "lost" after French armies occupied the regions east of the Rhine. Stange's seminar built on earlier efforts in the Rheinprovinz to develop such lists. As Apffelstaedt wrote later, this research was disguised as a university seminar but it was really preparation for the seizure of famous art collections in the western countries. The goal was to seize the collections before they could be transferred to America or other locations beyond the reach of NS authorities. Apffelstaedt called this "his idea."

Trying to find support for "his idea," he suggested that the ministry of education and science in Berlin extend such research throughout Germany. Landeshauptmann Haake explained to the ministry that since autumn 1939 the Rheinprovinz had been researching art, that this was an initiative of the head of the department of culture (Apffelstaedt), and that this research would be completed in one month. He proposed the founding of a commission of experts that would be authorized to go everywhere to continue this research. It is likely that Apffelstaedt himself wanted to play an important role in any future research projects in Germany and hoped, with the support of Haake, to make his administration a winner in the struggle for cultural authority among the NS officials. But the ministry took charge and in June 1940 gave itself the role of lead investigator.

An August 1940 letter from the Staatliche Museen Berlin provides the following information:

> Kümmel, general director of the Preußische Staatliche Museen (Prussian State Museums), Berlin, had become the "Reichskommissar for the protection of museums in the occupied countries in the West,"
> Zipfel, general director of the Preußische Staatsarchive (Prussian State Archives), Berlin, had become the "Reichskommissar" for archival documents, and
> Krüß, the director of the Preußische Staatsbibliothek, Berlin (Prussian State Library), had become the "Reichskommissar" for books and manuscripts.

Three weeks later a letter from the Reichspropagandaamt Düsseldorf stated that, according to the chief of Reichskanzlei, the ministry for propaganda (i.e., Goebbels) had received an

order to document centrally all works of art in the occupied countries.

What can we learn from this?

> The administration of the Rheinprovinz seems to be the first (or at least one of the first) actively to prepare lists for the "reclamation" of objects of art from the occupied countries. Apffelstaedt tried to advance his idea and make it a nationwide research effort. His hope had been to play a central role in organizing this research and, after that, to take the next steps in the occupied countries themselves.

> It is an open question whether the subsequent initiative from the ministry of education and science (under Reichminister Rust) shows that that Apffelstaedt was successful in his efforts. The initiative may have been the ministry's own idea.

> It is also an open question whether the ministry of propaganda (Goebbels) was to act in concurrence with Rust or was included as a way to get several competing parties involved. What we do know is that the latter is typical of how Hitler ruled.

> Apffelstaedt used his administrative role and his position in the NS party to try and get support for his activities. He was an SA Standartenführer, commander of a group of fighters in the SA/Sturmabteilung, the army of the NS Party until 1934. He co-opted the special identity and tradition of the Rhineland, making it an instrument for the purposes of NS hegemony.

Even though Apffelstaedt did not succeed in gaining full control over the "reclamation" of objects in the occupied lands, he nevertheless was able to build up useful contacts. And he was clever in using his unique Rhineland background to extend his reach. Looking at the military staff working on "military art protection" in Paris we see that most of them came from the Rheinprovinz. There were actually two "Rheinland circles": one around Apffelstaedt, Stange, and their circle at the Institute of the History of Art in Bonn; the other around Franz Graf Wolff-Metternich, the provincial conservator of the Rheinprovinz, who led the military art protection section in Paris from 1940 to 1942. Both groups probably saw themselves as part of the tradition of German art documentation that began during the First World War, though this remains to be researched. Apffelstaedt claimed to be a trained art historian and certainly knew what he was looking for; however, to him culture and art were merely instruments for the demonstration of National Socialist political hegemony.

Ultimately Apffelstaedt and his staff were limited to functioning as a second-tier art confiscation bureaucracy; in the end the National Socialist hierarchy did not allow give him the radius of activity he desired. But within his position he did everything possible to succeed as a leader and decision-maker, always with the aim of growing bigger and playing a more central role than he ever could as a mere provincial administrator in Dusseldorf. He was an active young man, full of ambitious dreams concerning the "national awakening" of his country, and he saw for himself an outstanding career working toward that awakening. To that end he made use of all the opportunities that would have been given to a trusted NS party member. The traditions in and history of the Rhineland offered him a means to open doors, and open them he did. My studies about Apffelstaedt and his activities in the Rheinprovinz from 1933 to 1944 establish that he pushed himself forward in the provincial Nazi hierarchy. Clear limits on his authority were imposed from higher levels, but even so, he did a great deal to advance his own political views. He respected works of art far more than he respected people.

Let us return finally to the label "Rhineland-Gang" as a description for Apffelstaedt and his group. After the war, the Allies perceived Apffelstaedt to be the leader of a "gang"—a mafia-like organized criminal group. This was an easy assumption to make directly after the end of a

terrible war, with researchers confronting a disastrous situation everywhere and encountering unbelievable facts in an unfamiliar country. Nevertheless, in the interest of historical accuracy, Apffelstaedt should not be labeled in this way. All of us know that understanding *what* happened requires a lot of very detailed work. Understanding *why* it happened requires delving to the very bottom, examining human actions with all their consequences. Apffelstaedt seems to have been driven more by personal ambition and National Socialist fervor than by the desire to amass money by criminal means. This does not excuse what he did, but it shapes our understanding of his motives. Let us be very careful about thinking inside the box and making judgments too quickly.

Notes

1. See Nicola Doll, "Die 'Rhineland-Gang': Ein Netzwerk kunsthistorischer Forschung im Kontext des Kunst- und Kulturgutraubes in Westeuropa" in *Museen im Zwielicht/ die eigene Geschichte, Kolloquien zur Provenienzforschung an deutschen Museen, Köln und Hamburg, Veröffentlichungen der Koordinierungsstelle für Kulturgutverluste Band* 2, Magdeburg 2002, p. 53; OMGUS, NACP, RG 260, Box 33 and NACP, RG 239/1 Befragung H. Bunjes, 1945.

2. See Bettina Bouresh, "Sammeln Sie also kräftig! 'Kunstrückführung' ins Reich—im Auftrag der Rheinischen Provionzialverwaltung 1940-1945," in *Kunst auf Befehl?* Hg. Bazon Brock, Achim Preiß, München 1990, pp. 59-75.

3. Archiv des Landschaftsverband Rheinland, ALVR 11240.

Ute Haug

UNTIL now, only the art collections of two prominent Nazi Party officials have been examined in any great detail: the collections of Adolf Hitler and Hermann Göring. Both continue today to be the subject of a good deal of research. In contrast, only brief mention has been made in the literature of the art collections of other Nazi leaders. We know almost nothing about the emergence of these collections, their scope, or their character. Reconstructing these Nazi officials' collections will make it possible to better understand the conception of art, the notion of collecting, and the networks that characterized the art world during those years. With this knowledge we can place collecting activities in Germany between 1933 and 1945 within the overall context of art collecting in the 20th century.

The Ribbentrop collection is one of those Nazi collections that has received little attention. Files in the archive of the Hamburger Kunsthalle that document the part of the Ribbentrop collection stored in the museum after 1945 gave me the opportunity to examine the history of this collection in more depth. I'd like to present a brief overview of my preliminary findings.

Joachim von Ribbentrop (born in 1893, executed by the Allies in 1946) grew up in Kassel, Metz, and Arosa. He lived in Canada prior to 1914, then returned to Germany after the outbreak of World War I and enlisted in the army. In 1919 he opened a wine store in Berlin and in 1920 married Anneliese Henkell, the daughter of Otto Henkell, a famous Wiesbaden maker of sparkling wine. In 1925, he acquired his aristocratic title via adoption by a distant relation, Gertrud von Ribbentrop.

Ribbentrop began supporting the Nazi Party in 1930 and became a party member in 1932. In 1935 he secured the signing of the German-British Fleet Treaty in his role as a special emissary for disarmament issues. This made him Hitler's key advisor in matters of foreign policy, and he soon established the "Ribbentrop Office" in Berlin. In 1936, he became the German ambassador to London. He reached the zenith of his power as foreign minister between 1938 and 1945. Ribbentrop was considered one of the "most active of Hitler's helpers," especially in the mass murder of Jews. In the Nuremberg War Crimes Trials, he was found guilty on all counts and was sentenced to death by hanging.

The Ribbentrop collection was supposedly the first private Nazi collection, and it presumably differed in make-up from other Nazi collections. From the Paris art dealer Ernst von Mohnen, we know that "Ribbentrop had, as he saw it, the best taste and was the only one who acquired avant-garde art and impressionism."[1] Hector Feliciano reports further that an emphasis of the collection was on French modern art.[2] But when and how did this collection emerge? What precisely was its character? Did it change over time? What importance can be attributed to it in relation to then-existing private collections? Where were the artworks located? And what happened to the collections after 1945?

When we speak of the "Ribbentrop collection," three individual collections are actually at

issue: first, the private collection of Joachim von Ribbentrop; second, the collection of his wife, Anneliese Henkell; and finally, the collection of Joachim von Ribbentrop as foreign minister—this third collection was government property. Determining how Ribbentrop's artworks were divided among these different collections will be possible only at a later stage of research.

The portion of the Ribbentrop collection I will explore in this essay was deposited by the Monuments, Fine Arts and Archives section of the British military government in the Heilig Geist bunker in Hamburg at the end of 1945. This part of the collection had been confiscated from a certain Schloss Julianke referred to in the files. After two works disappeared from Heilig Geist, the holdings were moved in mid-1946 to the repository of the Hamburger Kunsthalle. The director of the Hamburger Kunsthalle, Carl Georg Heise, was named the responsible trustee.

The portion of the Ribbentrop collection deposited at the Hamburger Kunsthalle consisted of 51 paintings and 59 carpets and textiles. These are the holdings that seem to account for the special character of the collection recalled by contemporaries, for they were primarily works by French masters: Francois Boucher, Jean-Baptiste-Camille Corot, Gustave Courbet, Jean-Honoré Fragonard, Jean Auguste Dominique Ingres, Jean Louis André Théodore Gericault, Eduard Manet, Claude Monet, Gustave Moreau, and Francois Louis Joseph Watteau de Lille.

Eventually most of the French works were restituted. In March 1948, Edgar Breitenbach took *Lukretia* by Lucas Cranach the Elder from the Hamburg Ribbentrop deposit to the Collecting Point in Munich. In October 1948, an additional 30 paintings were restituted; primarily, the aforementioned French masters, which were returned to France. In September 1950 control over the remaining 21 paintings, all by German painters, was transferred from the Hamburg Property Control Section to the Finanzbehörde (tax authorities)—more precisely, to the Landesamt für Vermögenskontrolle (State Office for Estate Control). Trusteeship remained in the hands of the museum director, Carl Georg Heise.

In mid-1952, the Ribbentrop family attempted to regain control of this part of the collection. The lawyer Bernd Gottfriedsen provided an expert certification for Rudolf von Ribbentrop listing the works with an unproblematic background remaining in the Hamburg Kunsthalle. It was established that nine paintings should be seen as part of the family's private collection and 12 others should be considered former government property.

In October 1954, the Hamburg tax authorities transferred official possession of the 12 paintings to the Hamburg Regional Tax Office, where the works were brought in June 1955. Nothing more is known about the fate of these works. The other nine works were returned to Anneliese von Ribbentrop in July 1955.

Incidentally, the files in the archives of the Hamburger Kunsthalle give the impression that an inventory was made of the Ribbentrop collection, for a number of the documents use inventory numbers. But the actual inventory list itself has not been found. If it still exists and was compiled properly, this document would provide a comprehensive overview of the collection.

A second important and extensive collection of archival records on the collection can be found at the Bundesdenkmalamt in Vienna. Here we can deduce that 111 objects of the Ribbentrop collection, including paintings on wood and canvas, prints, and photographs, were confiscated from Schloss Fuschl, Ribbentrop's Austrian residence, and were later deposited in the Salzburg Depot in seven boxes. These included paintings by Gustave Courbet, André Derain, Olaf Gulbransson, Ludwig Knaus, Barend Cornelis Koekkoek, Franz von Lenbach, André Lhote, Hans Makart, Wilhelm Trübner, and Ferdinand Georg Waldmüller; numerous works by contemporary artists like B. Georg Ehmig; and numerous paintings by Franz Lenk, Anton Müller-Wischin, Carl Schwalbach, and Adolf Wissel.

Unfortunately, based on a preliminary examination of this material, nothing final can be said about the extent of the Ribbentrop collection. An initial examination shows that the various lists are in part contradictory, or incomplete. The Austrian authorities divided the Ribbentrop works into four categories:

1. List of pictures that bear the attribution "Anneliese von Ribbentrop" or dedications to the same.
2. List of the family paintings of the family Ribbentrop, of only personal value.
3. List of paintings marked with "J.v.R." or "v.R."
4. List of remaining paintings not marked with "J.v.R." or "v.R.[3]

This inventory underscores the importance of distinguishing the private collection of Joachim von Ribbentrop from that of his wife.

Through research in these files it has been established that more that 100 art objects were distributed to various Austrian museums, libraries, and official agencies: the Gemäldegalerie des Kunsthistorischen Museums, the Österreichische Galerie, the Staatliche Graphische Sammlung Albertina, the Österreichische Nationalbibliothek, and the Bundesmobilienverwaltung. The four works that were handed over to the Österreichische Galerie still can be found there. The current location of the other paintings awaits confirmation.

Due to the efforts of Salzburg lawyer Walther Dillesberger, Anneliese von Ribbentrop was also successful in pressing property claims in Austria, leading to the return of 35 artworks, including 20 by Franz Lenk alone, in August 1959. A year earlier, she had recovered a set of engravings by L. Emil Grimm, 17 drawings by Olaf Gulbransson, and other portraits of family members.

Since other works had been transferred to Austria in January 1958, the official administration of personal property of Joachim and Anneliese von Ribbentrop came to an end. Even so, 34 more artworks were returned to the widow as late as 1960.

Through both the German and Austrian records, we can now discern three distinct emphases in the Ribbentrop collection as a whole. One part of the collection focused on 19th-century German masters like Lenbach, Trübner, and Waldmüller. However, Ribbentrop was aware of developments in contemporary art as a second focus, primarily making acquisitions from the Große Deutsche Kunstausstellung between 1937 and 1944. The collection also clearly exhibits a special affinity for Franz Lenk; it is possible that Ribbentrop was on friendly terms with this artist. The third focus, quite unusual for the time, was the interest in 18th- and 19th-century French masters. Although they can be found in other Nazi collections, in Ribbentrop's case these paintings were not just intended as objects to be traded, but formed a part of the collection on equal standing with the others. This predilection for French masters might be explained by Ribbentrop's own biography; however, it was also probably influenced by the collecting interests of Anneliese von Ribbentrop.

Notes

1. Translation from Hector Feliciano's *The Lost Museum* (1997) from the German version, *Das verlorene Museum. Vom Kunstraub der Nazis.* Berlin 1998, p. 140.

2. Ibid, p. 199.

3. Bundesdenkmalamt Wien—Archiv, Restitutionsmaterialien. Karton 44 / 1 Ribbentrop, Joachim von (1893-1946), 644/55, 62.

Case Studies, Part 1

Solved: A Case of Mistaken Identity

Laurie A. Stein

IN DECEMBER 2001, I presented a paper titled "Provenance Research and the Problem of Mistaken Identities" at a conference held at the Wallraf-Richartz-Museum in Cologne. The paper focused on an oil painting by German master Lovis Corinth, known as *Portrait of Max Silberstein* (1923), catalogued as WKK 914 in the standard Corinth *catalogue raisonné*. My talk highlighted two key issues: (1) the importance in provenance research of conclusively establishing the identity of any artwork in question; and (2) the challenge of researching artworks that were not owned by major collectors but instead by relatively unknown private individuals.

My research into the Corinth provenance had revealed that despite being known for over 70 years as *Portrait of Max Silberstein*, it was likely that the sitter was not actually Max Silberstein, but rather Walter Silberstein, a separate and unrelated individual. There was no pending claim on the work, but the current owner, a Berlin dealer, had asked me to research the painting since it appeared likely to be of a Jewish gentleman, and there was no known provenance for the work during the 1930s.

I am pleased to provide an update on the surprising new developments that have taken place in this case since 2001. This case now can be marked SOLVED. The solution occurred as a direct result of exchange of information and dialogue among colleagues during the original research process and after the public presentation of the Cologne lecture. It is a positive example of creative collaboration between an owner, an heir, legal representatives, and provenance researchers.

The first documented ownership of the Silberstein portrait was in 1926, when it was included in the major Lovis Corinth retrospective at the Nationalgalerie in Berlin, published in the catalogue as *Portrait of Max Silberstein*, belonging to "M. Silberstein, Berlin." No further information was available until the mid-1950s, when Felix Peltzer of Stolberg acquired the work from Galerie Hella Nebelung in Duesseldorf. Thereafter it was included in numerous exhibitions and publications. The current owner had purchased the painting in 1999 from a Munich dealer at the Basel Art Fair.

At the outset of the research, I aimed to find out about Max Silberstein, whom Charlotte Berend-Corinth, wife of the artist, had once mentioned was a Berlin banker. I was indeed able to identify a Max Silberstein, not a banker but a legal figure in Berlin, and of the right age. However, my review of surviving exhibition correspondence for the 1926 show in Berlin indicated that the lender of the portrait was not Max, but rather a Walter Silberstein, owner of an upscale men's clothing store on Friedrichstrasse and with a home address on Klopstockstrasse. I then discovered references in Corinth's own letters, which noted that the portrait was of a man with a clothing business, who lived on his street. He had appeared out of the blue at the artist's studio one day and revealed himself to be a confidential advisor for the finance authorities, and intimated that he could help Corinth with some ominous financial issues.

So the question was, was Walter or Max depicted in the portrait? Extensive inquiries into Jewish community resources, biographies, wartime documents, local records, newspapers, chamber of commerce documents, burial records, and even the Berlin telephone and address books of the period, all revealed no connection between Max and Walter except for a shared last name. My research concluded that the listing of the portrait as Max Silberstein, and the subsequent decades of acceptance of this title, were likely due to a simple editing error in the 1926 Berlin exhibition catalogue, probably confusing the name of Walter Silberstein with that of Max Silberberg, an important Breslau collector, who also had been approached about loans to the Corinth 1926 show. I just couldn't prove it conclusively.

Walter Silberstein was born in 1871 and died of natural causes in 1930. He left behind his second wife, Ada, and three children, one of whom, Werner, became a prominent young bacteriologist and moved to Palestine in 1933; another, Margot, apparently emigrated to Britain around 1938. The family's clothing firm was aryanized around Aug. 12, 1938. The fate of Ada and daughter Vera was elusive, but I determined that they had moved from Klopstockstrasse to an apartment in Charlottenburg in Berlin in the late 1930s.

All efforts to trace Ada and Margot were unsuccessful, and Werner Silberstein had recently passed away, leaving no children. There was no information to indicate whether the family had sold the portrait to gain funds to leave Germany or to pay Reichsfluchtsteuer (flight tax) during 1933-38. There was no record of the work being confiscated by the Nazis through seizures of Jewish-owned art, and the work did not appear in any auction or published sale that I could find. With no pending claim, all efforts to trace any heirs through the authorities, or to consult files for compensation and restitution, were stymied by the stringent Holocaust victim privacy regulations, which officially prohibit viewing of such file documents without the direct written permission of the victims' heirs.

Since Walter Silberstein had passed away well before 1933, it was also entirely possible that the painting might have left the family's hands before the Nazi era. Families often divest themselves of their inherited possessions, even family portraits, sometimes for financial reasons and sometimes simply because they don't like an inherited object.

The painting had landed in a gray area—an unmarketable gray area. During the course of the long research process, I had engaged in many productive conversations with colleagues, including several with Inka Bertz, a curator at the Jewish Museum in Berlin. Some months after hearing my talk in Cologne, she phoned and said, "You will never believe who I just met." There began the postscript to the Corinth story.

At a Sotheby's preview in London, standing before a work by Corinth, Bertz chatted with a London collector who mentioned that his grandfather, Walter Silberstein, had been painted by Corinth. He did not know the whereabouts of the painting. She told him that she thought she did. I was thrilled to have confirmation of my hypothesis of the sitter's mistaken identity and, after speaking with the grandson, I learned that Margot had married and moved to Leipzig in the late 1920s, and from there, under her married name, left for Britain, where she still lived. I had lost her trail because I was looking in the wrong city and under the wrong name. I also learned that Ada and Vera had disappeared in the war. There had been little love lost between the children of Silberstein's first wife and Ada, and the survivors had little specific knowledge of the widow's fate.

After Walter Silberstein's death in 1930, his art had remained with Ada on Klopstockstrasse. His collection included the Corinth portrait and also works by other artists, including Jewish masters such as Max Liebermann, Lesser Ury, Jakob Steinhardt, and Hermann Struck. There was another portrait of Walter, a realistic work by Friedrich Feigl, showing Silberstein as for-

mal patriarch in bourgeois attitude. And according to Margot Silberstein Hepner, she and her brother definitively preferred the Feigl to the Corinth. Margot's opinion of the Corinth was as a "grotesque Sketch," rather than a painterly expression of Silberstein's joie-de-vivre.

When Margot and her family emigrated in 1938 or 1939, according to her son, they stopped in Berlin en route to pick up some of their possessions, including the Feigl. In our very first conversation, Silberstein's grandson openly admitted that the Corinth had been consciously left behind in Berlin by Margot. The family always assumed that the possessions they had left behind were destroyed in the bombings at Klopstockstrasse. The mystery of how the painting was saved remains open—it likely moved with Ada.

I have to admit that my instincts told me to tread carefully in those first conversations. It had been a bit bold for me to speculate in my Cologne lecture that a Jewish family might have sold a family portrait by a great artist because of personal aesthetic taste in the pre-Nazi era. The fact that Silberstein's grandson was admitting exactly this seemed overly coincidental. But subsequent conversations were convincing.

Walter Silberstein's grandson had known little about his mother's family, and spurred by my findings, he embarked on a journey of rediscovery about his family history. In time, he began to talk about recovering the painting for his family. Establishing the validity of a claim seemed improbable, with many open questions about internal familial rights of inheritance, lack of earlier search or claim, and the issues of good-faith purchase on the part of the new owner.

But in the end, Walter Silberstein's grandson traveled to Berlin in February 2003 and came face-to-face for the first time with his grandfather. Discussions ensued among the grandson, the painting's owner, the owner's legal representative, me, and Monica Dugot, now head of restitution for Christie's. In the summer of 2003, the owner and the grandson reached a sensitive, pragmatic, and amicable agreement. The grandson agreed to reacquire his grandfather's portrait without legal or press machinations and presented the work to his mother for her 99th birthday. Rather than traversing the long, complex, and probably unsuccessful road of a legal claim, this was a process of respectful cooperation between the parties. And the grandson restored to the painting the rubbed-out phrase, "to Mr. Silberstein, In Memory, October 1923."

Perhaps the most important new aspect of the case for me, though, was that this opened a new Pandora's Box in the field of provenance research: namely, the issue of consciously abandoned artworks. There must be numerous objects in museum and private collections that suffered similar fates of abandonment or conscious leave-taking. This category of object from the Third Reich era needs to be acknowledged, and perhaps a method to deal with such matters should be developed.

Restitution of Portrait of Jean d'Albon: The Conclusion of a 60-Year Search

Karen D. Daly

ON JUNE 18, 2004, the Virginia Museum of Fine Arts (VMFA) restored rightful owner-ship of a small portrait painting in the manner of 16th-century artist Corneille de Lyon. *Portrait of Jean d'Albon* was restituted to Kurt H. Schindler, heir to this painting once owned by Julius Priester. It had been seized by the Gestapo in Vienna, Austria, on Feb. 11, 1944.

Sixty years after this confiscation by the Nazis, VMFA first learned about Julius Priester and his ownership of a portrait similar to the museum's *Portrait of Jean d'Albon*, which had been in the museum's collection since 1950. In February 2004, when Schindler first informed the museum of his potential claim to the painting, the museum requested that he submit all related docu-mentation, legal proof that he was the legitimate heir, and any photographic evidence in his possession. VMFA immediately undertook its own investigation, reviewing all related files, examining relevant publications, and conducting a thorough examination and documentation of the painting.

In March 2004, Schindler officially filed a claim for the painting through the New York State Banking Department's Holocaust Claims Processing Office (HCPO). Working with the claimant and the HCPO, VMFA made every attempt to resolve the matter as quickly as possi-ble. As this was the first such claim in the history of the museum, it was educational for the institution in a number of ways. Working with the HCPO proved to be ideal, in that it allowed the case to evolve outside of litigation. In addition, working with the HCPO, instead of direct-ly with the claimant, allowed for a more focused and expedited exchange of information.

It is important to note that VMFA responded to this claim at a time when improved research resources were becoming available through recent publications and the Internet. The museum benefited from such resources and through consultation with museum professionals who had experienced similar claims. It further was indebted to past art historians who had studied this particular painting as one of eight known versions of a similar composition. Furthermore, as a state agency, the museum had the benefit of legal counsel through the Commonwealth of Virginia's Office of the Attorney General.

The resolution of the claim transpired quickly, yet involved a complex sequence of commu-nications, actions, and decisions. This case study will review the history of the claim and resti-tution from the perspective of an art museum that also serves as a state agency. It will cover his-torical aspects of the painting and its known history of ownership, aspects of the restitution, and certain challenges that emerged during the process.

Portrait of Jean d'Albon was once directly attributed to artist Corneille de Lyon. Born c. 1500 at The Hague in The Netherlands, Corneille de Lyon was a portrait painter who was active mainly at Lyon in France, settling there sometime before 1533. As a native of The Hague, he often was referred to as "Corneille de La Haye" and only in the 19th century did he become known as Corneille de Lyon. The artist held a number of distinguished titles in his lifetime; for

example, in 1541 he was appointed painter to the dauphin, the future Henry II. Contemporary references reveal that he had a significant reputation as a portrait painter. His style was widely imitated, with many works in a similar style attributed to his name. Such paintings are mostly small in scale, with the sitter often set against a plain green or blue background. The artist, who died in Lyon in 1575, appears to have introduced this portrait format to France.[1]

The man depicted in the restituted portrait is considered to be Jean d'Albon de Saint-André. Previously, the sitter was thought to have been Jean de Rieux, an influential figure of the time, although evidently not as politically important as Jean d'Albon. Among many positions held in his lifetime, Jean d'Albon was seneschal of Lyon in 1534 and became governor of Lyon in 1539.[2]

There are eight published versions of this same composition and sitter. Of these, the portrait at Chatsworth, the Duke of Devonshire Collection in England, is most likely the prime original by the hand of Corneille de Lyon.[3] However, direct attributions to Corneille de Lyon are considered quite subjective, as the artist apparently did not sign his work and the works are rarely dated.[4] The other institutions with known versions of *Jean d'Albon* are: the Louvre Museum, Paris; Metropolitan Museum of Art, New York; Art Institute of Chicago; Waddeson Manor, the National Trust, James A. de Rothschild Collection, England; Taft Museum, Cincinnati; and Musée Bargoin, Clermont-Ferrand, France. Through VMFA's research, the seven other versions were easily eliminated as being the Priester version through examination of their respective dates of accession into the collections, as well as through visual comparison of reproductions with a reproduction of the Priester version.

It is not currently known how Julius Priester acquired his *Portrait of Jean d'Albon*, but evidently he owned it by 1926. The claimant provided VMFA with a copy of a handwritten evaluation of the portrait by art historian Max J. Friedländer dated Nov. 23, 1926, Berlin. The evaluation, which accompanied a photograph of the portrait, states that the painting reproduced in the photograph was a characteristic work by Corneille de Lyon. Given the 1926 evaluation by Friedländer, the dates of Julius Priester's ownership of the painting can be determined to be November 1926 to Feb. 11, 1944.

Born in 1870, Julius Priester was an industrialist and art collector who lived in Vienna until 1938, when he and his wife, Camila, emigrated to Mexico due to the increasing Nazi aggression against Jews. His art collection and possessions were stored in Vienna with a firm owned by Max Föhr. A painting by Corneille de Lyon, *Portrait of a Man (Männerportrait)*, is listed as part of that collection. In information submitted by the claimant and the HCPO, it is explained that in 1944 the Gestapo seized Priester's possessions, including his art collection, directly from Föhr's storage facility. Details of what happened next to the stolen collection are not known but it is likely that the Vugesta (Verwertungstelle für jüdisches Umzugsgut der Gestapo), the Gestapo's Office for the Disposal of the Property of Jewish Emigrants, was involved in its disposal.[5] An account of Julius Priester's collection can be found in the important 2003 book by Sophie Lillie, *Was Einmal War*, which VMFA considered a significant publication in relation to the claim.

Priester, who died in 1954, made attempts in his lifetime to recover his stolen artworks, and some objects were returned to him after the war. He had a solicitor working on his behalf in Austria, who filed claims for Priester's lost furnishings and works of art. Information from one such claim, which included a photograph of the Corneille de Lyon portrait, eventually came to the attention of the Vienna police. In May 1954, a reproduction of the Corneille de Lyon *Portrait of a Man (Männerportrait)* was published in a Vienna police circular with reproductions of other stolen Priester paintings.[6] This police circular, first brought to the museum's attention by

Corneille de Lyon (manner of), Dutch, c. 1500/10-1575, active in France. *Portrait of Jean d'Albon.* Formerly VMFA accession number 50.3.2. Deaccessioned from the VMFA collection on May 20, 2004. Restituted to Mr. Kurt H. Schindler on June 18, 2004. Photo: Katherine Wetzel. © Virginia Museum of Fine Arts.

the claimant, proved to be a crucial piece of evidence. Through the reproduction it linked not just a Corneille de Lyon portrait to Priester, but more specifically a Corneille de Lyon portrait of Jean d'Albon. In addition, it served as confirmation that this particular portrait had been stolen and was still missing in 1954.

It is not currently known where the painting was between its seizure on Feb. 11, 1944, and Dec. 15, 1949, when it was received at Newhouse Galleries in New York. VMFA learned that Newhouse Galleries acquired the Corneille de Lyon portrait from Frederick Mont, a New York dealer of Old Master paintings. This information was conveyed in a March 2004 e-mail, when the present-day Newhouse Galleries provided VMFA with the exact date it received the portrait. However, when asked for any form of documentation related to this date of receipt or any connection to Mont, gallery staff responded that there was no bill of sale and that the "records back then are sketchy at best."[7]

Although this lack of documentation was disappointing,[8] the revelation that the portrait came from Frederick Mont was still very important. Because of his research, Schindler had suspected Mont's involvement before he approached the museum. In his initial letter to VMFA, Schindler mentioned the portrait's connection to Newhouse Galleries, a fact he learned during prior research. He also recently had discovered that Mont had worked closely with Newhouse Galleries. Furthermore, he had learned of Mont's possible connection to another one of Priester's stolen paintings. This connection is found in a 1953 Vienna police report that Schindler submitted to the museum and which discusses certain Vienna art dealers and their possible connections to some of Priester's stolen paintings. In particular, the report mentions Bernhard Wittke, a Gestapo appraiser during the war,[9] alleging that Wittke had acquired a number of Priester's stolen paintings and sold them to other dealers working in Vienna at that time. The report further alleges that one of Priester's stolen paintings was "sold in the summer

of 1952 to New York art dealer Mont" through the Galerie Sanct Lucas in Vienna,[10] a gallery Frederick Mont had partly owned and directed under the name Frederick Mondschein, before his immigration to the United States in the 1930s.[11] Although the painting in question was not the Corneille de Lyon, the alleged relationship between Mont and Vienna dealers in 1952 suggests the possibility that Mont might have similarly acquired other paintings that once belonged to Priester.

At present, there is limited information available regarding Frederick Mont and there appear to be no accessible records of his art-dealing activities. Although Mont's connection to the portrait did not serve as direct evidence in this case, it was compelling circumstantial evidence that supported Schindler's claim.

Not long after Newhouse Galleries received the Corneille de Lyon, it was purchased by Mrs. A. D. Williams of Richmond, Va. It was received at VMFA in January 1950 and accessioned into the museum's collection as an anonymous gift on Feb. 4, 1950. Following the death of the donor later that year, the painting was credited publicly as a "Gift of Mrs. A. D. Williams." Interestingly, Newhouse Galleries provided a quote from Max Friedländer remarkably similar to that in the Priester papers, reportedly written only seven days before the gallery received the painting. This quote was found in a presentation book on the Williams Collection that Newhouse Galleries created for the Williams family.[12] It would be interesting to know if Friedländer in fact appraised this painting a second time in 1949 directly for Newhouse Galleries or perhaps for another dealer. In any case, museum staff found Friedländer's connection to this painting, once through Priester and later through Newhouse Galleries, to be an intriguing coincidence.[13]

At VMFA, the earliest record of the portrait being on view was July 1955. For the most part, it remained on view in various gallery installations until 1985. From 1985 to 2004, the painting was in the museum's art storage.[14]

In 2004, in response to the claim, VMFA examined the provenance as it had evolved over the years. In providing the painting's history to Mrs. Williams and to VMFA in 1950, Newhouse Galleries gave two names of collections with no associated dates: the L. H. Pelouse Collection in Paris and the Leo Lanczy Collection in Budapest. Subsequent VMFA curatorial research led to questions about the provenance provided by Newhouse Galleries. In the 1966 catalogue titled *European Art in the Virginia Museum of Fine Arts* (Richmond, Va.: VMFA, 1966), the Corneille de Lyon entry points out that prior publications stated that the Pelouse version is inscribed on the reverse with "Monsieur de Saint-André" and dated 1548; the museum's version clearly is not.[15]

Years later, two scholars of Corneille de Lyon, Guy Bauman and Anne Dubois de Groër, further researched the series of portraits of Jean d'Albon. In an essay titled "Sixteenth Century French Panel Paintings," which was published as part of a 1995 catalogue of the Taft Museum's collection, Bauman included an overview of all known versions with their respective provenances.[16] Anne Dubois de Groër's seminal 1996 catalogue raisonné of Corneille de Lyon's work titled *Corneille de La Haye dit Corneille de Lyon* (Paris: Arthena, 1996) also provided an analysis of each version of *Jean d'Albon* and their provenances. Not surprisingly, Bauman and de Groër both discredited the Pelouse connection to the VMFA portrait. Furthermore, both Bauman and de Groër identified the VMFA version as the same one sold in a 1902 auction as part of Count Brunsvik's Collection at the Dorotheum in Vienna.[17] In Bauman's essay for the Taft Museum catalogue, he mentioned that the Brunsvik version was bought by someone with the name M. Hamburger but gave no further information.[18] Years later, Schindler, in his pursuit of information related to a possible connection to Leo Lanczy, discovered a link to a man named Nikolaus

von Szemere. In a 1914 publication on Austrian collections that Schindler located, it appears that a number of paintings, including the Brunsvik Corneille de Lyon portrait, were bought from the 1902 auction on behalf of Szemere and sent to Budapest.[19] It is possible that the portrait, at some point, might have found its way into an art collection of Leo Lanczy, who was director of the Hungarian Bank of Commerce for many years.[20] Because of Schindler's research, more is currently known about the history of this portrait and perhaps further provenance information will come to light in the future.

The Brunsvik identification served as an important step in determining the portrait's history and helped to define a provenance gap of 1902 to 1950, which existed until 2004 when the museum learned about Priester's ownership of a version of the portrait. In view of this, it was clear to VMFA that Priester's known dates of ownership, 1926 to 1944, could be easily placed within the VMFA portrait's provenance gap of 1902 to 1950. As stated earlier, the museum determined that the Priester version could not have found its way into any of the other collections with versions of *Jean d'Albon*, based on their individual dates of accession. However, in an effort to obtain all related information, VMFA contacted the other institutions with known versions and requested their file information. Although the other institutions' files did not reveal anything that would directly affect the claim, it was an important step in showing the museum had acted with due diligence.

Another important part of VMFA's research process was to examine fully and document the painting by unframing it, recording all marks and labels, and photographing it extensively. The panel painting, in its inner frame, had not been removed from its outer box frame for many years. It was therefore a surprise to find a previously undocumented label from the Lebrun Gallery in Paris on the back of the inner frame. VMFA contacted the current Lebrun Gallery with a request for any information found in its archives. Although the request did not yield significant information relevant to the claim, VMFA remains interested in what the possible connection to Lebrun Gallery might have been, especially as that gallery is included in the Art Looting Investigation Unit's (ALIU) list of "red-flag" names.[21]

As the claim evolved, it became increasingly probable that the VMFA portrait and the stolen Priester portrait were one and the same. To ensure that VMFA lived up to its fiduciary responsibility, the museum sought to define a level of documentation that would be sufficient to make a recommendation to its board of trustees to deaccession the portrait as a step toward restitution. In addition to having acquired documents that showed the claimant to be the legitimate heir to the painting, the museum had sufficient documentation that the painting was stolen. Another area of concern was that VMFA be able to obtain the best possible photographic evidence available for examination; up to that point, the claimant had sent photocopies of an original photograph of the Priester portrait.

Throughout the process of the claim, it was necessary to organize and accurately convey all information compiled into a clear format to continuously document the claim's status. At various points, a detailed chronology and summary were disseminated to designated staff. These updates proved crucial because they allowed for a consistent approach, permitted an efficient way to keep senior staff and key members of the board of trustees informed, and enabled the museum to prepare a recommendation in time for the next board meeting, scheduled for May 2004.

Upon VMFA's request, the claimant submitted the original photograph of the Priester portrait. VMFA conducted a visual analysis, in which certain staff examined the photograph of the Priester version and conducted a point-by-point comparison with the VMFA painting. It became apparent that there were details in the surface of the painting that identically matched

details in the photograph. A "Visual Inspection Statement," one of numerous original documents created in consultation with the museum's legal counsel, conveyed that each examiner had conducted the analysis and had individually concluded that the VMFA portrait was the same as the portrait represented in the photograph.

On May 20, 2004, the VMFA Board of Trustees voted by special resolution to deaccession *Portrait of Jean d'Albon* with the intent of restitution. This resolution was an ideal way in which to record the decision by the trustees because it included a summary of the claim, outlined the steps taken by the museum, and allowed for the action to be officially documented in the minutes of the meeting, thereby becoming part of the historical record.

As VMFA is a state agency, it has a responsibility to inform the citizens of Virginia of actions taken in its board meetings. As such, the museum had prepared press materials for release immediately following the board meeting. Consequently, VMFA was able to clearly convey its action and information about the claim to the public. In addition, VMFA made the decision to have the portrait on view while plans were made for the return and legal transfer of the portrait. This exhibit provided visitors an opportunity to learn about the history of the portrait and its pending restitution.

In the effort to meet the claimant's request for a quick return of the painting, the museum made the necessary arrangements for the portrait's restitution. In addition, VMFA worked with its legal counsel, the claimant, and the HCPO to prepare a satisfactory legal transfer agreement.

Throughout the process of the claim and restitution, VMFA encountered certain challenges. As this was the first such claim in the history of the museum, there was no precedent for reference. Therefore, the museum had to anticipate the steps and actions it should take to ensure that it met its fiduciary responsibility to the Commonwealth of Virginia. There was also the related challenge of creating sufficient documentation to fully record the process and to protect the interests of the museum. Per the claimant's request, the museum agreed to act as expeditiously as possible, yet there was an inherent tension between acting quickly and ensuring due diligence in the matter. Ultimately, VMFA was able to meet these challenges due to the strength of the evidence, the dedication of staff and resources, the leadership of its board of trustees, the guidance of its legal counsel, and through the collaborative relationship with the HCPO.

The claim and its outcome transpired in four months' time, concluding with the transfer of ownership on June 18, 2004. It was ultimately an honor for VMFA to restore one of Julius Priester's stolen paintings to its rightful owner and bring a 60-year search to a successful end.

Notes

1. Guy Bauman, "Sixteenth Century French Panel Paintings," *The Taft Museum: Its History and Collections*, ed. Edward J. Sullivan and Ruth Ann Krueger Meyer (New York: Hudson Hills Press, 1995), 135-36.

2. In 1530 Jean d'Albon became a knight of the order of Saint Michael, and in the portrait the sitter is wearing the insignia of the order of Saint Michael suspended from a gold chain. See Bauman, 137-38.

3. Anne Dubois de Groër, *Corneille de La Haye dit Corneille de Lyon* (Paris: Arthena, 1996), 138-44.

4. Bauman, 135.

5. This information is from a May 10, 2004, letter, officially requesting restitution, to VMFA from Monica Dugot, then deputy director of the New York State Banking Department's Holocaust Claims Processing Office (HCPO).

6. This document, which came from the Austrian National Archives (Österreichische

Nationalbibliothek Zeitschiftensaal), was submitted by the claimant and later as an attachment to the May 10, 2004, letter from the HCPO.

7. This quote is from a March 30, 2004, e-mail sent to VMFA from the current Newhouse Galleries, Inc., New York.

8. Newhouse Galleries had a long relationship with the Williams family and with VMFA. The museum holds a number of paintings that came from Newhouse Galleries, via either gifts or purchases, most of which entered the collection between the late 1940s and early 1960s.

9. Wittke evidently worked as an appraiser with Vugesta. For information on Vugesta, see Robert Holzbauer, "The Seizure of Assets of Enemies of the People and the State in Austria: The Vugesta: The Gestapo's Office for the Disposal of the Property of Jewish Emigrants," *Spurensuche*, 1-2/2000: 38-50. A summary of this article, in English, can be found online: www.lootedart.com/InformationByCountry/Austria/Research%20Resources/Orcid_GSF_37713_4926620 37.asp.

10. This police report, submitted to VMFA by the claimant and translated from German into English, is dated Nov. 12, 1953, from Vienna.

11. See Nancy Yeide et al., *The AAM Guide to Provenance Research* (Washington, D.C.: American Association of Museums, 2001), Appendix D: Dealer Archives and Locations: 232.

12. This quote was found in an undated and unpublished presentation book on the Williams Collection that Newhouse Galleries compiled for the Williams family.

13. During part of World War II, in Amsterdam, the Nazis used Friedländer for his evaluations of artworks, in exchange for their releasing him from arrest and incarceration as a Jew who had fled Germany after 1933. See Lynn H. Nicholas, *The Rape of Europa: The Fate of Europe's Treasures in the Third Reich and the Second World War* (New York: Vintage Books, 1995), 101.

14. After 1985, gallery installations favored areas in which the VMFA European paintings collection is strongest. As VMFA holds a very small collection of French Renaissance art, *Portrait of Jean d'Albon* would remain off view. Also, VMFA records show that the painting never went on loan to another exhibition or institution.

15. *European Art in the Virginia Museum of Fine Arts* (Richmond, Va.: VMFA, 1966), 36. See also E. Jeanney and J. Déchelette, "Les Vitraux de Saint-André d'Apchon (Loire)," *Bulletin de la Diana*, 1897: 159; and Charles Sterling, *A Catalogue of French Paintings, Fifteenth-Eighteenth Centuries* (Cambridge: Harvard University Press, 1955), 40.

16. Bauman, 134-38.

17. De Groër, 138, 143-44, and Bauman, 136. Previously, the museum had poor quality photocopies of the auction catalogue in the object file and during the course of the investigation searched for an accessible original of the auction catalogue. The museum was not able to examine an original but obtained a good copy of relevant pages from an original catalogue held at the Frick Art Reference Library in New York.

18. Bauman, 136.

19. The sitter in the portrait, at that time, was referred to as "Marechal de Rieux." This information is found in materials sent on March 8, 2004, from Schindler to the museum via fax, in which he attached copies of relevant pages of his research, including pages from a 1913-14 publication by Theodor Frimmel in Vienna and a March 4, 2004, letter to Kurt Schindler from the Hungarian National Museum, Budapest.

20. This information is from the aforementioned materials sent to VMFA by Schindler on March 8, 2004.

21. Yeide et al., Appendix H: The Art Looting Investigation Unit (ALIU) List of "Red-Flag" Names: 278.

Collectors/Collections

Women Collectors of the Weimar Republic

Stephanie Tasch

PROVENANCE research is a study of absence. As we try to determine the history of a paint-ing, a drawing, a piece of furniture or porcelain, or an East Asian work of art, we follow the traces of collections that were dispersed years, decades, even centuries ago. In the case of Holocaust-looted art from European Jewish private collections, there is a double absence. Not only was the collection dispersed by means of forced sales, confiscation, or outright theft, or in any other of the ways known to us by now, but it was also the memory of the collector, or even his or her name, that became unknown and thereby absent from the history of collecting. Therefore, the most common question among provenance researchers is probably "do you know the collector X?"

While the names of many historic collectors resonate in our minds, this is by and large not the case for those Jewish collectors whose collections were spoliated between 1933 and 1945. In what amounts to a severe case of cultural memory loss, even if the name of an important col-lection survived, until a few years ago there was often little knowledge of or interest in the sub-sequent fate of collector and collection. For example, Emma Budge of Hamburg was known as a collector of decorative arts, and we know the dates of the auctions in which her collections were dispersed in Berlin in autumn 1937 at Paul Graupe and Hans W. Lange, respectively.[1] However, only a few people looking at these auction records would have related the names, dates, and artworks listed in them to the systematic looting of private Jewish collections that is now known to have been such an important part of the economic history of National Socialism and the Holocaust.

It is surely unnecessary here to repeat the reasons for the changes in perception that led to the rediscovery and sometimes even reconstruction (in theory if not in actuality) of those lost European private collections. As our knowledge of those collections increases, it becomes obvi-ous that there was more collecting activity by women in the European heartland between Breslau and Paris than first meets the eye. If the male art collectors of this period tend to be for-gotten, women collectors seem, with very few exceptions, to have been relegated to complete obscurity. I do not intend to present the results of any completed research into female collect-ing here but rather would like to propose a research project in this area. Much can be done to illuminate this under-researched area in the history of collecting.

By focusing on the history of women collectors in Germany in the years before the First World War and during the Weimar Republic, it is possible to explore patterns of collecting, shifts and changes in taste, and the economic background to collecting. The various types of women collectors that emerge can shed light on the larger role of women in the art world dur-ing this period. I am aware of other current research projects that deal with the reconstruction of Jewish private collections in Germany. Unlike some of these efforts, I do not intend to com-pletely reconstruct or completely document what was lost. Rather, I seek to establish a broad-

er perspective on female collectors—particularly, but not exclusively, Jewish female collectors.

Private art collections, the role of the art collector and patron, as well as the display of private art in public spaces become a factor in the German history of collecting from the late 19th century. In that era Wilhelm von Bode initiated a series of exhibitions at different venues in Berlin, with a view to displaying the private collections of Old Master paintings belonging to the members of the prestigious Kaiser-Friedrich-Museumverein, founded by Bode in 1897.[2] The exhibitions then continued at regular intervals during the 1920s. During this period there was a growing emphasis on other schools of painting, including impressionism, modernism, and even German expressionism. The culmination probably was reached in 1925, when three such exhibitions with works from private collections took place in Hamburg, Berlin, and Frankfurt within months.[3] Obviously the lists of lenders, members of honorary committees, and Friends of Museums are important sources in determining the role of women as collectors and patrons of art.

Some very basic statistical data will introduce a few of the names that appear with a certain regularity in these lists and might give you an idea of the involvement of women as lenders to exhibitions in public institutions, excluding private (commercial) art galleries:

> Out of 102 lenders to the "Leih-Ausstellung aus Hamburgischem Privatbesitz in der Kunsthalle" at the Kunsthalle Hamburg in May 1925, 33 were women. Two of them also sat on the nine-member exhibition committee, namely Mrs. Henry P. Newman and Mrs. Henry B. Simms. Dr. Rosa Schapire, collector and promoter of German expressionist art, especially work by Karl Schmidt-Rottluff, was one of the lenders.
>
> In 1928, two consecutive exhibitions of contemporary art from private collections were shown at the Nationalgalerie in Berlin ("Ausstellung Neuerer Deutscher Kunst aus Berliner Privatbesitz" in April 1928, and "Zweite Ausstellung Deutscher Nach-Impressionistischer Kunst aus Berliner Privatbesitz" in July 1928). The lenders' lists feature well-known names of collectors, patrons, and artists (presumably some, but not all of them, Jewish) such as Kaethe Bernard-Robinson, Tilla Durieux, Elisabeth Erdmann-Macke, Mrs. Dr. Julius Freudenberg, Mrs. Hermann Mayer-Freudenberg, Margarethe Oppenheim, and Nell Walden-Heymann. In April 1928, 13 out of 59 lenders were women; in July, the head count is 18 of 136, with the same names reappearing, plus a few others like Renee Sintenis and Minna Tube-Beckmann.

To pick just one name for further exploration, Kaete Bernard-Robinson's loans to the 1928 exhibitions consisted of one painting each by Lyonel Feininger,[4] Erich Heckel,[5] and Emil Nolde,[6] two by Otto Mueller,[7] three by Ernst Ludwig Kirchner,[8] and four works on canvas by Karl Schmidt-Rottluff,[9] as well as works by lesser-known local painters. Her loans place Ms. Bernard-Robinson, who lived in Schmargendorf, a middle-class quarter in western Berlin, squarely in the group of Bruecke collectors, those patrons who supported the most controversial works of German modernism. However, looking at the dates of the pictures from her collection, we can deduce that she must have acquired them during or after World War I, when the group itself already had broken up. Nonetheless, buying German expressionist pictures in the early 1920s speaks of a taste in fine arts that had nothing in common with the highly conventional collections of Old Master paintings that would have decorated many middle-class and upper-middle-class living rooms in Berlin at the time—collections that were themselves a memento of Wilhelm von Bode's influence.

It is difficult to deduce Ms. Bernard-Robinson's status as a single or married woman from the way she is listed as a lender; however, it is perhaps fair to assume that she belonged to a differ-

ent generation than, say, Maria (Mrs. Henry P.) Newman, who was born in 1868. In the exhibition catalogue of the Hamburger Kunsthalle in Hamburg in May 1925, Kaete Bernard-Robinson is listed under her husband's name.[10] Does that make her a "neue Frau," a prototype of the "new woman" of the Weimar Republic? At this point, we cannot say. Certainly she emerges as her own woman, one who was obviously independent-minded, possibly of independent means, who was sufficiently well known as a collector of contemporary art to be asked lend items to a large exhibition at Berlin's most prestigious venue for modern art. However, this bare summary leaves many questions about her life and collecting activities unanswered, not to mention the question of how and when her collection was dispersed. To give just one example, according to Martin Urban's *catalogue raisonné* of Nolde's work, there is a provenance gap between the last known owner, Kaete Bernard-Robinson, and a sale at the Stuttgarter Kunstkabinett in 1955, where the Nolde was sold to a private collector in the United States. Urban does not mention the exhibition in Berlin in 1928.[11]

One of the crucial factors in the study of female collectors in this period is the relationship between public and private space. These exhibitions and lists of supporters represent a moment when a private passion for acquiring art becomes public through the display of works in exhibitions, loans to museums, membership in institutions supporting the arts, or publication in contemporary art journals or fashionable magazines. A better-known example of a woman who negotiated this boundary between private and public space is Dr. Rosa Schapire in Hamburg.[12] As I mentioned before, she was an avid collector of Karl Schmidt-Rottluff's art and, as an art historian and lecturer, a keen promoter of his work. While the acquisition of pictures by upper-class women like Maria Newman has been described, somewhat polemically, as a continuation of salon- or court-style patronage in the tradition of great women collectors such as Madame de Pompadour, Rosa Schapire's personal collecting tastes and her tireless support of modern art in Germany certainly belong to a different type of patronage. Contrary to conventional wisdom, Dr. Schapire was not a wealthy woman. As one of the cofounders of the Frauenbund zur Foerderung Deutscher Bildenden Kunst (Women's Association to Promote the Fine Arts in Germany), she was actively engaged in creating a public support network for the arts. Her flat in Hamburg serves as a perfect example of how her collecting tastes converged with the supposedly feminine taste and talent for interior decoration: the entire apartment was furnished with objects designed by Schmidt-Rottluff and also displayed his art.[13]

Looking at more conventional decorating styles, one cannot help noticing the importance of decorative arts from East Asia. Historical photographs of upper-middle-class homes in Berlin in the 1920s and early 1930s show the abundance of Chinese and Japanese ceramics, bronzes, and carpets in these interiors.[14] However, interest obviously went beyond the mere decoration of one's home, as the membership lists of the Deutsche Gesellschaft fuer Ostasiatische Kunst (German Association for East Asian Art) testify. In 1929, an important exhibition of Chinese Art was organized at the Academy of Fine Arts in Berlin.[15] Edith Rosenheim, who collected East Asian art, mainly Chinese works, appears on the exhibition's list of honorary committee members and was also one of the lenders to the exhibition. Another collector in a related field was Lene Schneider-Kainer, the first wife of the artist and art collector Ludwig Kainer and a renowned illustrator in her own right. In 1929, the year of the exhibition at the Academy, her collection of East Asian and Southeast Asian animal figures was featured in an illustrated article in *Die Dame*, a fashionable periodical produced by Ullstein publishers in Berlin and Vienna.[16] For various reasons, any widespread collecting interest in Asian art in Berlin seems to have been too closely tied to the members of Berlin's pre-Nazi and pre-war society for their interest and taste to have survived either the Nazis or the war.

This is just a brief outline of a field of research that is as fascinating as it is under-researched. Provenance research can make a real contribution to the in-depth study of a type of art collector in a well-researched period that has gone largely unnoticed until now. From German expressionism to East Asian art, women collectors acquired artworks from highly diverse areas, allowing an equally large scope of investigation. Patterns of taste in collecting should be explored as well as patterns of patronage and the economic basis of the acquisitions. As we begin to reconstruct the lives and histories of the Jewish art collectors whose biographies have remained unwritten, there is also the challenge of filling in the gaps in the history of women collectors.

Notes

1. Paul Graupe, Berlin, scheduled for Sept. 27-29, 1937, postponed to Oct. 4-6, 1937. There was a another sale later that year: Hans W. Lange, Berlin, Dec. 6-7, 1937.

2. To give just one example: "Ausstellung von Werken Alter Kunst. Aus dem Privatbesitz von Mitgliedern des Kaiser-Friedrich-Museums-Vereins," Königliche Akademie der Künste, Berlin, May 1914.

3. *Leihausstellung aus Hamburgischem Privatbesitz in der Kunsthalle*, exhibition catalogue, Kunsthalle Hamburg, Hamburg, May 1925; *Ausstellung von Meisterwerken alter Malerei aus Privatbesitz*, summer 1925 (beschreibendes Verzeichnis bearbeitet von O. Götz, G. Swarzenski und A. Wolters, Veröffentlichungen des Städelschen Kunstinstituts, Bd. 2), Frankfurt a.M., Städelsches Kunstinstitut, 1926; *Gemälde Alter Meister aus Berliner Besitz*, (vorwiegend aus dem Besitz der Mitglieder des Kaiser-Friedrich-Museums-Vereins), exhibition catalogue, Akademie der Künste, Berlin, July-August 1925.

4. Cat. no. 18, Lyonel Feininger, *Dom*, 1920.

5. Cat. no. 23, Erich Heckel, *Bauernhof*, 1912.

6. Cat. No. 152, Emil Nolde, *Goldschmiede*, 1919.

7. Cat. no. 133, Otto Mueller, *Liebespaar*, 1919; cat. no. 134, *Vor dem Spiegel*, 1919.

8. Cat. no. 64, Ernst Ludwig Kirchner, *Königstein*, c. 1915/16; cat. no. 66, *Der Besuch*, 1917; cat. no. 69, *Der Mistwagen*, c. 1923.

9. Cat. no. 190, Karl Schmidt-Rottluff, *Schulkinder*, 1920; cat. no. 193, *Wäscherinnen am Meer*, 1921; cat no. 198, *Rote Rosen*; cat. no 200, *Arbeiter*, no date.

10. For a biography of Maria Newman see *Private Schätze. Über das Sammeln von Kunst in Hamburg bis 1933*, exhibition catalogue, Hamburger Kunsthalle, Hamburg 2001.

11. Martin Urban, *Emil Nolde. Catalogue Raisonné of the Oil-Paintings, Volume Two 1915-1951*, London 1990, no 857 (ill.).

12. Shulamith Behr, "Anatomy of the woman as collector and dealer in the Weimar period: Rosa Schapire and Johanna Ey" in Marsha Meskimmen, Shearer West (ed.), *Visions of the "Neue Frau": Women and the Visual Arts in Weimar Germany*, Aldershot 1995.

13. Gerhard Wietek, Karl Schmidt-Rottluff. *Plastik und Kunsthandwerk. Werkverzeichnis*, edited by the Karl and Emy Schmidt-Rottluff-Stiftung, Munich 2001, nos. 301-309.

14. One example would be the apartment of film director Fritz Land and actress Thea von Harbou, in Enno Kaufhold, *Berliner Interieurs. Photographien von Waldemar Titzenthaler*, p. 9 (ill). The taste in collecting is also apparent, albeit retrospectively, in many Berlin auction catalogues, including those of the so-called "Jew auctions" of the late 1930s.

15. *Ausstellung Chinesischer Kunst*, exhibition catalogue, Akademie der Künste, Berlin 1929.

16. *Die Dame* 56, no. 8 (January 1929), pp. 16-17.

Recreating the Rothschild Family Collection

Michael Hall

"RECREATING the Rothschild Family Collection" sounds like an innocuous enough project. A fairly easy project, in fact, considering the number of relevant published sources, *catalogues raisonnés*—beginning with John Smith's magisterial work on the Dutch and Flemish masters and continued by Cornelis Hofstede de Groot—monographs, and sales catalogues. To these we can now add above all the Getty Provenance Index, available online.

However, I have a problem, in that the Rothschild family includes over 40 individual collectors, in several countries, over five generations. Most of them collected the same types of pictures of the same schools and the same periods, and all the collectors were interrelated: in the third generation after the founding of the banks by Meyer Amschel Rothschild from Frankfurt in the late 18th century, 14 out of 19 marriages were to other Rothschilds. To any casual student this is dangerous territory, for not only did the Rothschilds rarely use their first given names—so the family tree becomes redundant—but those names themselves are remarkably repetitive—Carl Mayer, Mayer Carl, Mayer Amschel, Amschel Mayer—along with endless Edmonds, Lionels, and names beginning with "A"—Amschel, Alfred, Arthur, Adolphe, Alphonse . . . and even a lady, Alice de Rothschild, who owned Waddesdon Manor in the early 20th century and was also an avid collector.

My project for the past several years has been to compile an index of all the Old Master and British paintings owned by the 11 members of the British Rothschild family, that is, the descendants of Nathan Mayer Rothschild (1777-1836), who founded the Rothschild Bank in London in the early 19th century. I have concentrated on works in oil on canvas or panel primarily because their details appear with greater accuracy than other types of works of art, with artist's names, titles or descriptions, and often sizes and media, all of which help with accurate identification. To date these collectors have been recorded as owning a remarkable 1,027 individual works, mostly of the highest quality and from a very wide range of schools and periods, far wider in many respects than commonly imagined by those who know something of what is called *le goût Rothschild*—the Rothschild taste.

The principal and well-recognized areas of picture collecting for virtually the entire Rothschild family are Dutch and Flemish masters of the 17th century; French works of the 18th century, particularly Boucher, Watteau, Lancret, Pater, and Greuze; English 18th-century portraits by Gainsborough, Reynolds, and Romney; some Italian and Spanish works, particularly Murillo but also contemporary paintings. The French Baron Gustave de Rothschild (1829-1911) bought thousands of modern pictures as gifts for provincial French museums, while his nephew Baron Maurice de Rothschild (1881-1957) bought or commissioned over 30 works by Boldini. In our own time my employer, Edmund de Rothschild (b. 1916) and his family were painted by Sir Alfred Munnings; his great uncle Walter, 2nd Lord Rothschild (1868-1937), was

Lists of an inventory of the Rothschild Archive in Vienna, made by special order of the Nazi DS, April 2, 1938. The Rothschild Archive, London.

painted by Sir John Everett Millais; while his great-great-great aunt, Baroness Betty de Rothschild (1805-86) was famously painted by Ingres.

Having dealt, successfully I hope, with the British Rothschilds, I am now turning my attention to Europe—to Austria, Germany, and France—widening the net considerably. I intend, with the help and support of the Getty Provenance Index and the Rothschild Archive in London, to set up an online database that eventually will list all the pictures the family has ever owned, with details of their provenance from easel to current or last known locations. The Rothschild Archive in London is the most important resource in this project. Set up as an independent charitable trust just a few years ago, it grew out of the commercial records of the bank, N. M. Rothschild & Sons, which still comprise the bulk of its material. However, among the mass of documentation on the financial world in the 19th century, it also contains a large amount of private records of the family, as indeed it should considering that the bank is still a private business, owned and run by the Rothschild family for over 200 years. There are a large number of inventories, wills, valuations, receipts, and correspondence, which give valuable details of the creation of the English Rothschild collections, their passage from generation to generation, and their dispersal.

For example, of the 138 Old Master and British paintings owned by the earliest English Rothschild collector, Baron Lionel de Rothschild (1808-79), over half are now in public collections or in private collections open to the public. I encourage anyone interested in this particular splinter of history to log onto the Rothschild Archive's website at

www.rothschildarchive.org and register for the Rothschild Forum, where scholars and students from a wide range of disciplines exchange information, search the ever-expanding amount of archival material available, ask questions, and present research.

As I am sure many of you are aware, the Rothschild banks were founded by the five sons of Meyer Amschel Rothschild, who were sent out to the financial capitals of late-18th-century Europe—Paris, London, Vienna, and Naples—while one stayed at home in Frankfurt. All five brothers produced collectors, even the short-lived Neapolitan branch headed by Baron Adolphe de Rothschild (1823-1900). The importance of archival research for the accurate provenancing of works of art cannot be stressed too much, but I would also add a word of caution: memory is a very powerful and important tool in this research. I often have come across pictures that I have been told came from the Rothschilds but without any clear evidence other than an individual's memory. However, upon closer research and often by chance, memories have been proved to be correct, if often distorted or half-remembered. Never dismiss these tales, however unlikely or remote they might seem.

For the provenances of the Dutch and Flemish pictures, we had resources of inestimable value in Smith and Hofstede de Groot, but given the complexity of the family they are rarely accurate on ownership. This is exemplified and highlighted by their recent discovery of a manuscript inventory of the famous van Loon collection, formed in Amsterdam in the late 18th and early 19th centuries and bought *en bloc* by a consortium of Rothschilds in 1877. It had been believed that this purchase was made by the French Rothschilds, but with this inventory it has become clear that though the transaction was led from Paris by Barons Gustave, Alphonse, and Edmond de Rothschild; they included their uncle Baron Lionel and Austrian cousin Baron Ferdinand—of Waddesdon fame—in the purchase. They divided the 100-odd pictures among them according to the values in the inventory made by Frederic Reiset, director of the Louvre and friend of Baron Alphonse.

For example, Ruysdael's *Landscape with Shepherds* was bought by Pieter van Winter in 1789, bequeathed to his daughter Annaweiss van Winter van Loon, acquired by Baron Lionel de Rothschild when the collection was divided by drawing lots, inherited by his son, Nathaniel, 1st Lord Rothschild, swapped by him with his brother Leopold de Rothschild (1845-1917), inherited by his second son, also Lionel de Rothschild (1882-1942), and sold from our collection by his son Edmund de Rothschild to pay death duties in 1942. It has reappeared several times at auction, most recently in 1992 at Christie's in London.

A second, as yet unexamined document in the Rothschild Archive in London is the daily record book of purchases of art and antiques made by Baron Alphonse de Rothschild covering the period c. 1860 to 1895. This record book lists all purchases of works of art chronologically, giving provenances and prices. It includes figures for his share of the van Loon purchase, with a commission paid to a dealer, Louis Gauchez, who arranged the shipping and also disposed of a number of the less interesting pictures.

We have discussed at this conference the restitution of looted artworks in the period 1939-45, and it is worth mentioning here some little-known facts regarding the restitution of art from French Rothschild collections. Though there are a number of pre-1939 French Rothschild inventories, after the war the French family was reluctant to hand them over to the Allied restitution officers as they had sent a number of important works abroad before the German invasion.

In allowing the authorities access to the lists of the collections before the Nazi confiscations, they would have revealed the full extent of those collections. Rather than submit a list of looted works, the family asked the Central Collection Point in Munich to return all those items

The strong room at the Rothschild Archive, London. The Rothschild Archive, London.

clearly marked as Rothschild property. In this way they retained some privacy.

After the nationalization of the French Rothschild bank in the 1980s, the French archives were stored at château Lafite, though the financial records have been placed on loan at the Archive National's depository at Roubaix near Lille. Recently the papers at Lafite have been transferred to the Rothschild Archive in London and now can be properly consulted, though they are as yet not fully catalogued. The papers of the German bank at Frankfurt were transferred to Vienna when the bank closed in the late 19th century.

While recreating the Austrian Rothschilds' collections has been helped enormously by the recent publication of the Nazi inventories by Sophie Lillie in *Was einmal war*, the archival documents that will help discover the sources of the collection were recently returned to family ownership. The archives of the German and Austrian Rothschild banks were confiscated simultaneously with their art collections by the Nazis after the Anschluss in 1938. They then were confiscated by the Soviets after they occupied part of Vienna in 1945 and removed to the Moscow State Archive. Though part of the archive was returned to London at the beginning of Glasnost in the late 1980s, the remainder of the papers were restituted to the Rothschild Archive only recently, after the chairman of the London bank, Sir Evelyn de Rothschild, pur-

chased a collection of letters to and from Emperor Alexander III and presented them to the Moscow State Archive. The papers were returned to London in the original order that they had been catalogued by the Nazis, but in Soviet cardboard boxes, and they will remain in this order for future research.

Adrian van Ostade's *Peasants Dancing Before a Cottage Door* presents another way of identifying Rothschild works of art, via the salerooms in the United States and Europe. Many members of the Rothschild family have sold considerable amounts of art since the Second World War, not always revealing their provenance. When these pictures are subsequently presented for sale at auction, their Rothschild provenance can be easily overlooked or is unrecorded. However, the family's taste for certain types of pictures, by style or particular artists, can alert the researcher to a potential Rothschild picture, a method that can be carried on in museum collections around the world.

Sold at Sotheby's in London in December 2004, *Peasants Dancing Before a Cottage Door* has a particularly rich provenance, having been in the collection of the French 18th-century connoisseur Pierre-Louis-Paul Randon de Boisset. Previously it was with Claude Tolozan in Paris at the beginning of the 19th century and was owned by the duc de Berry and passed to his widow by 1837, when it was bought at the Berry sale by Sir Anthony de Rothschild (1812-76). As it is signed and dated 1660, it is comparatively easy to follow its history as it passed to Sir Anthony's nephew Alfred de Rothschild (1842-1918), to his nephew Lionel de Rothschild (1882-1942) by inheritance, and then to his son, Edmund de Rothschild (b.1916) at Lionel's death in 1942, when it was sold to pay death duties. It is a usual Rothschild picture in terms of taste though it was popular over three generations, which is highly unusual in families.

However, Rothschild taste is sometimes not all that it seems: van Dyke's *The Abbé Scaglia Adoring the Virgin*, now in the National Gallery, London, was also in Sir Anthony de Rothschild's collection. It is by no means at first glance a typical picture for Jewish collectors. Though a clearly Christian scene, the representation of motherhood and family values greatly appealed to the Rothschilds, and they owned several works by Murillo of the Virgin and the Holy Family as well as the great Andrea del Sarto *Freis Madonna*.

British portraiture has an excellent literature for research and is well represented in Rothschild family collections, being synonymous with *le goût Rothschild*. Though Waddesdon has a remarkable group of these works, it is not so well known that all members of the family throughout Europe shared this taste. The Austrian Rothschilds owned several works by Gainsborough and Romney, while the iconic image of Reynolds's *Portrait of Master Hare* was bought by Baron Alphonse de Rothschild in London in 1872 and presented by him to the Louvre in 1905 at a time when British painting was comparatively unknown in France.

Any study of a particular family collection could have a distinctly introverted feel to it, especially if all the archival material is still controlled by that family and all in one place. However, the influence of Rothschild taste was massive and, I believe far greater, more widespread, and certainly earlier in its influence than has been previously recognized. In particular, the importance of the Rothschilds in forming the taste of the highly influential American collector J. P. Morgan has yet to be fully discussed. Morgan first came to London in the 1840s, the golden age of Rothschild collecting, and his father's main business partner in London was none other than Baron Lionel de Rothschild, a relationship the Morgans maintained until Baron Lionel's death in 1879. The influence of Rothschild taste on the creation of many American museums—the Frick, the National Gallery in Washington, and the Huntington, among others—can be clearly seen, but further research needs to be done in the archival material available now in London.

We have discussed many problems of restitution—successful, unsuccessful, or unconcluded—during this conference, and the Rothschild Archive has its own contribution to make in a plea for help in this area. While in the hands of the Soviet government, several letters to the Rothschilds in Vienna from the Austrian statesman Prince Metternich were "given" to the president of Austria during a diplomatic visit. These letters, though rightfully the property of the Rothschild heirs, are important historical documents that deserve to be available to a wider audience. All requests to the current Austrian authorities to make these papers available have been unsuccessful; indeed, they have elicited no response whatsoever. It is hoped that this conference and more open discussions of the issues that we have raised will enable items like the Metternich letters to be made available to scholars and historians such as yourselves.

The Jenny Steiner Collection:
A Case Study in Private Collecting in Pre-1938 Vienna

Sophie Lillie

STRICTLY regulated by public offices, Nazi art theft in Austria was marked by a complex network of systematic and quasilegal mechanisms of expropriation. At its center was the so-called Vermögensverkehrsstelle, a department within the Ministry of Economic Affairs responsible for documenting and subsequently dispossessing private and business assets owned by Austrian Jews.[1] The Internal Revenue Authorities (Finanzamt) impounded artworks as payment for discriminatory taxes and charges, such as the so-called Reich Flight Tax and Judenvermögensabgabe (Jewish Property Tax), both of which were levied at 25 percent of the total assets. The Monuments Office (Zentralstelle für Denkmalschutz) barred the export of objects considered of national value and worked in tandem with the municipal authorities (Wiener Magistrat) to "safeguard" these objects. Under the Eleventh Decree to the Reich Civil Code of 1941, the State Revenue Authorities (Finanzlandesdirektion) and the Gestapo confiscated as enemy property all assets belonging to Austrian Jews who had fled the country or had been deported.

The story of the Jenny Steiner Collection demonstrates this interplay of different, partially competing institutional interests. It was one of countless small, private art collections that existed in Vienna prior to 1938, unusual for its combination of Old Masters and modern art and for Jenny Steiner's early patronage of Gustav Klimt and Egon Schiele.[2] Like many other pre-1938 collections, the Jenny Steiner Collection can be reconstructed only by focusing on the conditions of its destruction. Research on this collection takes one to all of the pertinent sources in Austria and the different kinds of archival materials available, including pre-1938 auction catalogues, exhibition catalogues, and catalogues raisonnés; asset reports, export records, and confiscation reports from Nazi sources; acquisition records of the so-called Führermuseum in Linz; sale records of the Vugesta (Verwertungstelle für jüdisches Umzugsgut der Gestapo) as well as the Dorotheum auction house; and, finally, restitution claims filed after 1945, which document Steiner's efforts to recover assets in Austria until her death in 1958.

Until recently, Jenny Steiner was virtually unknown as an art collector. In fact, her name only became more widely known with the news of a claim pending on two paintings, Egon Schiele's Houses by the Sea[3] and Gustav Klimt's Landhaus am Attersee. The claims were made by Steiner's heirs following the Austrian Art Restitution Act of 1998, which governs the restitution of artwork from Austrian federal museums and public collections.[4] In the artists' catalogues—that is, Fritz Novotny and Johannes Dobai's Klimt catalogue of 1967[5] and Jane Kallir's catalogue raisonné on Schiele, first published in 1990[6]—references to Steiner are quite marginal. In the important exhibition "Klimt und die Frauen" (Austrian Gallery Belvedere, 2000), which featured Klimt's portraits of women and his female patrons,[7] Steiner was overlooked entirely.

At once a result of the destruction of a generation of Austrian collectors in the Holocaust and a symptom of the culture of oblivion that dominated postwar Austria, this peculiar omis-

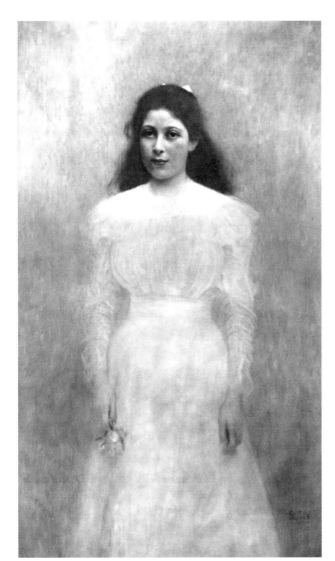

Above: Italian, formerly attributed to Matteo da Gualdo, *Visitation of the Virgin*. Formerly Jenny Steiner Collection, Vienna; current whereabouts unknown. © Arye Wachsmuth, Vienna.

Left: Gustav Klimt, *Portrait of Trude Steiner*, 1900. Formerly Jenny Steiner Collection, Vienna; current whereabouts unknown. © Galerie Welz, Salzburg.

sion can be remedied only by concentrating on the circumstances of expropriation. In studying the various sources that describe the conditions of theft—the Vermögensanmeldung of 1938[8]; the inventory of household furnishings impounded by the Internal Revenue Authorities on Reich Flight Tax charges[9]; the application for an export license to Paris, dated October 1938[10]; as well as several catalogues of sales at the Dorotheum, where objects from the Jenny Steiner Collection were sold after 1940[11]—we discover Jenny Steiner the collector, her interests, and her economic means.

Born Eugenie Pulitzer on July 11, 1863, in Budapest, Steiner was the daughter of Simon Siegmund Pulitzer and his wife, Charlotte Politzer (1833 Vasarhely–1920 Vienna). Her husband was the textile magnate Wilhelm Steiner (1859 Dobrisch–1922 Vienna); the couple had five children. The family lived in a luxurious apartment in the Palais Colleredo-Mansfeld in Vienna's first district.[12] Like her sister Serena Lederer (1867 Budapest–1943 Budapest) and Serena's husband, August (1857 Ceska Lipa–1936 Vienna), who owned the largest private collection of works by Gustav Klimt,[13] Steiner was an important patron of the artist's work.

Numerous family portraits, depicting three generations, were commissioned by the Pulitzer sisters. All of these family-owned portraits were looted by the Nazis after 1938. They include a portrait of the mother, Charlotte, which remains lost to this day[14]; a portrait of Serena Lederer, which was recovered by her son Erich Lederer (1896 Vienna–1985 Geneva) and acquired by the Metropolitan Museum of Modern Art in 1980[15]; a portrait of Serena's daughter Elisabeth Bachofen Echt (1894 Vienna–1944 Vienna), which also was recovered and is owned by the Neue Galerie New York[16]; a portrait of Steiner's daughter, Trude, which was painted posthumously after the girl's death in 1900 at age 13 and remains lost[17]; and the famous portrait of Steiner's niece, Ria Munk, also painted posthumously, following Ria's suicide in 1911. This painting currently is located at the Lentos Museum in Linz.[18]

In 1938, immediately following the Anschluss, Steiner fled to Paris with her eldest daughter, Daisy, son-in-law Wilhelm Hellmann,[19] daughter Anna Weinberg, and granddaughter Susanne. A Vermögensanmeldung in her name was filed in absentia by Dr. Friedrich Hauenschild. In October 1938, a warrant was issued for Steiner's arrest on alleged charges of Reich Flight Tax evasion in the amount of 1.5 million Reichsmark.[20] Levied at 25 percent, the Reich Flight Tax gave the Internal Revenue Authorities access to assets worth an estimated 6 million Reichsmark, which Steiner had surrendered at the time of her escape and were subsequently impounded.

Steiner apparently was able to maintain some sort of control over her personal effects, since in October 1938 she hired the shipping company Schenker & Co. to crate and ship her belongings to Paris. On Oct. 3, 1938, the apartment in Zedlitzgase where she lived with her unmarried daughter Clara,[21] was impounded with all of its contents and individual rooms sealed. Her apartment was subsequently vacated and allocated to a local coal trading company, which filed a formal complaint with the Vermögensverkehrsstelle regarding the cost of removing wall paneling and fitted furniture from the apartment to adapt it for business use.[22] A list of the apartment's contents that was subsequently drawn up includes the only known inventory of Jenny Steiner's art collection.[23] Apparently, however, the collection was not left to be disposed by the Revenue Authorities, which in all likelihood would have arranged a house sale of the entire estate.[24] Only individual pieces of silverware were sold forcibly at the Dorotheum in 1939.[25] It should be noted that after 1939, the Monuments Office, the Customs Investigation Department, and the Dorotheum were automatically furnished with copies of these inventories. A precedence had been set by the case of Lola Kraus (coincidentally, Steiner's niece), who allegedly had attempted to evade paying export dues on her valuables.[26]

On Oct. 31, 1938, Schenker & Co. filed the mandatory application for an export license, the next bureaucratic hurdle that had to be cleared by people attempting to flee Austria. The Monuments Office inspected the collection and barred three particularly valuable objects from export, namely Klimt's *Watersnakes II*, the *Landhaus am Attersee*, and the 16th-century sculpture *Christ and the Apostles*.[27] The legal basis for this embargo was the Art Preservation Act of 1923,[28] a national heritage protection law originally devised to prohibit the export or sale of objects deemed of historical, artistic, or cultural value to the Austrian state. Under the Nazis, this law was honed into a powerful instrument of expropriation since it allowed the municipal authorities to "safeguard" any object deemed to be in imminent danger of being taken out of the country.[29] Most typically, the best selection of "safeguarded" objects would be submitted to the so-called Führermuseum; others would be put at the disposal of local museums. The extent of this practice is evidenced by a photo archive comprising some 6,000 objects that fell under the administration of the Monuments Office between 1938 and 1945, one of the most important sources in Austria available to provenance researchers today. Interestingly, in Steiner's case,

only the sculpture *Christ and the Apostles* appears in the photo archive, suggesting that both *Watersnakes II* and *Landhaus am Attersee* remained with Schenker & Co., along with the other objects that had been released for export. Schenker & Co., however, never sent this shipment.

Only very few refugees, those who acted immediately after the Anschluss in 1938, succeeded in shipping their belongings overseas. The best-known case is that of Otto Kallir-Nirenstein (1894 Vienna–1978 New York), who managed to send most of his collection from Europe to the United States.[30] Other collections were dispatched from Vienna but subsequently confiscated in another occupied country, such as the collection of Fritz and Anna Unger, which was confiscated by the Einsatzstab Reichsleiter Rosenberg in Paris.[31] In the overwhelming majority of cases, the Viennese shipping companies held back the crates that had been assigned to them. Their owners had fled the country, leaving no one to negotiate the tedious formalities on their behalf; in most cases, a fiduciary or *curator absentis* had been appointed by the court. With the outbreak of war in 1939, all communication with enemy countries broke down and private transport came to an absolute standstill. Many crates that had already reached their port of departure—typically Trieste or Hamburg—were recalled, and any shipping crates still in Vienna at this time stayed put. By 1940, unsent shipments totaled approximately 5,000 in number.

Individual confiscations of this property began in the same year and continued until the process was replaced in 1941 by the Eleventh Decree to the Reich Civil Code, which proclaimed as property of the German Reich all assets owned by Austrian Jews who had fled or who had been deported. To dispose of these goods, the union of shipping companies founded an organization called the Vugesta.[32] The two agencies worked in tandem; the Gestapo confiscated the shipping goods while the Vugesta broke open the crates and sorted their contents. Household wares were sold at the Vugesta's own sale complex; luxury goods were put up for sale via the Dorotheum. From 1940 on, most particularly in 1941-42, thousands of objects—including furniture, paintings, rugs, and books, whose owners had fled or had been deported—were sold at public auction, adding up to some 11 million Reichsmark for the Dorotheum.[33] After March 1940, objects from the Jenny Steiner Collection began to appear in sales at the Dorotheum. The collection thus was included among the first sales of objects seized by the Vugesta. With the exception of three objects—the panel *Christ and the Apostles*, the Egon Schiele painting *Mother with Two Children*, and Klimt's *Watersnakes II*—Steiner's entire collection was auctioned via the Dorotheum under Vugesta Lot-No. 3591 for a total of 7,500 Reichsmark.[34]

Objects sold at the 458th Dorotheum sale on March 4 and 5, 1940, included the Carinthian *Martyrdom of St. Barbara*[35]; the painting *St. Hieronymus* by Allesandro Magnasco (1681 Genoa–1707 Genoa)[36]; a Flemish tapestry depicting a river landscape with trees[37]; *The Visitation of the Virgin Mary*, set in a Renaissance hall with a view to a landscape, falsely attributed to Matteo da Gualdo (1430 Umbria–1503 Umbria)[38]; the painting *The Death of Lucretia* by Niccolo Renieri (1590 Maubeuge–1660 Venice)[39]; and a *Portrait of a Lady* in a red dress with fur trimmings in the manner of George des Marées (1697 Stockholm–1776 Munich).[40] In April 1941 the Dorotheum sold the portrait of Steiner's daughter, Trude, which had been listed in February 1941 but did not sell at that time.[41] It is interesting to note that family portraits were typically subject neither to confiscation nor to export restrictions. They became subject to expropriation only with the confiscation of shipping goods and their sale via the Vugesta.

With the sole exception of the Magnasco painting, which was recovered and restituted to Steiner in the early 1950s,[42] the current whereabouts of these paintings—which were acquired by private collectors—are unknown. Austrian law stipulates that buying at public auction affords the buyer good title as a *bona fide* purchaser, a basic principle that was confirmed retroac-

tively by postwar legislation. The Third Restitution Act of 1948, which governed moveable property between private persons, stated that restitution was required only in those cases where the buyer knew or must have known that the object he purchased was stolen property, a condition that is practically impossible to prove.

It is therefore possible to reconstruct only the fate of those paintings that were acquired by public institutions after 1940. One of these is Klimt's *Portrait of Mäda Primavesi*,[43] which the Historical Museum of Vienna acquired at the Dorotheum in 1941. Steiner recovered the painting in 1951.[44] After her death in 1958, the painting was donated to the Metropolitan Museum of Art in New York in her memory by her daughter Clara and son-in-law André Mertens.[45] It should be noted that Clara and André Mertens gave generously to the Metropolitan Museum, where a wing is named in their honor. Objects include not only the Mertens' collection of musical instruments but a Chinese statue from the Ming period of the Goddess Kwanyun (or Boddhisattva) atop a throne of lotus wearing a dome-shaped shrine as a tiara. This had been looted from the apartment that Clara once shared with her mother and was recovered and brought to the United States in 1947.[46]

Another known painting from the Jenny Steiner Collection is Klimt's *Landhaus am Attersee*,[47] also included in the Dorotheum sale in March 1940.[48] This painting had been on permanent loan to the Austrian Gallery Belvedere since 1963 and in 1995 was given to the museum by Emma Danzinger, in memory of her husband, Michael Danzinger.[49] Considered one of Klimt's most important landscapes, the painting was restituted to Steiner's heirs in 2001 pursuant to the Art Restitution Act of 1998.[50] The restitution was particularly noteworthy since it did not fulfill either of the two conditions stipulated by the 1998 legislation: it had not been acquired between 1938 and 1945 and its restitution had not been hindered by the imposition of a strategic export embargo in the postwar period. Since it was donated to the museum only three years prior to the Art Restitution Act, however, the painting satisfied the requirement of being a gratuitous acquisition. It therefore must be considered a landmark case, accurately illustrating the importance of researching museum acquisitions right up to the present day.

Egon Schiele's painting *Houses by the Sea*[51] remained unsold at the Dorotheum in March 1940 and was offered again twice until it was finally sold in 1941.[52] It is one of only two Schiele paintings that I am aware of sold by the Dorotheum in those years, the other was the *Krumau Landscape* formerly owned by Steiner's daughter Daisy Hellmann, which was sold in 1942.[53] As evidenced by several other important early collections of Schiele's work—such as those belonging to Dr. Oscar Reichel (1869 Vienna–1943 Vienna)[54] and Dr. Heinrich Rieger (1868 Szered–1942 Theresienstadt)[55]—Schiele paintings were not usually sold at the Dorotheum; for the most part, only Schiele drawings occasionally came up for auction there. The purchaser of *Houses by the Sea* was a man called Johann Ernst, whose son sold the painting to Rudolf Leopold in 1953.[56] Today it is held by the Leopold Museum, which has to date refused to consider its restitution. Ironically, it was a controversy over two paintings from the Leopold Museum—*Portrait of Wally*[57] and *Dead City III*[58]—that led to the Art Restitution Act of 1998.

Also in the catalogue of the Dorotheum's 458th sale is *Wasserschlangen II* (*Watersnakes II*), arguably the most important painting in the Steiner collection and one of three objects barred from export in 1938.[59] *Watersnakes II* was withdrawn from the sale after the intervention of Baldur von Schirach, the Reich governor of Vienna. It was acquired by Gustav Ucicky (1899 Vienna–1961 Vienna),[60] a film director and Klimt's illegitimate son, who owned the painting until his death.[61] After reaching the United States in 1941—via France, Portugal, and Brazil with the help of her father's cousin, the newspaper magnate Joseph Pulitzer—Jenny Steiner would have needed to have known the painting's whereabouts to pursue a claim. Ucicky, how-

ever, never registered the painting as stolen property, although he was legally required to do so under the Third Restitution Act of 1948. Moreover, since 1943 the painting had not been loaned to an exhibition and had been infrequently reproduced. The standard work on Gustav Klimt by Novotny and Dobai, which cited the work's full provenance, was first published in 1967, nine years after Steiner's death in New York. Without this knowledge, Steiner had no legal recourse to assert a claim for the painting's restitution during her lifetime.

Not included in the Dorotheum sale was the Egon Schiele painting *Mother with Two Children*, which Steiner had acquired in 1922 from the art dealer Karl Grünwald.[62] Considered "degenerate" art, the painting was considered unfit for resale and placed in the custody of the Nazi Propaganda Office; in 1945 it was transferred to the Association of Fine Artists. As former property of the Nazi Party, the restitution of the painting was governed by the First Restitution Act. Despite a ruling in Steiner's favor on Nov. 9, 1950, restitution was only theoretically achieved since the export license to New York needed the consent of the Austrian Gallery Belvedere. Praising *Mother with Two Children* as one of Schiele's major works, the Belvedere's director, Karl Gazarolli, both ordered that it remain in Austria and requested that it be acquired for the museum's collection.[63] Steiner had never intended to sell the painting, which was of great sentimental value to her.[64] Without an export license, however, she had little alternative; in 1951 the painting was sold to the Belvedere for 20,000 Austrian schillings.

A single object from the collection, the Carinthian sculpture *Christ and the Apostles*, was acquired in February 1940 for the planned Führermuseum in Linz.[65] Toward the end of the war, it was stored in the Altaussee salt mine, along with thousands of other objects destined for Linz. It was recovered there by U.S. troops at the end of the war and restituted to Steiner in 1949. Its subsequent export from Austria could not be verified.[66] The fact that only one object from the Jenny Steiner Collection was acquired for the Linz museum puts the Führermuseum's role into perspective. Primarily ideologically motivated, the early confiscations of Viennese collections for Linz—including the collections of Alphonse Rothschild (1878 Vienna–1942 Bar Harbor, Maine) and Louis Rothschild (1882 Vienna–1955 Montego Bay, Jamaica)[67]—were not the model for the continued expropriations of art during the Nazi regime. The majority of artworks plundered in Vienna were not destined for the Führermuseum but were sold and traded on the local art market; in that sense, plans for Linz invigorated the art market more than they controlled the looted art trade.

Individual objects from the Jenny Steiner Collection were impounded, "safeguarded," confiscated as enemy property, forcibly sold at the Dorotheum, retained for Nazi officials, or allocated to the Führermuseum in Linz. Thus this case study is an appropriate example of the various means employed by the Nazi regime in Austria to destroy an art collection.

Notes

1. Decree regarding the Declaration of Jewish Assets per April 26, 1938. By July 30, 1938, some 50,000 individual declarations had been submitted, comprising a total value of approximately 2 billion Reichsmark in private assets, including real estate, business assets, stocks and bonds, bank accounts, insurance policies, art and luxury items, etc.

2. Regarding the Jenny Steiner Collection, see Sophie Lillie, *Was einmal war: Handbuch der enteigneten Kunstsammlungen Wiens* (Vienna: Czernin Verlag, 2004), 1,244-251.

3. Hans Haider, "Ein Schiele in der Leopold Stiftung ist zwangsversteigertes jüdisches Eigentum," *Die Presse*, March 15, 2000.

4. Federal Law on the Restitution of Art Objects from Austrian Federal Museums and Public Collections, Dec. 4, 1998, *Federal Law Gazette*, no. I/181/1998.

5. Fritz Novotny and Johannes Dobai, *Gustav Klimt* (Salzburg: Galerie Welz, 1967).

6. Jane Kallir, *Egon Schiele: The Complete Works* (1st ed., New York: Harry N. Abrams Inc., 1990; expanded ed., New York: Thames & Hudson, 1998).

7. Tobias G. Natter and Gerbert Frodl, eds., *Klimt und die Frauen*, exhibition catalogue, Austrian Gallery Belvedere, Vienna, Sept. 20, 2000–Jan. 7, 2001 (Vienna: Cologne: DuMont, 2000).

8. Austrian National Archive (ÖStA), Archive of the Republic (AdR), Vermögensverkehrsstelle (VVSt), Vermögensanmeldung (VA) 46567, Jenny Steiner.

9. Ibid., Inventory of apartment furnishings.

10. Federal Monuments Office (BDA), Record Group: Ausfuhrmaterialien, Application for Export, No. 8163/38, Klara Grossi-Steiner.

11. The majority of Steiner objects were included in the 458th Kunstauktion (KA) at the Dorotheum, Vienna, March 4-6, 1940.

12. Zedlitzgasse 8, corner of Parkring. It is interesting to note that the building today houses the Austrian Federal Police Headquarters.

13. On the Lederer collection, see Christian M. Nebehay, *Gustav Klimt, Egon Schiele und die Familie Lederer* (Bern: Verlag Galerie Kornfeld, 1987); Tobias G. Natter, *Die Welt von Klimt, Schiele und Kokoschka: Sammler und Mäzene* (Cologne: Du Mont, 2003), 111–39 (August and Serena L.), 154–64 (Erich L.); Lillie, 2003, 656–71.

14. Novotny and Dobai, no. 190.

15. Novotny and Dobai, no. 103. The Metropolitan Museum of Modern Art, New York, Purchase Catharine Lorillard Wolfe Collection, Bequest of Catharine Lorillard Wolfe, by exchange, and Wolfe Fund; and Gift of Henry Walters, Bequest of Collis P. Huntington, Munsey and Rogers Fund, by exchange.

16. Novotny and Dobai, no. 188.

17. Novotny and Dobai, no. 104. Novotny and Dobai date the painting 1898-99, correctly stating that it had been painted posthumously from a photograph. The correct date is 1900, the year that Trude died and that the painting was acquired by Jenny Steiner according to the VA.

18. Novotny and Dobai, no. 209.

19. On the Hellmann collection, see Lillie, 2003, 490–97.

20. ÖStA, AdR, VVSt, VA 46567, Jenny Steiner, Letter of the Internal Revenue Authority of Vienna's First District to the VVSt, Sept. 22, 1939.

21. To secure papers for herself, Clara entered a marriage of convenience with a French citizen, Armando Marcello Grossi, in 1938. She later married Andre Mertens (1904 Berlin–1963 Baden, Switzerland), the former director of the Opera Division of the State Ministry of Fine Arts in Berlin and the son of Otto Mertens, director of Berlin's Komische Oper.

22. ÖStA, AdR, VVSt, VA 46567, Jenny Steiner. Letter Südostdeutsche Kohlen-Handelsgesellschaft m.b.H. (coal trading company) to VVSt, Oct. 5, 1938.

23. ÖStA, AdR, VVSt, VA 46567, Jenny Steiner, Inventory of apartment furnishings.

24. In 1938, the Dorotheum conducted a number of estate sales in which the entire household furnishings were sold, e.g., the residence of Bernhard Altmann (Versteigerung der kompletten Villeneinrichtung Wien XIII., Kopfgasse 1 / Hietzinger Hauptstrasse 31, Dorotheum, June 17-22, 1938), the summer residence of Jenny Mautner at Geymüller castle (Freiwillige Versteigerung von reichhaltigem Biedermeier-Mobiliar und Zubehör aus einem Biedermeier-Schlössel zu Pötzleinsdorf, Dorotheum, Vienna, Dec. 9-10, 1938), and the residence of Wilhelm and Fanny Löw and Dr. Marianne Hamburger-Löw (Versteigerung der Wohnungseinrichtung Döblinger Hauptstrasse 56, Tür 5 und 7,

Dorotheum, Vienna, May 25-26, 1939). See Lillie, 2003, 32-77 (Altmann), 748-53 (Mautner), 712-27 (Löw).

25. ÖStA, AdR, VVSt, VA 46567, Jenny Steiner. Dorotheum Sales Receipt, No. 10065, March 8, 1939.

26. ÖStA, AdR, VVSt, VA 61699, Lola Kraus. Letter VVSt to Dorotheum, June 5, 1939; Letter to Customs Investigating Office in Vienna, June 5, 1939.

27. BDA, Record Group: Ausfuhrmaterialien, Application for Export, No. 8163/38, Klara Grossi-Steiner.

28. Austrian Federal Law of Jan. 25, 1923, amending the Law of Dec. 5, 1918, State Law Gazette. No. 90, Prohibiting the Export or Sale of Objects of Historical, Artistic or Cultural Value, Federal Law Gazette No. 80/1923.

29. Compare BDA, Record Group: Ausfuhrmaterialien, File no. 2182/38, regarding the tightening of export regulations.

30. On Kallir's flight from Austria, see *Otto Kallir-Nirenstein: Ein Wegbereiter österreichischer Kunst*, exhibition catalogue, Historical Museum of the City of Vienna, 1986; Jane Kallir, *Saved from Europe: Otto Kallir and the History of the Galerie St. Etienne*, exhibition catalogue on the occasion of the 60th anniversary of the Galerie St. Etienne, New York, 1999. On the Kallir-Nirenstein collection, see Lillie, 2003, 540-45.

31. Dr. Anna and Dr. Fritz Unger had inherited these artworks from Anna's father, Gustav Arens (1867 Reichenau, Bohemia–1936 Vienna). Other objects from the Arens estate that had been inherited by Anna's sister and brother-in-law, Lisa and Felix Haas, were confiscated by the Gestapo in 1938, placed in the custody of the Kunsthistorisches Museum at the Neue Burg, and allocated to the so-called Führermuseum. On the collection of Dr. Gustav Arens, see Lillie, 2003, 86-107.

32. On the Vugesta, see Robert Holzbauer, "Einziehung volks- und staatsfeindlichen Vermögen im Lande Österreich: die Vugesta—die Verwertungsstelle für jüdisches Umzugsgut der Gestapo," *Spurensuche*, no. 1-2/2000: 38-50.

33. Criminal Court of Vienna, Volksgericht, VG 3c Vr 2272/48, Criminal charges against Karl Herber based on para. 6 of the War Crimes Act. Expertise by Felix Romanik, July 25, 1951.

34. ÖStA, AdR, VVSt, *Vugesta Journal 6*, no. 3591, Klara Grossi Steiner.

35. Dorotheum Vienna, 458th KA, March 4-6, 1940, Lot 77, Plate XVII.

36. Ibid., Lot 38, Plate IV.

37. Ibid., Lot 110, Plate XXII.

38. Ibid., Lot 24, Plate I.

39. Ibid., Lot 45, Plate V. The painting remained unsold and was reoffered in the fall of 1940, see Dorotheum, Vienna, 461st KA, October 24, 1940, Lot 54, Plate IV.

40. Dorotheum, Vienna, 458th KA, Lot 39, Plate III.

41. Dorotheum, Vienna, 463rd KA, February 4-5, 1941, Lot 34; 465th KA, April 22-23, 1941, Lot 48a.

42. BDA, Record Group: Ausfuhrmaterialien, Application for Export, no. 2098/54, Anna Weinberg.

43. Dorotheum, Vienna, 458th KA, Lot 224, Plate XIV; 463rd KA, February 4-5, 1941, Lot 35.

44. BDA, Record Group: Ausfuhrmaterialien, Application for Export, no. 1960/51, Spedition Bäuml on behalf of Eugenie Steiner.

45. Metropolitan Museum of Art, Inv. Nr. 64.148; Novotny and Dobai, No. 179.

46. Dorotheum, 458th KA, March 4-6, 1940, Lot 98, Plate XVII; BDA, Record Group:

Ausfuhrmaterialien, Application for Export No. 197/47, Clara Mertens. The statue had been exhibited at the Austrian Museum for Art and Industry in 1930, see *Ausstellung von Werken Asiatischer Kunst aus Wiener Besitz*, exhibition catalogue, Society of Friends of Asian Art and Culture in Vienna in cooperation with the Austrian Museum for Art and Industry, June-July 1930.

47. Novotny and Dobai, No. 189.

48. Dorotheum, Vienna, 458th KA, Lot 223, Plate XIV.

49. Austrian Gallery Belvedere (ÖG), Inv. No. 8983. See *Neuerwerbungen 1992–1999*, exhibition catalogue, ÖG, Vienna, 1999.

50. Austrian Federal Ministry for Education, Science and Culture, Annual Restitution Report, 1999-2000, 7.

51. Kallir, 1998, No. P 281.

52. Dorotheum, Vienna, 458th KA, Lot 244, Plate XV; 463rd KA, February 4-5, 1941, Lot 68; 465th KA, April 22-23, 1941, Lot 99a.

53. Kallir, 1998, No. P 298; Dorotheum, Vienna, 471st KA, February 24-27, 1942, Lot 175, ill. The painting was acquired for 1,800 Reichsmark by the Galerie St. Lucas on behalf of the art dealer Wolfgang Gurlitt (1888 Berlin–1965 Munich). As part of the Gurlitt collection, the painting was loaned to the City of Linz in 1947 and subsequently acquired in 1953 for the establishment of the Neue Galerie der Stadt Linz. Daisy Hellmann's claim on the painting was denied by the Austrian Restitution Court in 1948 and it was only restituted to her heirs in 2003. See Walter Schuster, *Die 'Sammlung Gurlitt' der Neuen Galerie der Stadt Linz* (Linz: Archiv der Stadt Linz, February 1999), 60-64; Lillie, 2003, 490ff.

54. Dr. Oscar Reichel was among the most important collectors of Austrian modernism before 1938. He is regarded as having discovered the work of Anton Romako, whom he likened to the young Oskar Kokoschka, another of his favorite artists. A physician by profession, Reichel founded the art gallery Kunst und Wohnung Lorenz and Reichel in 1920, together with Rudolf Lorenz and Samuel Goldfarb Reichel. The gallery dealt primarily with decorative arts and interior furnishings and was managed by the architect and Wiener Werkstätte member Hugo Gorge. See "Aber den Kokoschka würde ich nicht empfehlen," chapter in Werner J. Schweiger, *Der junge Kokoschka: Leben und Werke* 1904-1914 (Vienna: Munich: Edition Christian Brandstätter, 1983), 142-55; Werner J. Schweiger, "Kunsthandel der Zwischenkriegszeit in Wien," in *Galerie Würthle: Gegründet 1865* (Vienna: Galerie Würthle, 1995), 20; Werner J. Schweiger, "Your love affair with my paintings: Oskar Kokoschka and his early Viennese collectors," in *Oskar Kokoschka: Early Portraits from Vienna and Berlin, 1909-1914*, exhibition catalogue, Neue Galerie, New York, March 15-June 10, 2002, 61-66. On the Reichel art collection, see Natter, 2003, 251-62; Lillie, 2003, 936-46.

55. Dr. Heinrich Rieger, a dentist by profession, was one of Schiele's most important early collectors; an overview of his work was given at the Autumn Exhibition at the Künstlerhaus in Vienna in 1935. Rieger and his wife, Berta, perished in Theresienstadt Concentration Camp; much of the Rieger collection was never recovered. See Schweiger, 2002, 61-66; "Erbe nach Heinrich Rieger, Wien—Theresienstadt", in Gert Kerschbaumer, *Meister des Verwirrens: Die Geschäfte des Kunsthändlers Friedrich Welz* (Vienna: Czernin Verlag, 2000), 111-29; Stephan Templ, "Die verschwundenen Sammlung," *Der Standard*, March 5, 2002, 30. For an overview of the Rieger collection, see Natter, 2003, 216-24; Lillie, 2004, 968-85.

56. Coll. Provenance Research, Leopold Museum, Vienna. A full provenance report for holdings of the Leopold Museum is available on the Internet: www.leopoldmuseum.at/html/provaktuell.php

57. Leopold Museum, Vienna, Inv. no. 453; Kallir, 1998, No. P 234. The painting originally belonged to Lea Bondy Jaray (1880 Vienna–1969 London), the owner of the prestigious Galerie Würthle in Vienna. In 1938, the gallery was "aryanized" by the art dealer Friedrich Welz. See "Galerie Würthle: Jaray–Welz–Jaray," chapter in Kerschbaumer, 2000, 104-10.

58. Leopold Museum, Vienna, Inv. no. 460; Kallir, 1998, No. P 213. The painting came from the collection of Austrian comedian Fritz Grünbaum (1880 Brno–1941 Dachau). See "Tote Stadt III: Ein Bild

macht Geschichte," in Thomas Buomberger, *Raubkunst—Kunstraub: Die Schweiz und der Handel mit gestohlenen Kulturgütern zur Zeit des Zweiten Weltkrieges*, ed. Bundesamt für Kultur und der Nationalen Informationsstelle für Kulturgütererhaltung (Zurich: Orell Füssli Verlag, 1998), 376 ff.; Tina Walzer and Stephan Templ, *Unser Wien: "Arisierung" auf österreichisch* (Berlin: Aufbau-Verlag, 2001), 98-101; Sophie Lillie, "Die Tote Stadt: Das ungeklärte Schicksal der Kunstsammlung Fritz Grünbaum," in *'Grüß mich Gott!' Fritz Grünbaum*, exhibition catalogue, Austrian Theatermuseum, Vienna, Feb. 16, 2005-April 30, 2005 (publication date: February 2005). An inventory of the Grünbaum collection is included in Lillie, 2003, 428-33.

59. 458th KA, Lot 222, Plate XV.

60. On Gustav Ucicky, see Hubertus Czernin, *Die Fälschung: Der Fall Bloch-Bauer und das Werk Gustav Klimts* (Vienna: Czernin Verlag, 1999), vol. 2, 411f.

61. District Court of Vienna's First District, Probate No. 10 A 343/61, Gustav Ucicky. Appraisal by Hans Enzinger, Oct. 14, 1961. Interior views of the Ucicky apartment are featured in "Wiener Privatsammlung von Werken Gustav Klimt: Die Wohnung des Regisseurs G. Ucicky in der Strudelhofgasse," *Alte und moderne Kunst: Österreichische Zeitschrift für Kunst, Kunsthandwerk und Wohnkultur* 2, no. 2 (March 1957), 13-16.

62. Karl Grünwald (1887 Vienna–1964 USA), was a friend and patron of Egon Schiele, who sold many important works after Schiele's death in 1918. On the Grünwald collection, see Lillie, 2003, 434-37.

63. BDA, Record Group: Restitutionsmaterialien, Personenmappe (PM) Jenny Steiner, fol. 1f. Letter BDA to ÖG, Nov. 16, 1950.

64. BDA, Monika Mayer, "Dossier Jenny Steiner," Letter Klara Mertens to ÖG, Jan. 28, 1951.

65. BDA, Record Group: Restitutionsmaterialien, Box 10: Posse Correspondence, fol. 62, Letter Internal Revenue Office of Vienna's First District to Monuments Office (Zentralstelle für Denkmalschutz), Feb. 12, 1940.

66. BDA, Record Group: Restitutionsmaterialien, PM Jenny Steiner, Receipt Gustav Steiner, Aug. 25, 1949.

67. The collections of the brothers Alphonse and Louis Rothschild were the foundation of the Linz collection. On the Rothschild collections, see Thomas Trenkler, *Der Fall Rothschild: Chronik einer Enteignung* (Vienna: Molden Verlag, 1999); Lillie, 2003, 1,002-010 (Alphonse), 1,112-34 (Louis). On the Linz collection, see Birgit Schwarz, *Hitlers Museum* (Vienna: Böhlau Verlag, 2004).

<div align="right">

From Berlin to Ascona:
</div>

German Collectors in Southern Switzerland, 1920-1950

Esther Tisa Francini

TICINO (also known as Tessin) is the Italian part of sunny southern Switzerland. Since the beginning of the 20th century this area has accommodated a great number of people who were seeking shelter for a variety of reasons, including politically persecuted artists, writers, actors, and collectors. The collectors have been the focus of my research, particularly the effects of National Socialism on the Swiss collecting scene. I would like to find answers to the following questions: Which collectors settled in the southern part of Switzerland? What were their networks and their motives? What kinds of collections did they have? Can traces of German collectors be found in Ticino today?

Collecting Foreign Art in Switzerland

Historically Switzerland lacked an inherent culture of collecting foreign art.[1] Only at the beginning of the 20th century, with the growing popularity of French impressionism, especially in the German-speaking parts of Switzerland, did Swiss collectors start buying foreign works of art.[2] This private initiative laid the way for Swiss museums to begin collecting foreign art after the Second World War.[3]

From Berlin to Ascona

In the 1920s there were several centers of collectors, art dealers, and *maecenas* (art patrons) in Germany. Unlike the modern German cities, Switzerland, especially the canton of Ticino, was rather provincial and unenlightened. A leading cultural centre, Berlin was a metropolis with large and unique collections and an important art trade. This flourishing period ended in the beginning of the 1930s.[4] A global economic crisis forced collectors to sell their artworks; a lot of auctions took place. After the National Socialists took power in 1933, many of the artists living in Berlin emigrated or escaped to Switzerland. Jewish collectors—in danger of losing their livelihoods and in fact their lives—were faced with the problem of saving their property. They were thus obliged to seek ways to transport their art collections out of Germany.[5] Switzerland was close by and politically neutral. Furthermore, in Switzerland there were art dealers and gallery owners that, because of their own experience as emigrants, could help with connections and arrangements.[6] But not everybody fled the Nazis because of persecution; some left Germany to avoid paying taxes, for health and quality of life reasons, or to avoid legal persecution (strafrechtliche Verfolgung).

But why did some of them choose Ascona, a beautiful village in Ticino, as a place of exile? Ascona sits on the bank of Lake Maggiore, near Locarno. It has a lovely boardwalk; magnolias, camelias, almond trees, and tall palms; and the famous Monte Verità (the mountain of truth). At the beginning of the 20th century it was a meeting place for nature lovers, nudists, and purists.[7] Later Ascona became a colony of artists that attracted writers and others. Reasons for

this included Switzerland's neutrality; Ascona's favorable, warm, and invigorating climate; and the village's small size, which automatically turned its residents into a big family.

How did people close to the Nazi regime, such as Eduard von der Heydt, Hans Wendland, and Heinrich Thyssen-Bornemisza, manage to live in the same village as people persecuted by the Nazis, such as Curt Glaser, Erich Maria Remarque, and Max Emden? After reading several biographies it seems clear to me that they managed to live together quite well. Some of them paid visits to each other from time to time, and others probably just ignored each other.[8]

The Collectors

I will give short descriptions of six collectors—three persecuted collectors and three who were close to the Nazis.

Curt Glaser (1879-1943), the well-known Berlin art historian, moved to Ascona in 1933.[9] He had been collecting since 1910 and owned works of art by Kirchner, Beckmann, Matisse, Corinth, and van Gogh. But Munch was his favorite artist. As early as 1929 he sold two Munch paintings; in 1930 he sold others to the Berlin Nationalgalerie.[10] On May 9, 18, and 19, 1933, he was forced to sell a big part of his collection at two different auction houses.[11] None of his important paintings turned up in Ticino, but he managed to bring part of his collection to the Kunsthaus in Zurich between 1935 and 1938; the director of the Kunsthaus, Wilhelm Wartmannm was an admirer and scholar of Munch.[12] In 1939 Glaser brought one more painting to the Kunsthaus with the help of Wartmann.[13] In 1941 he flew to New York.

Between 1939 and 1946 the Kunsthaus purchased four Munch paintings from Glaser or his family. Glaser consigned the paintings he wasn't able to take to Switzerland to his brother Paul, who seems to have sold them, contrary to Glaser's wishes. Curt Riess, a historian of film and theater and author of an important monograph about Ascona, describes Curt Glaser as follows: "One saw him often, one never heard from him. He was reserved and very modest; nobody would have assumed that he is a famous international scholar."[14] Most of Glaser's paintings remained in Germany; some were acquired by the Kunsthaus, which still owns them today; some may have been taken to Glaser's house in Ticino. No paintings from Glaser's collection have been found in Ticino, although there were people there willing to buy art during the war years.

Due to the subject matter of his bestseller *All Quiet on the Western Front* (Im Westen nichts Neues), *Erich Maria Remarque* (1898-1970) was not a popular writer in Nazi Germany. For this reason but also to avoid paying taxes, in 1931 he bought a villa in Ticino, settling in the Casa Monte Tabor in Porto Ronco in April 1932.[15] In 1939 Remarque emigrated to the United States. After the war he resided in both Porto Ronco and New York until his death in 1970.

In 1930, thanks to the sales of his book, Remarque was quite well off and started to collect art. He got to know the Berlin art dealer Walter Feilchenfeldt and the two became close friends.[16] The paintings he purchased in the 1930s hung in his villa in Ticino.[17] Later he transferred some works to New York and after the war exhibited several in the Kunsthaus Zürich.[18] Finally, in 1979 Sotheby Parke Bernet, Inc., in New York sold 28 modern paintings at auction for $3 million.[19]

What was the provenance of his paintings? At the 1979 Sotheby's auction Remarque's collection comprised 13 Degas, two Pissarros, two Daumiers, three Monets, six Renoirs, and two Cézannes. Based on information from auction catalogues, biographies, and people's memories we know quite well from whom he acquired his paintings. A big part of his collection probably originated from "flight assets" (those cultural assets that were transferred to Switzerland by their lawful owners in an attempt to prevent their seizure by Nazi authorities). Three were pur-

chased directly from Feilchenfeldt[20]; others came from Paul Cassirer, Amsterdam, and Helmuth Lütjens, Küsnacht near Zurich—all connected to Feilchenfeldt.[21] In 1940 Remarque bought a lot of paintings from Sam Salz in New York.[22]

But he sold paintings before the 1979 auction as well; these works were also flight assets, for example a van Gogh *Bahnübergang* (Railroad Crossing) from the belongings of Tilla Durieux and Ludwig Katzenellenbogen.[23] Another painting sold by Feilchenfeldt to Remarque was Cézanne's *In der Ebene von Bellevue* (In the Plain of Bellevue), which formerly belonged to Margarete Oppenheim.[24] The details of these transactions should be analyzed more carefully.

Remarque socialized with a wealthy Jewish-German collector who, for personal reasons, had lived in Ticino since 1927.[25] *Max Emden* (1874-1940)[26] bought the Brissago Islands in Ticino, where he settled and built a real palace. In 1939 when the war began and he couldn't live on the islands anymore, he moved to Porto Ronco where he died a year later.

Emden originally had built his collection in his hometown, Hamburg. Due to the Depression, in 1931, Emden sold 54 paintings and 206 pieces of applied arts.[27] We don't know which items he transferred to Switzerland in the 1920s but we do know that he had a *Blumengarten* (Flower Garden) by van Gogh and *L'église de Moret au Soleil* (The Church of Moret in the Sun) on display in the Brissago Islands. There also were Monets, Renoirs, Courbets, and some Dutch paintings. A van Dyck *Madonna mit Kind* (Madonna with Child) was returned from Luzern to Germany via a sale by the gallery Fischer either to the Reichskulturkammer or to Goebbels; we don't know for certain.[28] A Canaletto titled *Zwingergraben bei Dresden* reached the collection of Adolf Hitler via the Gallery Haberstock in 1938.[29]

After the war Emden's son, Hans-Erich, sold both the Brissago Islands and the art objects for very little money.

In 1926 *Eduard von der Heydt* (1882-1964) moved next door to Bernhard Mayer, a Jewish collector who had settled in Ascona. According to Mayer, von der Heydt "was impenetrable. He looked like a Buddha. There was no warmth, even though he was very generous towards artists, many of them Jewish. Nobody [knew] his true attitude."[30]

This is the crucial issue that faces anyone doing research about Eduard von der Heydt: he was a man of many faces so it is impossible to gain one image of him. But we can try to understand at least parts of his personality. Eduard von der Heydt was a dazzling and fascinating banker and collector. In 1926 he bought the Monte Verità in Ascona. In 1929 he co-founded the Association of Friends of the Nationalgalerie in Berlin,[31] and by 1933 his collection was described as outstanding and exceptional. In 1937 von der Heydt became an honorary citizen of Ascona and also received Swiss citizenship. He was widely known as one of the most active sponsors of living artists and managed his collection well. Early on, he took some of his art treasures—some from Germany, some from Holland—to Switzerland, where they were protected from the destruction of the war.[32] His collection of non-European art was preserved in Zurich from 1941 onwards.

In 1946 von der Heydt bequeathed parts of his collection to the city of Zurich. Immediately after the war several loans were spread among 30 to 40 museums worldwide. In 1948 von der Heydt decided to donate parts of his collection to the Wuppertal Museum. A so-called tripartite division of his collection followed: parts went to Wuppertal (1956), the Rietberg Museum in Zurich (1952), and the Canton Ticino, Monte Verità (1956). What remained in Ticino certainly were not the most brilliant pieces in the collection; one might say they represented what was left over. Still, they were of high quality. In 1952 the Rietberg Museum opened and in 1956 von der Heydt received an honorary doctorate from the University of Zurich. Finally in 1961 the Wuppertal Museum was renamed the Von der Heydt Museum.[33]

It is in this museum that three paintings are very much discussed. One of them is a pastel drawing *Memory of a Steamship on the Danube* by Adolph von Menzel, auctioned on Feb. 7, 1939, by Lange. It previously belonged to the collection of Alfred Sommerguth, who had fled to Switzerland.[34] It is unclear whether von der Heydt acquired the piece directly at a "Judenauktion" (Jew auction) or via some other way. Another painting that the museum does not want to restitute is *Felsige Flusslandschaft* (Rocky Riverscape) by Otto Scholderer. It was in the possession of the Jewish factory owner Max Meirowsky, who fled to Geneva in 1938. The painting was auctioned at a 1938 "Judenauktion," where it was acquired by the gallery owner Aenne Abels and then by von der Heydt.[35] Another painting once belonged to Ernst Flersheim; it is *Tatar mit Pferd* (Tatar with Horse) by Hans von Marées.[36]

It is likely that these paintings were kept at the Monte Verità in Switzerland during the war. However, I can only confirm the fact that Switzerland was a shelter for flight assets just as it was for looted assets.

In the years after war, the Allies conducted comprehensive research into Eduard von der Heydt, which did not result, however, in any legal consequences for the eccentric collector. The conclusion was that 2,560 of his works of art were scattered in 69 different places and that more than 700 objects could still be found in Switzerland.[37] However, if you scrutinize the numerous von der Heydt catalogues, it seems that he made only one acquisition during the war. It is a Lovis Corinth painting titled *Rudolf Rittner als Florian Geyer*, 1906.[38] Where this painting came from remains unclear.

Let's talk briefly about *Hans Wendland* (1880-?), a collector and a dealer and who lived in Ticino for a long time.[39] He bought a big estate near Lugano in 1926. In 1931 he sold his Luganese collection in Berlin through Hermann Ball and Paul Graupe. He had acquired parts of the collection in Russia between 1918 and 1920.[40] In 1936 there was another auction at Theodor Fischer in Lucerne; this one only concerned the works of art belonging to Wendland's wife.[41] Wendland moved to Paris in 1933 and returned to Switzerland after the war broke out. In Paris and Switzerland he sold objects to Göring, partly via Hofer.

Wendland was arrested by the Americans in July 1946 in Rome and all his assets in Switzerland were seized. The Swiss clearing authority carried out investigations, yet took no action apart from making voluminous lists of assets and valuables. As yet, items on these lists have not been pursued; it would be worthwhile to conduct some research into the works of art listed there.[42] After all, Hans Wendland is a frequently mentioned character about whom one hardly knows anything—neither about his career after the war nor about the remnants of his collection or his dealers' sources. From a recent publication about heirless assets in Switzerland, we know that Wendland's heirs made claims on his bank account without success.[43] A biography about him would be important not only because he had an interesting international career but particularly because he had a huge network, which could provide many more clues for further research. It could be that Wendland managed to save his assets during the post-war confusion thanks to such a network.

The last collection I would like to highlight was established by *Heinrich Thyssen-Bornemisza* (1875-1947) in the golden years of the 1920s, separate from the collection created by his father August Thyssen (1842-1926). The collection first was shown in 1930 in the Neue Pinakothek Munich as "The Collection Schloss Rohoncz." In 1932 Thyssen-Bornemisza—whose brother Fritz Thyssen was a co-founder of United Steelworks—acquired the Villa Favorita in Lugano. He opened his gallery in 1936. He had been looking for a suitable place of exhibition and found an agreeable location in the south of Switzerland. Thyssen-Bornemisza could see the trouble that the National Socialists would create, and he predicted the war and even the occu-

pation of Holland. He managed to transport almost all of his paintings to Switzerland. The few that were left behind in Holland were lost.[44] The gallery was closed in 1939 and reopened in 1948 by his son, Hans-Heinrich (1921-2002). The collection moved to Madrid in 1992, where it can be viewed today at a wonderful location right across from the Prado.

If you search the various catalogues for information about the Thyssen-Bornemisza collection, you learn that Wilhelm von Bode and Max J. Friedländer were important advisors and that Rudolf Heinemann was the most important dealer. But if you look for provenances, they are hard to find, if at all. The most you will find is the date of the painting's acquisition, not its history.[45]

I could list many more collectors. My aim, however, is not an enumeration but to present single case studies that explain how German collectors functioned in Switzerland between 1920 and 1950.[46] What can we deduce from these case studies?

Traces of German Collectors in Modern Switzerland

Today there are hardly any traces of the collectors mentioned above in Ticino. There is nothing left of the collections once owned by Glaser, Remarque, Emden, and Wendland. Only parts of the von der Heydt and Thyssen-Bornemisza collections are left; they are on display on the Monte Verità and in the Villa Favorita, respectively.

Most of the objects from the collections have left Switzerland (Eduard von der Heydt, Thyssen-Bornemisza) or the collections themselves were dissolved completely (Remarque, Emden, Wendland). Some objects likely are owned privately and therefore not publicly accessible. We can also conclude that in 1939 several collectors emigrated to America, removing their collections from Ticino at the same time. Some collections were returned to Europe, even to Switzerland. But little of the pre-war German collections remain in Ticino today, for various reasons, and must be reconstructed. Today, the three most important Ticino museums show works of artists who have lived in Ticino or works that are owned by the families of collectors who live in Ticino.[47]

What is so exciting about looking for traces of German collectors in Ticino? Such research results in the reconstruction of the lost collections at the center of provenance research. Switzerland plays a crucial role—the entire country, not just the collections deposited in Ticino or the collectors who lived in Ticino (who may even have deposited their paintings in other places, such as Glaser did with the Kunsthaus in Zurich). A manual about collections in exile in Switzerland still needs to be written and I am sure that new information can be found. It is clear that not all the collections have been investigated or discovered.

Just as important as the reconstruction of lost collections is the documentation of their history. This is particularly true of objects owned by Jewish collectors, which—in contrast to those owned by collectors close to the Nazi regime—hardly can be traced in their entirety. Most Jewish collections were torn apart; various parts were auctioned and sold in Switzerland, or taken to America, or remained in Germany. We realize that knowledge about Jewish collections is broader than knowledge about collections owned by Germans with ties to the National Socialist administration, such as von der Heydt, Wendland, and Thyssen-Bornemisza.

Let me conclude by emphasizing two points: It is not sufficient to know the name of a particular collector to know the fate of his collection. Most collections that changed hands during the war years—especially those belonging to Jewish collectors——had highly complicated histories that still need to be researched in detail.

Notes

1. Huggler, Max, "Die europäische Kunst in den Schweizer Sammlungen," in *Chefs-d'oeuvre des collections suisses de Manet à Picasso*. Catalogue officiel, Exposition nationale suisse, Lausanne, 1964.

2. Lukas, Gloor, *Von Böcklin zu Cézanne. Die Rezeption des französischen Impressionsitmus in der deutschen Schweiz*, Bern/Frankfurt/New York 1986. See also Dorothy Kosinsky/Joachim Pissarro/Maryanne Stevens, *From Manet to Gauguin, Masterpieces from Swiss Private Collections*, Royal Academy of Arts, London, June 30-Oct. 8, 1995.

3. Huggler, Max, "Die europäische Kunst in den Schweizer Sammlungen, 1964. Tisa Francini, Esther, *Der Wandel des Schweizer Kunstmarkts in den 1930er– und 40er Jahren. Vorausset zungen und Folgen einer internationalen Neuordnung*, Traverse 2002/1, Zeitschrift für Geschichte, pp. 107-23.

4. Max J. Friedländer, *Erinnerungen und Aufzeichnungen*, Main und Berlin, 1967.

5. Adriani Götz, *Cézanne Gemälde. Mit einem Beitrag zur Rezeptionsgeschichte von Walter Feilchenfeldt*, Köln 1993, p. 306.

6. Tisa Francini, Esther, *Der Wandel des Schweizer Kunstmarkts in den 1930er- und 40er Jahren*, pp. 107-23.

7. See also Tobias Engelsin, Die Erfindung des Tessin, *Die Zeit*, Sept. 2, 2004, no. 37.

8. Descriptions of this period in Ascona include, among others, Swiss collector Han Coray who, although he left Ascona, was a Dadaist with connections to many artists and personalities (Rudolf Koella, *Die Leben des Han Coray*, Zurich, 2002); Bernhard Mayer, one of the soon to be described collectors (Bernhard Mayer: *Interessante Zeitgenossen. Lebenserinnerungen eines jüdischen Kaufmanns und Weltbürgers 1866-1946*, Konstanz, 1998); and Wolfgang Oppenheimer (Wolfgang Oppenheimer, *Das Refugium. Erinnerungen an Ascona*, München, 1998). There are also other biographies, monographs, and catalogues documenting this time (Curt Riess, *Ascona, Geschichte des seltsamsten Dorfes der Welt*, Zürich, 1977 [1. Auflage 1964]; Robert Landmann, *Ascona–Monte Verità. Auf der Suche nach dem Paradies*, Frauenfeld/Stuttgart/Wien, 2000).

9. Riess, *Ascona*, 1977, p. 127. Glaser was born in Leipzig in 1879. He studied medicine but abandoned this for art history with, among others, Heinrich Wöfflin. His 1907 doctorate was on the topic of Hans Holbein. His wife Elsa Kolker (d. 1932) was one of the most elegant and renowned hostesses in the Berlin art world. In 1907 Glaser became a curator at the Kupferstichkabinett in Berlin, in 1924 director of the Staatlichen Kunstbibliothek. In 1933 he lost his position on the basis of the Wiederherstellung des Berufsbeamtentums law. He emigrated to Ascona and from there to Italy. In 1941 he emigrated to New York, where he married again. He died in 1943. Glaser was an author at Bruno Cassierer, directed the important research for the scholarly journal *Kunst und Künstler* (1902-33), and was a specialist in Asian art.

10. Schmidt-Burkhart, *Glaser*, 1988, p. 71.

11. Internationales Kunst- und Auktions-Haus, May 9, 1933; Max Perl, May 18 and 19, 1933.

12. Tisa Francini/Heuss/Kreis, *Fluchtgut*, 2001, p. 168.

13. Tisa Francini/Heuss/Kreis, *Fluchtgut*, 2001, p. 169.

14. Riess, *Ascona*, 1977, p. 127.

15. Riess, *Ascona*, 1977, pp. 120-24.

16. Riess, *Ascona*, 1977, pp. 168 -71; Feilchenfeldt, *Bilder*, 2001, p. 122.

17. Wilhelm von Sternburg, "Als wäre alles das letzte Mal," *Erich Maria Remarque*, biographie, Köln 1998 (1. Auflage 1996), pp. 196f. and 234.

18. See *The Paulette Goddard Remarque Collection of Impressionist Paintings, Pastels and Drawings, Wednesday, November 7, 1979*, Sotheby Parke Bernet Inc., New York: nos. 513, 514, 519, 520, 527, and 528. Thanks to Jasper Sökeland at Sotheby's London for copies of the catalogues.

19. www.remarque.uos.de/bio.htm (Nov. 8, 2004).

20. Edgar Degas, *Danseuse vue de profil*, no. 504); Pierre-Auguste Renoir, *Portrait de fille*, no. 524, and *Jeune Femme en torero, joueur de mandoline*, no. 525.

21. Edgar Degas, *Danseuse vue de dos*, no. 506, Edgar Degas, *Degas en gilet brun*, no. 512, Honoré Daumier, *Homme debout (L'amateur)*, no. 516, Claude Monet, *Venise, Le Palais Ducal*, no. 519), Pierre-Auguste Renoir, *Jeune Femme du moulin de la galette*, no. 521.

22. Edgar Degas, *Miss Lala au cirque Fernando*, no. 507), Edgar Degas, *Deux Danseuses en repos*, no. 508, Edgar Degas, *Deux Danseuses*, no. 510), Camille Pissarro, *Jardin du louvre effet de brume*, no. 514), Claude Monet, *Effet de brouillard près de Dieppe*, no. 518, Claude Monet, *Venise, le Palais Ducal vu de San Giorgio*, no. 520), Pierre-Auguste Renoir, *Jeune fille blonde*, no. 522), Paul Cézanne, *Paysage en Provence*, no. 527), and Paul Cézanne, *Auvers : Le quartier du Val Harme*, no. 528.

23. Tilla Durieux, *Meine ersten neunzig Jahren: Erinnerungen, Die Jahre, 1952-1971*, reprinted by Joachim Wener Preuss, Frankfurt am Main/Berlin, 1991, p. 338; Feilchenfeldt, *Bilder*, 2001, p. 124. These two collectors—she was the ex-wife of Paul Cassirer,—were also in Ticino in 1933 and in need of money for their further emigration. (See the biography of the son of Ludwig Katzenellenbogen: Konrad Kellen, *Katzenellenbogen. Erinnerungen an Deutschland*, Vienna, 2003. In exile in America, Konrad Katzenellenbogen changed his name to Kellen.

24. Götz, *Cézanne Gemälde*, 1993, p. 312; Rewald-Werkkatalog, no. 715. Margarete Oppenheim had collected modern art since 1904, in collaboration with Paul Cassirer. Her collection became one of the most important in Germany. After her death, the collection was sold in 1936 at Julius Böhler in Munich; one part was sold by Walter Feilchenfeldt in Zürich. (www.ghwk.de/sonderausstellung/villenkolonie/oppenheim.htm, (Nov. 8, 2004).

25. Sternburg, *Remarque*, 1998, p. 234.

26. Riess, *Ascona*, 1977, pp. 97-107, here without reference to the art collection.

27. *Die Sammlung Dr. Max Emden-Hamburg: Gemälde Deutscher und Französischer Meister des 19. Jahrhunderts, Möbel, Teppiche, Bronzen, Deutsches Silber, Fayencen*, Berlin: Hermann Ball/Paul Graupe, June 3-8, 1931. I thank Dr. Ute Haug, Hamburger Kunsthalle, for checking the catalogue for me.

28. Tisa Francini/Heuss/Kreis, *Fluchtgut*, 2001, p. 145, n. 453.

29. Tisa Francini/Heuss/Kreis, *Fluchtgut*, 2001, p. 231.

30. Wolfgang Oppenheimer, *Das Refugium, Erinnerungen an Ascona*, Munich, 1998, p. 26.

31. Mayer, Andrea, *In guter Gesellschaft: Der Verein der Freunde der Nationalgalerie Berlin von 1929 bis heute*, Berlin 1998 (Bürgerlichkeit, Wertewandel, Mäzenatentum, Bd. 3).

32. Oppenheimer, *Refugium*, 1998, S. 176.

33. Information from Sabine Fehlemann, Mäzenatentum mit Stil: August und Eduard von der Heydt, in *Von Marées bis Picasso: Meisterwerke aus dem Von der Heydt-Museum Wuppertal*, Ascona/Bern 1986.

34. Stadtarchiv St. Gallen. 6/3/450. XVIII. d) Leihgaben von a. Reg.-Rat Sommerguth. Sommerguth and his wife fled to Cuba in 1940. Some of the works of art of their collection were sold by Fritz Nathan, e.g., Pissarro's *Boulevard Montmartre in Paris* as well as Hodler's *Thunersee* and *Aarekanal*. They not only deposited their works of art in the art museum of St. Gall, but also in the duty-free office. Nathan sold also the paintings *Hühnerhof* by F. von Lenbach as well as *Herrenbildnis* (Aquarell) by Franz Krüeger. The remaining goods belonging to Sommerguth were embargoed as German assets and liberated again in May 1946 (Stadtarchiv St. Gallen. 6/3/450. XVIII. d) Leihgaben von a. Reg.-Rat Sommerguth). See also Krummenacher, Jörg, *Flüchtiges Glück. Die Flüchtlinge im Grenzkanton St. Galen zur Zeit des Nationalsozialismus*, Zürich 2005, p. 55.

35. Thomas Binger, Wuppertal: Unter Räubern, www.klick-nach-rechts.de/ticker/2004/03/wuppertal.htm, July 13, 2004).

36. See Wolfgang Kohrt, *Bilder aus Wuppertal*, Berliner Zeitung, 27.7.2004.

37. Bondesarchiv Bern, E 2001 (E) 1969/262, B. 9, Bericht zu Handen des EPD in Bern über die Untersuchungen der SVSt im Spezialfall Nr. 277/Baron Ed. von der Heydt, Dr. Gisevius, Dr. Josef Steegmann, Bank für Anlagewerte etc., o.D

38. Charlotte Berend-Corinth, *Die Gemälde von Lovis Corinth*, Werkkatalog, München 1958, Nr. 327.

39. He was an art historian with a Ph.D. from Berlin in 1906; after 1910 he worked as an independent art dealer. In 1918, he worked as an attaché of the German Embassy in Moscow. In 1920 he got to know Karl Haberstock and Theodor Fischer. These acquaintances coincide with his setting up his offices in Basel in 1920. In 1922 he got acquainted with Walter Andreas Hofer. In the 1920s he was a close business partner of Karl Haberstock until business quarrels ended the friendship in 1927.

40. See the catalogue *Sammlung Dr. Hans Wendland, Lugano* by C. F. Feerster, Berlin: Hermann Ball and Paul Graupe, 1931.

41. Nachlass Frau Dr. Wendland, Bissone. Mobiliar Schloss Chardonne. Berner und Luzerner Patrizierbesitz. Museums- und diverser Besitz, Auktionskatalog Nr. 51, Galerie Fischer Luzern, 1936 (Auction in Zürich).

42. Bundesarchiv Bern, E 7160-07 (-) 1968/54, Bd. 1087: List 1: "List of valuables, suspected to be looted goods by Dr. Wendland"with 111 works of art, primarily Old Masters, but also paintings by Amiet, Toulouse-Lautrec, and others. List 2: "List of valuables with known location in Switzerland, of which Dr. Hans Wendland has the right of co-possession," with approx. 60 works. List 3: "List of valuables of Dr. Hans Wendland, which were deposited in Switzerland at the time of the embargo and whose place of location is not known by us or cannot be defined by with certainty," with a little more than 100 objects. List 4: "List of valuables of Dr. Hans Wendland with well-known location in Switzerland," approx. 60 works, some of them at Fischer's, Lucerne; at Natural Lecoultre's, Geneva; or at Wendland's, Versoix; also deposited at Zürcher Kantonalbank and A.G. Bronner & Co. in Basel. Finally Dr. Rudolf Kaufmann has evaluated the paintings again and registered them on a list with almost 500 items.

43. Thomas Maissen, *Verweigerte Erinnerung: Nachrichtenlose Vermögen und Schweizer Weltkriegsdebatte 1989-2004*, Zürich 2005, p. 472.

44. Roman Norbert Ketterer, *Dialoge*. Stuttgarter Kunstkabinett, Moderne Kunst, Stuttgart/Zürich 1988, p. 183.

45. Sixtieth anniversary of the Picture Gallery at the Villa Favorita. Masterworks from the Carmen Thyssen-Bornemisza Collection, Lugano, Sept. 5-Nov. 2, 1997, Milan.

46. A German-Jewish chemist and former professor at ETH Zurich, Richard Willstätter (1872-1942), fled to Ticino at the beginning of March 1939. He lived in Locarno until his death in 1942 (Tisa Francini/Heuss/Kreis, *Fluchtgut*, 2001, p. 90; Riess, *Ascona*, 1977, p. 127). Willstätter owned an art collection as well but he had to leave most of it behind in Germany. His collection can be considered a flight asset. Willstätter describes his collection in his memoirs, *Aus meinem Leben*, Weinheim, 1958 (1. Auflage 1949), z.B. S. 367-77). In addition to Feilchenfeldt's role, research about the role of Wladimir Rosenbaum would be interesting. He was dealer and lawyer and of importance at the time (Riess, *Ascona*, 1977, S. 143–150. See also Peter Kamber, *Geschichte zweier Leben: Wladimir Rosenbaum, Aline Valangin*, Zürich 2002 (3. Auflage).

47. 1. Museo d'arte comunale in Ascona: Location of two foundations, one by Marianne von Werefkin (1860-1938) and one by Ulli und Richard Seewald (1896-1976). The museum was esablished in 1922 by a number of artists. Marianne von Werefkin donated several pictures, among them works by Alexey Jawlensky, Cuno Amiet, and Paul Klee. The most important elements in the museum are the works by Werefkin with over 80 paintings and 170 sketch books. 2. The Museo d'Arte Moderna in the Villa Malpensata in Lugano was owned at the end of the century by a family of collectors in Ticino called Caccia. It has displayed modern art since 1950 but has very little concerning German collectors in Ticino. Its collection consists mainly of works gathered by Ticino collectors. 3. Museo Cantonale d'Arte in Lugano has been the repository various loans since 1987 (i.e., very late), and most probably has nothing concerning with German collectors.

Provenance Research at the Sprengel Museum, Hanover:
The Margrit and Bernhard Sprengel Collection, 1934-1945

Vanessa-Maria Voigt

IN AUGUST 2002, the Sprengel Museum in Hanover decided to comply with the Washington Conference Principles of 1998 and the joint German "Statement by the Federal Government, the Laender, and the National Associations of Local Authorities on the Tracing and Return of Nazi-Confiscated Works of Art, Especially from Jewish Property," made the following year. A temporary post was created at the museum within the framework of a doctoral scholarship, its chief aim being to reconstruct the early collection of Margrit and Bernhard Sprengel and then to research the provenance of the individual works of art.

History of the Collection

Between 1934 and the end of the Second World War, Margrit and Bernhard Sprengel acquired almost 600 works of German expressionism, which in those years had been banned as "degenerate." Their collecting activity was focused primarily on the works of Wilhelm Lehmbruck and Emil Nolde.

What inspired this young married couple to build a collection of contemporary art? More than anything else, it was their visit to the propaganda exhibition of "Degenerate Art" in Munich in the late summer of 1937. Contrary to the intentions of the exhibition organizers, the Sprengels were fascinated by the artworks on display, above all by those of Emil Nolde, whose work they had never seen before. Their acquisition, immediately following their visit to the exhibition, of two of Emil Nolde's watercolors from Günther Franke's Graphisches Kabinett marks the beginning of their collection.[1] During the years up to the end of the war, and in opposition to the official cultural policy of the Nazi government, the couple succeeded through constant correspondence and personal contact with artists, collectors, and leading art dealers in building a substantial collection of modern art. In so doing, they "assum[ed] a significant culture-preserving function at a time when even the very existence of art was jeopardized."[2]

For Bernhard Sprengel—born in Hanover in 1899, the first son of chocolate manufacturer August Sprengel and his wife Elisabeth—music and art were indispensable parts of life. Strongly influenced by his father, who was a passionate collector of the works of Carl Spitzweg, Wilhelm Trübner, Anselm Feuerbach, and Carl Schuch, he purchased his first Rembrandt etching in 1923 while still a law student. He also regularly visited exhibitions, including those of Wilhelm Lehmbruck and Hans von Marées in the Glaspalast in Munich.

Sprengel had taken his first steps toward collecting modern art before he married his second wife, the violinist Margrit Backhausen; he had acquired a sculpture and two charcoal drawings by Georg Kolbe from the Nierendorf Gallery in Berlin three years before. Immediately after purchasing the two Nolde watercolors from Franke in 1937, the Sprengels approached Josef Nierendorf, who had been running his Berlin gallery on his own since his brother Karl's emi-

gration in 1936. Nierendorf still was selling to selected clients works of modern art that had been suppressed by the Nazis as "degenerate." Before the end of 1937, he sold the Sprengels their first Wilhelm Lehmbruck sculpture, *Little Pensive One*, previously owned by Anita Lehmbruck, for the price of 4,500 Reichsmark; two watercolors by Lyonel Feininger; and other works.[3] The couple continued to buy from Nierendorf regularly for the next three years, purchasing works by Carl Hofer, Wilhelm Lehmbruck, Christian Rohlfs, Erich Heckel, Gerhard Marcks, Georg Kolbe, Emil Nolde, Emy Roeder, and Franz Marc. The purchases ended only when Nierendorf was called up for military service.

Besides Franke and Nierendorf, Hamburg art dealer Dr. Hildebrand Gurlitt and Berlin art dealer Hanns Krenz also played an important part in the development of the Sprengel collection. With Karl Buchholz, Bernhard A. Böhmer, and Ferdinand Möller, Gurlitt officially was entrusted with the sale of "degenerate art" confiscated from German museums to overseas buyers for foreign currency. He sold the Sprengels numerous works of art from their place of storage in Schloss Niederschönhausen between the years 1940 and 1942. These included 409 prints and two watercolors by Emil Nolde, confiscated from the Museum Folkwang in Essen in August 1937; another watercolor by Nolde originally owned by the Landesmuseum in Oldenburg; and the painting *Bed of Tulips* from the Städtische Kunsthalle Mannheim.

In their search for a suitable landscape by Emil Nolde, Margrit and Bernhard Sprengel, through the offices of a good friend, approached Hanns Krenz, the Berlin book and art dealer. Krenz had been the artistic director of the Kestner-Gesellschaft in Hanover from 1923 until 1930 and had long embraced the cause of contemporary art.[4] Though the Sprengels' inquiry concerning a landscape came to nothing in the end, thanks to his personal acquaintance with Emil Nolde, Krenz was able to sell the Sprengels five watercolors by the artist as well works by Käthe Kollwitz and Ernst Barlach.

The Sprengels' regular purchases of works of art, especially those by Emil Nolde, ultimately led to an invitation from Ada and Emil Nolde to their home in Seebüll on the north German coast in 1941. This meeting, which had been arranged by Günther Franke and Hanns Krenz, marked the beginning of a deep friendship between the Noldes and the Sprengels, one characterized by great mutual respect and support. Margrit and Bernhard Sprengel profited a great deal from this friendship, not only from the discussions on art but also from the privilege of being able to acquire works directly from Nolde. The Sprengels, for their part, were able to advise this officially defamed artist on legal matters—especially regarding the confiscation of his works and the fact that he had been forbidden to paint by the Nazi regime—and soon were involved in questions concerning Nolde's will and the possibility of establishing a foundation.

Fearing confiscations of the works in Nolde's private possession, the young couple hid the major part of the artist's collection, using their weekend house on Steinhuder Lake, not far from Hanover, and other hiding places in Bavaria and the Harz. Through their close friendship with Ada and Emil Nolde and also their regular contact with art dealers and business friends, the Sprengels also were able to locate other collectors of contemporary art. Their systematic search resulted in a great many additional acquisitions from private collections. After paying a personal visit to the collector Martha Rauert in Hamburg in 1938, for example, the Sprengels acquired two paintings by Emil Nolde: *Rough Sea II* and *Still Life with Burmese Dancer*.

Although the art of Emil Nolde was central to their collecting activity at that time, Margrit and Bernhard Sprengel also collected the works of a great many other artists before the end of the war. The list includes such famous names as Karl Hofer, Lovis Corinth, Christian Rohlfs, Otto Mueller, Franz Marc, Karl Schmidt-Rottluff, Josef Scharl, Lyonel Feininger, Erich Heckel, Käthe Kollwitz, Gerhard Marcks, Alfred Kubin, Emy Roeder, and—in the field of sculpture—

Ernst Barlach, Wilhelm Lehmbruck, Karl Knappe, and Georg Kolbe.

In conclusion it may be said that, between 1934 and 1945, and mostly in disregard of the prevailing laws and with the aid of a surviving network of artists, collectors, and dealers, Margrit and Bernhard Sprengel succeeded in building up an extensive collection of works of German expressionism that had been branded as "degenerate art" by the Nazi regime. The assembly of this collection of so-called degenerate works of art testifies to the existence of a well-functioning art market and a wide network of connections among artists, art dealers, and collectors in Germany, even under the repressive rule of the National Socialists.

Notes

1. Margrit and Bernhard Sprengel purchased the following works from Günther Franke's Graphisches Kabinett: Emil Nolde, *Snow Mountains (Bernese Oberland)*, c. 1932—watercolor on Japanese woodcut paper, 36.5 x 46 cm; signed bottom left: Nolde. Provenance: Graphisches Kabinett Günther Franke, Munich; Bernhard Sprengel, Hanover (1937); sold through Stuttgarter Kunstkabinett, 34th auction (1959); present whereabouts unknown. Emil Nolde, *Tiger Lilies and Iris*, c. 1935—watercolor on Japanese woodcut paper, 35 x 46 cm; signed bottom right: Nolde. Provenance: Graphisches Kabinett Günther Franke, Munich; Bernhard Sprengel, Hanover (1937); sold through Stuttgarter Kunstkabinett, 37th auction (1962); present whereabouts unknown.

2. Ulrich Krempel, "Zur Geschichte der Sammlung Sprengel, 1937 bis 1945," in Markus Heinzelmann and Ulrich Krempel, *Emil Nolde und die Sammlung Sprengel 1937 bis 1956. Geschichte einer Freundschaft*, exhibition catalogue, Sprengel Museum Hannover, 1999, p. 37.

3. In a letter written to Josef Nierendorf dated Nov. 22, 1937, Bernhard Sprengel confirmed his purchase of the watercolors *Barque* (1930) and *Summer's Day* (1932) by Lyonel Feininger, which had been sent to him on approval. Private estate of Bernhard Sprengel.

4. Letter from Dr. Bernhard Sprengel to Hanns Krenz, April 23, 1941. Private estate of Bernhard Sprengel.

New Research on a Collector:
Alphonse Kann and Michael Stewart

Madeleine Korn

THE NAME Alphonse Kann has become, in the past few years, synonymous with provenance research and spoliation claims. Establishing the provenance of works once in Kann's collection, seized from his home in St. Germain-en-Laye in 1940, has become a problem for curators in institutions all over the world.

Two factors have become important in establishing the true ownership of these works: first, locating Kann's papers, which were believed to include correspondence relating to the restitution of his collection after 1945,[1] and second, reconstructing Kann's second collection of masterpieces, kept in his home in London, Flat A, 5 the Albany, at the time of his death in 1948.[2] While most of the paintings were in London before the outbreak of the war, it is possible that at his death the collection in London also included works returned to Kann after 1945 but whose return is not recorded in their provenance.

All Kann's property in England and Portugal—including, it is believed, his papers—was bequeathed not to Peter Pitt-Millward, his long-term partner, but to Michael Stewart, a stranger whom, by all accounts, Kann met in the last few years or even months of his life. However, Stewart, his family, and the papers have continued to elude researchers. This essay, the result of a joint research project supported by the Tate in London and the Pompidou Centre[3] in Paris, chronicles my attempt to trace Stewart and Kann's papers.

How do you find a man last seen on a plane to Portugal some 50 years ago?[4] Stewart's age was not known; neither was whether he was living or dead. John Richardson remembered Douglas Cooper saying that there was "some sort of young butler" living in Kann's flat at the Albany and that he had assumed this was Stewart.[5] This meant that in 1948 Stewart could have been as young as 17 or 18 and, therefore, only in his late 70s now.

My first port of call was the archives of the dealer Arthur Tooth, as I already knew that Stewart had sold two Cézannes through Tooth in the 1950s. The archives now are owned by Simon Matthew, Tooth's grandson. The main stock books have never been copied and still can be seen only at Matthew's home in London.[6] The Tooth records showed that Michael Stewart sold 12 paintings through the gallery between 1951 and 1959 (see figure 1). The Tooth photographic albums noted alongside each of these images that the works had been in Alphonse Kann's collection, leaving no doubt as to their provenance.

Although I searched for records of Stewart at the Wills and Probate Principal Registry of the Family Division in London, I drew a blank.[7] Nothing looked immediately likely and, as I have already noted, I did not even know if Stewart was dead.[8] One of the greatest problems in trying to trace Stewart himself, besides establishing whether he was alive or dead, was that no one was clear about his correct name. He is recorded simply as Michael Stewart in the Tooth archives and the entry in the Cézanne catalogue raisonné for *The Temptation of St Anthony*, c. 1870 (Sammlung E.G. Bührle, Zurich).[9] A search at the Courtauld Institute library, which keeps a

Figure 1: Works sold by Michael Stewart through Arthur Tooth

DATE SOLD	ARTIST	TITLE OF PAINTING	YEAR PAINTED	PRESENT WHEREABOUTS	REFERENCE
1951	Matisse	*Les Glaieuls*	1928	Private Collection, New York	
1951	Matisse	*Fenêtre sur le jardin*	1919	MOMA, New York	
1951	Manet	*Jeune femme voilée — Berthe Morisot*	1872	Private Collection	JW207
1951	Corot	*Paysage Breton*	c. 1840	R.A. Vestey	ROBAUT477
1952	Cezanne	*Jeune fille à la poupée*	c. 1896	Berggruen Collection	R806
1952	Renoir	*Portrait of Mme Henriot*	1916	Christie's, Tokyo, 27 May 1969, lot 297	
1952	Renoir	*Le Thé**	1916	Takashima, Japan	
1953	Degas	*Femme nue*	1896	Private Collection	L1233
1955	Van Gogh	*Still Life with Thistles*	1890	Private Collection, Canada	F599
1955	Cézanne	*The Temptation of Saint Anthony*	c. 1870	Sammlung E.G. Bührle, Zurich	R167
1956	Renoir	*La Source*	1910	Present whereabouts unknown	
1959	Courbet	*Portrait of Madame Boreau*	1862	Art Institute of Chicago	

* The sale was possibly not made through Tooth in the end but through Alex Reid and Lefevre or Agnews.

card index system of auction sales by name, revealed two sales under the name of "J. Michael Stewart."[10] The first sale[11] contained three drawings by Stanley Spencer that had been record-ed at Tooth's as being sold to Stewart, and the second[12] included a 16th-century Netherlandish painting and a Flemish painting dated c. 1490, both giving Kann's name in their provenance.

My lucky break came as I was checking the Stanley Spencer catalogue raisonné.[13] Stewart had loaned the oil, *Christ Rising from the Tomb*, 1954 (private collection), to the Worthing Art Gallery in 1961.[14] The exhibition catalogue said that the work was loaned by "Michael C. Stewart." This was definitely the same person, as he also loaned the three drawings acquired from Tooth.[15] Fortunately, Worthing Art Gallery must be one of the few places that still has files that have not been destroyed by flood or fire or simply disposed of, and just two phone calls later the staff was able to tell me that they had Stewart's address at the time of the exhibi-tion as 13 Montagu Square, London, W1.

By checking the electoral register in London, I was able to find that J. Michael Stewart was lived at 13 Montagu Square just for the year 1962. No one was recorded as living with him at that address. The British Telecom Archives in Holborn, London, which keeps the telephone directories for the country since 1880, showed that a J. M. C. Stewart lived for just one year at Montagu Square. While checking the electoral register for the Montagu Square address I also

looked up the Albany. A John Michael Stewart was listed as living at Flat A, 5 the Albany in 1948.

At this point I had a Michael Stewart in the Tooth records; a J. Michael Stewart in the Sotheby's sales catalogue; a Michael C. Stewart lending works to Worthing Art Gallery; a J. M. C. Stewart in the British Telecom records; and a John Michael Stewart on the electoral register at the Albany in 1948.

Armed with all these different versions of Stewart's name, I started to trawl the Family Records Office of Births, Marriages, and Deaths. Believe it or not, I finally found a match to a death certificate that used all three initials.[16] Using these same records, I also found that Stewart had been married three times and had six children, though unfortunately he was no longer alive. The members of the families from his second and third marriages that I have met have been extremely helpful and, although they ask that we respect their privacy, with their permission I am at liberty to pass on what they told me.

John Michael Campbell Stewart was born on March 31, 1918, in Hammersmith, London. He married his first wife, Esme Scott, a childhood sweetheart, just before the Second World War and had a son from this marriage.[17] In 1939 Stewart joined the Navy. He became a diver and served in Burma on secret missions. It is believed that, as a result of this, he suffered a nervous breakdown at the end of the war and was admitted to Netley, a military hospital in England.

He met his second wife, Ann, in early 1949 through a couple named the Vaizeys. Gillian Vaizey had had a number of miscarriages and had stayed at a nursing home in Sheen that Stewart's mother owned at that time. Ann met Gillian on a secretarial course. The Vaizeys had a cocktail party and invited both Ann and Stewart.[18] I have learned little about Stewart's father. His occupation is recorded as a post office clerk on his son's birth certificate but he must have moved on from this as he became fairly prosperous, living in a large house in Wales. According to newspaper coverage during Stewart's second divorce, when he was 12 or 13 his father committed suicide in front of him, causing him great anguish in later life.

A photo of Stewart taken by Lotte Meitner-Graf in the 1950s portrays a dashing and handsome man in his 30s. By all accounts he was still in the Navy, or at least in uniform, when he met Kann. It is still unclear just how or when they met. Susan Davidson, who has worked a great deal on Kann and his collection, suggests that they may have met through Stewart's mother as Kann was in the London Clinic just before this time.[19]

Stewart was not recorded as living at the Albany with Kann on the electoral register drawn up in June 1947 but is shown on one a year later, dated June 1948.[20] On Jan. 9, 1948, Kann changed his will in favor of Stewart, less than a year after Stewart had moved in. Kann died some eight months later, leaving an estate valued at £80,000[21] as well as some property in England and Portugal to Stewart.[22]

By the time Stewart met Ann in 1949, he was living at the Albany and Kann was dead.[23] Ann's impression of Kann from Stewart was that Kann was a dilettante; in Ann's words, "he was an Edwardian gentleman."[24] This fits with the known view of Kann's cultured life.[25] Ann believes that Stewart was a secretary-companion to Kann and became his protégé, with Kann teaching Stewart things such as the rules of etiquette. She says that "Michael was devoted to old Kann—Kann was very good to him."[26]

Ann visited the Albany several times and had dinner there. She remembers a large living room, dining room, and at least one bedroom and bathroom but suspected that there were more bedrooms. The paintings were "absolutely floor to ceiling—in tiers."[27] She remembers classical busts—she thinks one was of Marcus Aurelius. It was "quite an overwhelming place" she recalls.[28]

Stewart moved from the Albany to an apartment at 98 Eaton Place, London, in May or June 1949.[29] Most things went from one place to the other, according to Ann. She and Stewart were not married until January 1950 as he needed to obtain a divorce from his first wife.[30]

After Kann died, his former partner, Peter Pitt-Millward, claimed the property in Portugal and a number of paintings.[31] Ann was not aware of the case brought by Pitt-Millward. She knew of "a Kann connection" to him and that he lived in Portugal, where her family also had a home, but nothing more than that. She also knew that Stewart occasionally sold a painting, and she remembers him saying that he should not have sold them, as the heirs, a niece and nephew in Paris, were contesting the will.[32] In her opinion, however, there was no animosity between her husband and the heirs, as they came to London and met and dined with the Stewarts.

In 1953 the Stewart family moved to Underdown Manor in Herne Bay, Kent. With Kann's money, Stewart became an archaeologist, specializing in Central America.[33] Most of his work was in Belize in British Honduras, where he worked on a number of sites. These digs were all self-financed. In his absence, Albert Peek, a clerk from Vandercom Stanton, Kann's solicitors, gave Ann money for living expenses on a regular basis. Indeed, from accounts given by both families, it looked as if Peek controlled the dispersal of Kann's money and that Stewart needed Peek's permission before he could spend any of it. However, Kann's will shows that Stewart received all the property and money in one go. For reasons I have been unable to discover, Stewart chose to have this money paid over piecemeal so that it appeared to his family as if the money had been left in trust and could only be paid out with the solicitor's approval. Peek took a great personal interest in Stewart, according to Ann, encouraging him to buy the house in Herne Bay. Ann is sure that Peek would have dealt with the insurance of the paintings and says that he was quite "miffed" that Stewart had sold certain things, again suggesting that they were held in trust and were not his to sell.

There survives just one photograph of the home in Eaton Place.[34] This shows Stewart's eldest daughter, Fionna, standing with her mother, Ann, next to a painting by van Gogh, *Still Life: Vase with Thistles*, 1890 (private collection, Canada). In the top left of the photo is another painting, *Still Life with Oysters*, c. 1726 (private collection) by Chardin. This same work appears in a photo of Kann's home in St. Germain-en-Laye. Although most of the works left to Stewart were in Kann's London home before the war, this work appears in a photo of the house in Paris. What is not known, however, is the date the photo in France was taken. The work may have been sent over just before the war.[35]

The only paintings left to Stewart that are known to have been seized by the Nazis from Kann's home in France are Matisse's *Les Glaieuls*, 1928 (private collection, New York), and *Fenêtre sur le jardin*, 1919 (Museum of Modern Art, New York). [See figure 1.] A letter dated Dec. 5, 1945, from Matisse to Kann is in the Tooth archives in an album of Matisse photos. The letter is marked "COPY" and has a handwritten addition at the end, above Matisse's name. The staff at the Matisse archives in Paris have concluded that the copy at Tooth's was taken from the original letter in Kann's hands and not from the copy retained by Matisse (and still at the archives), which does not have the additional anecdote Matisse added by hand. It also proves that Stewart had access to at least some of Kann's papers in the 1950s, when he sold this Matisse through Tooth, and may suggest that at that time he had all of Kann's papers in his possession.

The *Fenêtre sur le jardin* was in Matisse's hands in Paris in December 1945 when he wrote a letter to Kann saying that he was sending the painting to London for the Picasso-Matisse show at the Victoria and Albert Museum.[36] *Fenêtre sur le jardin*, 1919, was no. 23 in the exhibition and is recorded as lent by the artist in the list of loans in the "Inventory of Loans" register in the

Vincent van Gogh, Dutch, 1853-90. *Mulberry Tree*, 1889. Oil on canvas. Norton Simon Art Foundation; gift of Mr. Norton Simon.

Victoria and Albert Museum Archives.[37] Although Matisse did not make clear how he came to have the painting, he did indicate that he knew that it had been seized from Kann's collection and hoped that the collector would not object to its inclusion in the exhibition. This became a means for its return, as Matisse suggested that Kann collect this and another work after the end of the London show.[38]

Although Matisse wrote that another work from Kann's collection, *Jeune Fille en noir*, 1919, would be loaned to the show, he made a mistake. A letter to Major A. Longden of the British Council from Mr. Ashton of the Victoria and Albert Museum in the museum's archives notes that the mistake probably stemmed from Matisse's own letter, which was in Kann's hands when he came to collect the paintings. The second work was not *Jeune Fille en noir* but *Les Glaieuls*.[39] It is clear from Ashton's letter that both *Fenêtre sur le jardin* and *Les Glaieuls* were the works returned to Kann in London. The show then travelled to a number of venues, including Glasgow and Amsterdam, but *Les Glaieuls* and *Fenêtre sur le jardin* were not included.

Stewart's second wife, Ann, who seems to have largely blanked this period of her life, does recall some details that clearly demonstrate that Kann left other paintings to Stewart, besides those sold through Arthur Tooth. She remembers another van Gogh, a landscape with a large tree, which was still there when she left Stewart around 1956. By checking the de la Faille catalogue raisonné for details of works by van Gogh in the Kann collection, I concluded that this was *The Mulberry Tree*, 1889, which is now in the Norton Simon Museum, Pasadena.[40] Both mother and daughter confirm that this is the work. According to Carol Togneri of the Norton Simon, this came from David Gibbs, a dealer who had worked for Tooth but later set up his own business in New York.[41] The present whereabouts of Gibbs's records are not known, but anyone who has a painting with a Kann-Gibbs provenance should look into the possibility that the work was left to Stewart by Kann.

Ann remembers the Degas bath scene and Renoir's *La Source*, which hung above the fireplace (see figure 1).[42] She also remembers another much older painting, possibly 15th century, that depicted a group of men wearing hose, one of whom had bright scarlet tights, and holding lances or staves above their heads. There was a painting she refers to as *Rose Bay Willow Herb*, which was large and square.[43] Another, a "modern nude," she describes as "a female nude with orangey circles whom they called the 'Balloon Lady.'"[44] This was apparently portrait in shape and very big.

Ann does not recall seeing the Cézannes hanging in either London or Kent. As *Jeune fille à la poupée*, c. 1896 (Berggruen Collection), was sold in 1952, it was in Stewart's ownership from 1949 to 1952. *The Temptation of Saint Anthony* was with Stewart until 1951, then on consignment with Tooth until it was sold in 1955.[45] Curiously, in 1954, while the painting was with Tooth, it was loaned for an exhibition of Cézanne's work at the Tate Gallery in London. Ann specifically recalls visiting this show with her husband, but she does not remember him pointing it out to her. One explanation may be that Stewart stored some of the paintings elsewhere during this period.

A painting by Braque, as yet unidentified, was sold around 1951-52 while the Stewarts were still living in Eaton Place. This Ann describes as an abstract work in creams, blacks, and greys with a musical instrument but no figures. There was, however, "a bit of newspaper," she notes. This was sold to help Ann's father when the family business was in trouble. He, like many people who came into contact with Stewart, really liked his son-in-law. The money was never repaid to Stewart but instead was used, after the divorce, to fund the education of his three daughters.

In 1950 Stewart, who was very friendly with Jacob Epstein, commissioned the artist to make a bust of his daughter Fionna titled *Baby with Arms*, 1950 (private collection).[46] He told Ann that he had paid Epstein's gas bills when the artist had no money. This, like all the other works, was sold by Stewart many years ago.

Ann also recalls her husband's contacts in the London art world. He was quite friendly with the owner of Zwemmers and a good friend of Colin Agnew—a close friend of Kann's who was named in Kann's will—and took Ann to tea to in Agnew's flat. Ann says that Stewart was in awe of Agnew. They were also very friendly with a dealer called John Hewett who dealt in Mayan and Aztec jades, which her husband bought and sold, rather than in paintings.[47] Ann remembers that one time John Sainsbury, the British supermarket king, and his wife came over to the flat to buy jades.

The divorce papers show that Stewart had an affluent life style in the 1950s.[48] He had a chauffeur and lived like a gentlemen of leisure in large homes. Unfortunately, his marriage went badly wrong. He suffered another nervous breakdown on his return from a trip to Honduras, by which time he had also developed a drinking problem.[49] Ann eventually left, taking nothing but the children, and fled to Portugal, filing for divorce from there.[50] She says that she never went back to the house, not even to collect her belongings. She never received any money from Stewart, apart from the money from the sale of the Braque, and, until the time of our meeting, had no idea what had happened to anything hanging in the house or its other contents.

Ann's daughter put me in touch with an old friend of her father's, Olga, who had known Stewart when she was a child in Wales. Olga says Stewart was called John at that time[51]; she evidently had been beguiled by him since their first meeting. She talks of a charming man who was kind and sensitive. She tells how, on her birthday, Stewart had given her a nest of mice he found in the woods, in a box to look at. He had, according to her, an unusual ability to hear

Portrait photograph of Ann Stewart and Fionna Stewart [Ashmore] at Eaton Place, 1951. Courtesy F. M. Ashmore; reproduced with permission.

the sounds and calls of birds and small animals. Indeed, no one he knew painted a picture of a con-man or a fortune hunter. On the contrary, he was known for his sensitivity and generosity that verged on recklessness.

After Wales, Olga lost contact with Stewart until the war, when she met him in Ceylon.[52] She never went to Kann's apartment nor did she meet him. Asked if Stewart ever mentioned why Kann gave him the paintings, she says that all Stewart told her was that he had worked for this very interesting man as a secretary, looking after his collection.

On June 1, 1962, Stewart married his third wife, Mary, at a registry office in Hampstead. By this time Stewart was living at 60 Greenhill in Hampstead, London. Stewart had a daughter and a son with his third wife. Both Mary and her daughter Bella maintain that they knew nothing of what had been written about the spoliation claims from Kann's family that had been in the newspapers over the past few years. The daughter, a performance artist, even put on a small exhibition about Kann in her home a few years ago. As Mary had not been well, her daughter met with me.

The family lived in Cambridge for a short time after the marriage before moving in 1965 to West Cork in Southern Ireland, where they lived in quite a large house that Stewart had built. They moved back to the United Kingdom in autumn 1972, living in Whitley Bay in North Tyneside. In the spring of 1978 the family moved down to Salisbury, where they lived for a year in the house where Mary had grown up. By March 1979 Stewart had sold everything he had and was forced to move into a council house in Salisbury. He died of a heart attack on March 31, 1983. The profession listed on the death certificate was "Archaeologist (retired)."

Much of what Bella told me confirmed what I had learned from other family members. Again, Mr. Peek features in their stories, handing over money and paying for the house. She says that many of the objects found by Stewart in British Honduras were in the British Museum and believed that paperwork and reports relating to them could be found there. However, attempts to trace any objects or papers at the museum have so far failed.

Stewart left nothing to his family other than an old rug and a briefcase. We hoped that the papers in this briefcase would contain the answers to our questions. However, our hopes were dashed when the case revealed only five photographs of the house at St. Germain-en-Laye and two address books, both belonging to Kann.[53]

One book gives the names and addresses, in alphabetical order, of Kann's contacts in France; the other lists his contacts in all other countries.[54] Many are names of artists—including Gris, Léger, Matisse, and, of course, Picasso. There are also names and addresses of dealers and collectors with whom Kann was involved. It is hard to say exactly when the books were begun, but the presence of Sir Hugh Lane's name and address indicates that one volume was started during or before the First World War, as Lane died on the *Lusitania* in 1915. The books were updated by Kann until his death. After this, it is evident that Stewart used them, as they are annotated by him with changes of address and notes of people's deaths. Although they show the extent of Kann's involvement in the art market at the time, they did not reveal the information we were seeking.

While the address books provide a tantalizing glimpse of the records kept at the Albany up to Kann's death in 1948, it now seems unlikely that any of Kann's papers will resurface. Kann's solicitors confirmed that all copies of his correspondence were destroyed in the 1970s, and Peter Pitt-Millward's files at his solicitors have gone missing. Michael Stewart may well have destroyed or disposed of whatever was left to him by Kann some time after the sale of the Matisse works in 1951.

Author's note: I am greatly indebted to a number of people, without whose help this paper would not have been possible. In particular, Susan Davidson has continued to share her deep knowledge of all Kann material with me. Without this, I would have been unable to interpret the information that I found. Lucian Simmonds, John Richardson, and Didier Schulmann have also all talked freely with me. I have been greatly assisted by Wanda de Guébriant of the Archives Henri Matisse, Paris, in my research on the works by Matisse. I thank Matthew Gale for ensuring that my imagination does not run away with itself when putting pen to paper and that I do not jump to the wrong conclusions. Without Bella and Fionna's help and permission this article could not be published.

Notes

1. It is believed that works may have been returned to Kann after the war and then immediately sold by him.

2. The Albany is a small apartment block that runs between Burlington Gardens and Piccadilly in London. You can only lease there. The feeling is very much of a gentlemen's club and there is a long waiting list to acquire an apartment as they usually only become free when someone dies. Kann died on Sept. 5, 1948.

3. Musée national d'art moderne, Paris.

4. Information provided by Lucian Simmonds of Sotheby's.

5. This may have been Keith T. Lofts whose name appears on the electoral register for the Albany for three years.

6. Simon Matthews can be contacted at simon@easyart.com. The Getty holds copies of a number of early ledgers.

7. The books are filed alphabetically by surname and by year. I was looking for someone who I thought would have a large estate including a number of paintings.

8. It later transpired that Stewart died without making a will.

9. Stewart's name is not recorded in the provenance for the entry for Cézanne's *Jeune fille á la poupee,* c. 1896 (Berggruen Collection, Berlin) in the *catalogue raisonné.* See further John Rewald, *The Paintings of Paul Cézanne: A Catalogue Raisonné,* 2 vols., London, Thames & Hudson, 1996, pp. 135-6.

10. This is only a library of "last resort."

11. Sotheby's, London, July 9, 1969, lots 106-8.

12. Sotheby's, London, April 8, 1970, lots 135-6.

13. Keith Bell, *Stanley Spencer: A Complete Catalogue of the Paintings, London, 1992,* no. 395, p. 504. The Tooth records do not show that Stewart bought the oil from them.

14. Exhibition catalogue, *Sir Stanley Spencer RA,* Worthing Art Gallery, 1961, no. 37.

15. I have not been able to establish from whom Stewart bought the painting by Spencer.

16. All births, marriages, and deaths in England are recorded here. Copies of these certificates can be ordered.

17. His first wife is no longer alive. I have not spoken with his son.

18. Michael Vaizey dealt with Stewart's divorce from Esme in 1949 and later acted for Stewart in his divorce from Ann.

19. She may have been running a convalescent home or private hospital where Kann went to recover after he had been in the London Clinic after suffering a fall in 1945. Information provided by Susan Davidson.

20. These electoral registers are dated Oct. 15, 1947, and 1948 respectively.

21. The probate document does not make clear whether this figure includes a value allocated to the paintings but it seems unlikely that they were.

22. Although Stewart had inherited the contents of the flat in the Albany, the building itself was only leased. See above. There were also a few bequests and gifts to family members and friends.

23. According to Ann, Stewart was living there with a man servant. Stewart had been asked to give him a job by a Father Darcy, a Jesuit priest. I believe that this may have been Keith Tofts.

24. Information taken from a conversation with Ann Stewart and her daughter Fionna.

25. Ibid.

26. Ibid.

27. Ibid.

28. Ibid.

29. This was a ground floor and basement duplex apartment.

30. The divorce was later blamed for problems within their marriage as Stewart had not had his first marriage annulled and, as they were both Roman Catholics, they had to get married in a registry office.

31. The case was brought by Peter Pitt-Millward who claimed that the property belonged to him and that Kann had bought it for him as a gift. It appears that Peter Pitt-Millward won the case as he lived in the house in Portugal until his death and also acquired a number of Kann's paintings.

32. It is possible that Ann met the family members who had benefited from Kann's will and not the ones contesting it, as she says.

33. Although he was a member of the Royal Anthropological Institute, he never qualified as an archaeologist.

34. This photograph was taken by Bassano. Efforts to trace possible further photographs from this series have to date failed.

35. It does not seem to be on any of the confiscation lists.

36. There are several versions of the 1945 exhibition catalogue, one of which records that *Les Glaieuls*, no. 24, was lent by Alphonse Kann. *Fenêtre sur le jardin*, 1919 (Museum of Modern Art, New York), no. 23, is recorded as being lent by the Musée national d'art moderne. The show then travelled to a number of venues, including Paris, but *Les Glaieuls* was not included.

37. Inventory of Loans, December 1945–Jan. 13, 1946, "Picasso and Matisse: An Exhibition under the auspices of La Direction Generale des Relations Culturelles and The British Council," London, 1945, Victoria & Albert Museum Archives.

38. Information relating to the return of *Les Glaieuls* and its loan to the exhibition of paintings by Picasso and Matisse, Victoria and Albert Museum, London, December 1945, has been provided by Susan Davidson. The other painting mentioned in the letter is *Jeune Fille en noir*, 1919 (Stephen Hann, 1969). Wanda de Guébriant of the Archives Henri Matisse established which paintings Matisse was referring to in the letter to Kann. In addition to this, she has made available to me the details of other letters to Matisse that discuss Kann's paintings and his role as a dealer. Although Matisse says that the other work, *Jeune Fille en noir*, 1919, is being loaned to the show, the painting cannot be identified in any of the catalogues.

39. Letter to Major A. Longden from Mr. Ashton, Dec. 13,1945, File MA/28/70, Ref 45/676, Victoria and Albert Museum Archives.

40. J. B. de la Faille, *The Works of Vincent van Gogh*, Amsterdam, J. M. Meulenhoff, 1970, F637, pp. 255, 636.

41. It is probable that Stewart met him while Gibbs was at Arthur Tooth. I thank Carol Togneri for helping me with this painting.

42. She also recalls a Ruisdael on the stairs but this may well be the work hanging on the wall to the far left in the photo.

43. Op. cit., note 25.

44. Op. cit., note 25.

45. Tooth's records show that from 1951 it was on consignment with them until it was sold in 1955.

46. See further Richard Buckle, *Jacob Epstein Sculptor*, London, 1963, pp. 323, 428, ill. Although Buckle dates the work as 1949, the receipt, which is still in the Stewart family, shows that it was made in 1950. The bust can be seen in the picture of Stewart's daughter and wife with the van Gogh.

47. The firm of K. J. Hewett, Ltd. sold a number of works on Stewart's behalf through Agnew's, London, in the 1960s.

48. The family has copies of articles that appeared in the newspapers at the time of the divorce. It attracted a great deal of press in England because it was the first time that "unreasonable behaviour" was used as grounds for the divorce.

49. In 1962 he was living in a rented flat, 13 Montague Square, London, as by this time he and Ann were having a trial separation.

50. These details were taken from newspaper cuttings provided by the family.

51. Their parents had been friendly while living in Monmouthshire in South Wales.

52. She was in the Wrens as a cipher officer and he was a "rating" in the Navy. He was doing something secret at the time, she says. They met up again after the war around 1947-48.

53. These have now been lodged with the Tate Gallery Archives where they are on closed access but can be viewed with the permission of the family.

54. These range from Cairo to Cologne, Marseilles to Manchester, Rome to Rio.

Archives and Resources

Introduction to the Getty Project for the Study of Collecting and Provenance:
Collectors' Files as a Resource for Provenance Research

Patricia A. Teter

THE GETTY Project for the Study of Collecting and Provenance (formerly known as the Provenance Index) has compiled approximately 25,000 files on various collectors of primarily Western European and American art, dealers, and institutions, as well as other topics relevant to the history of collecting and provenance research. The scope of the information varies for each file. Many files contain copies of inventories, sale catalogues, articles, guidebooks, travel diaries, and biographical and genealogical information. Some of the material in the files, such as articles from *Burlington Magazine*, is readily available; however, a significant portion of the material is obscure and unique. Notable resources in the files include Frank Simpson's and Ellis Waterhouse's material, which was acquired in the 1980s.

Given the early focus of the Provenance Index, the strength of the files has been primarily British and Italian; however, the files continue to grow, expanding into other areas of collecting. With the growth in Nazi-era research, we have attempted to gather more material related to this issue and, in fact, several scholars participating in this conference have generously donated some of their own research to our files. Many scholars have shared their articles and research with us, specifically for use in the Collectors' Files, and we always welcome additional information. Currently, the department is creating an online index of the Collectors' Files, and at some point in the future the searchable index will appear on our website.

The history of the project closely follows the history of the department, which evolved out of the Paintings Department at the Getty Museum. Burton Fredericksen, then curator of paintings at the Getty Museum, began indexing British 19th-century sale catalogues in the mid-1970s. This interest in provenance research and the history of collecting resulted in the formation of the department. Around 1980 the Getty purchased Frank Simpson's archive of provenance material and this became the foundation of the early Collectors' Files. Simpson's material contained annotated sale catalogues, guidebooks, old newspaper articles, and a wide variety of other material related to collecting. Also included within the Simpson material were W. G. Constable's notes on collections, which are in the Collectors' Files, and his artist cards, which list specific paintings and locations.

In the mid-1980s, Ellis Waterhouse willed his *Notebooks* to the Provenance Index, and they contain his comments on British and European collections from 1924 to 1985. Waterhouse kept notebooks in which he recorded artworks seen in public and private collections. His comments ranged from remarks on the collection as a whole to specific notes regarding individual paintings, including condition, size, artist, and provenance information. Occasionally, he even illustrated a painting or design with a quick pen sketch. The department photocopied and broke up the material into separate files pertaining to specific collectors, and today the original notebooks are on deposit in the Getty Special Collections.

Another major area of research within our department relates to inventories; our files con-

tain over 10,000 from Italy, the Netherlands, Spain, France, and Germany dating from the 15th through the 19th centuries. References to the inventories can be found on our website; if the inventory contents have not been added to the Web database yet, they can be found in the files. The inventories are in the form of photocopies of original archive records, transcriptions, or copies of published inventories.

The files contain a variety of other resources that are very helpful in tracing provenance or learning more about specific collectors. Over a period of years, Burton Fredericksen transcribed sections of the Roman export records, dating from the late 18th century through the 1850s. The department has additional published information on the export records from Italy as well.

Another very helpful resource is the Courtauld Photographic Survey lists. The Photographic Survey has been in existence since the early 1950s, and it was founded to record works of art in private collections in England, Wales, and Ireland. The photographs are housed in the Witt Library at the Courtauld Institute, and over 500 collections have now been photographed. The lists contain information on school, artist, title, material, size, and photo reference numbers.

Our Collectors' Files continue to expand as a result of the department's projects, and, while some files may contain only one or two items, other files will be a gold mine of information several inches thick. For a better understanding of the resources the Project for the Study of Collecting and Provenance maintains, please visit our website at

www.getty.edu/research/conducting_research/provenance_index or contact us

at www.getty.edu/research/conducting_research/provenance_index/email_request.html.

A New Archival Resource for
World War II-era Provenance Research

Mark Henderson

SINCE the 1980s the Research Library at the Getty Research Institute—(www.getty.edu/research/conducting_research/library)—has assembled a significant collection of primary research materials related to World War II-era provenance research. The Research Library long has sought to acquire materials related to the study of the history of collecting and display, the history of patronage, of aesthetics, of taste, and of the history of the art market itself. These include old auction catalogues, dealer archives, the inventories of private collections, and the papers of art critics and art historians who have been closely involved in the art market. Not surprisingly these materials have proven incredibly useful for provenance research, and, since many of these collectors, scholars, dealers, artists, and others were active and played important roles in Europe during and after World War II, their archives serve as a rich resource for the study of Holocaust-era issues. Some of these collections are fairly well known to researchers: the library and papers of the art historian-collector-dealer Douglas Cooper and the papers of the art museum director Otto Wittman, both of whom served at the Munich Central Collecting Point; the records of the German art historian Alois Schardt, the photos of the German photographer Johannes Felbermeyer, and the papers and photographs from the archive of the German collector and attorney Wilhelm Arntz.

A significant recent acquisition is the records of the Oude Kunst Gallery (acc. #2001.M.5), known informally at the Getty as the Cramer archive because the collection comprises the business (and to a lesser extent the personal papers) of three generations of the Cramer family over the last 100 years. Because it is such a new acquisition, the archive has not been completely processed although a preliminary box list is currently available. Only three or four researchers have ever looked at the collection so its contents remain relatively unknown. The story of the firm's move from Berlin and remarkable survival in the Netherlands during the war has never been properly presented or even fully understood but deserves to be explored.

Max Cramer started the family business in the late 19th century in Kassel, Germany. Max's son Gustav later took over the business and moved the family to Berlin in 1923. In 1938 the family again relocated, this time to The Hague. Gustav's son Hans assumed management of the firm in 1949 and has remained the owner and operator of the gallery to this day. It is Hans who donated the archive to the Getty Research Institute so that the collection, especially those records dating from the war years, would be available to a wide range of researchers.

For the first few decades of its history the gallery sold mostly antique furnishings and a few paintings, but the firm's greatest financial success came in the 1950s, '60s, and '70s when Hans Cramer began to concentrate almost exclusively on the sale of high-quality Dutch Old Master paintings. The firm was responsible for the dispersal of several important Dutch private collections including the Ten Cate, Sidney Van den Bergh, and Van Aalst collections. Cramer included Norton Simon, Baron Thyssen, and Mr. and Mrs. Edward Carter of Los Angeles among his

best clients. The archive includes vast documentation from this fruitful period, but it is the dozen or so boxes containing the gallery's business records and some of the Cramer family's personal papers from the 1930s and '40s that are, not surprisingly, the most fascinating. Among other items, this portion of the archive contains extensive correspondence with such key figures as Hans Posse, Karl Haberstock, Erhard Goepel, Julius Bohler, and others, all filled with commentary regarding the German and Dutch art markets.

In April 2004 Hans Cramer was invited to speak at the "Art of the Dealer" conference at the Getty Center, and while he was there Louis Marchesano, Jonathan Petropoulos, and Anja Heuss were able to interview him for the Getty Research Institute's Oral History Project (acc. #2004.M.26). Hans is now almost 85 years old and although he was in his late teens and early '20s at the time, he retains quite a few early memories of his family's business during the 1930s and '40s. Among other revelations, he was able to dispel an oft-repeated misconception regarding his family history. In published sources (e.g., *The AAM Guide to Provenance Research*), it is recorded that Hans Cramer's mother, Gustav's wife, was Jewish. It was assumed that to preserve the life of Mrs. Cramer, Gustav was forced to cede legal ownership of the business to his son.

This story is only partially true. Gustav Cramer did transfer ownership of the firm to his young son, but Mrs. Cramer was not Jewish. The Cramers, however, are of Jewish ancestry, although non practicing. Hans says he didn't even know what Jewish was until he was 15 years old, when the Nuremberg laws were passed. According to Hans, mixed marriages with children received a preferential "attitude." In his interview, he also hints that his family was almost certainly helped by prominent art world friends such as Hans Posse and Karl Haberstock. Probably due to their influence, Gustav Cramer was able to remain in business in Berlin until 1937, at which point the family was given permission to leave the country legally, which it did in April 1938. The Cramers were allowed to take the contents of their home to The Hague but the gallery's stock remained in Berlin with the dealer Hans Hartig. The large amount of correspondence in the archive between Cramer and Hartig indicates that even in exile Gustav managed to keep track of at least some of the items he had to leave behind.

Once in the Netherlands Gustav Cramer reestablished his business, albeit with some difficultly. Among his first customers was Hans Posse. Although Hans Cramer believes that his father was not aware of it at the time, Posse was almost certainly buying for Hitler. After the Nazi occupation of the Netherlands, Gustav transferred legal ownership of the firm to his son but continued to run the business as usual. How this art dealer of Jewish ancestry escaped arrest and managed to continue his business throughout the war years remains an interesting question. Major clues to the Cramer family's survival exist in a series of typed invoices scattered throughout the Cramer archive that record the "sale" of paintings to Erhard Goepel and Hans Posse. Several of the invoices actually record the Linz Museum as the destination of the work. Hans Cramer maintains that his father was acting on behalf of Dutch collectors who wanted to remain anonymous, and that his father most likely never saw the paintings or handled the money but simply created the invoices.

Gustav Cramer's role and motivation for assisting in these wartime transactions has not yet been thoroughly researched. However, once the archive is more fully processed it will undoubtedly shed light on this period of Cramer's activities. In addition, the archive will serve as a rich resource for the study of the art market during the Holocaust and the post-war era.

Looted, Yet Documented: Tracing Works of Art and Their Former Owners in Austrian Archives

Robert Holzbauer and Ruth Pleyer

Questionable Provenance? Researching an Owner's Identity and Tracing His or Her Property

Identifying both individuals persecuted during the National Socialist regime and their property is a complicated process that differs from country to country. The following essay offers instructions for basic provenance research in both federal and provincial Austrian archives. Standard procedures show how to establish the identity of victims of persecution residing in Austria before 1938 and where to find the first traces of their former property. Wherever possible, URLs are listed to facilitate research.

Personal Data

Asset Registration Forms

Under the Decree Regarding the Declaration of Jewish Assets of April 26, 1938, individuals considered "Jewish" under the "Nuremberg Laws" were obliged to fill out declarations if the overall value of their assets exceeded 5,000 Reichsmark (RM). By July 30, 1938, more than 50,000 individuals had filled out a Vermögensanmeldung (Asset Registration) in Vienna and its surroundings and had filed them with the so-called Vermögensverkehrsstelle. This was a newly created department of the Ministry of Economic Affairs dedicated to documenting the property of Austrian Jews before expropriating it. The path a researcher usually travels after coming across an Austrian provenance is to check whether an individual name is listed among those who filled out an Asset Registration in 1938.

The roughly 50,000 declarations filed in Vienna are preserved today in the Archiv der Republik (Archives of the Republic), a department of the Staatsarchiv (Austrian State Archives).[1] Jewish people residing in the Austrian provinces were forced to register with the appropriate provincial department of the Ministry of Economics. Copies of most of the declarations filled out in the provinces also still exist. The researcher searching for such a form is advised to contact the provincial archives in question, specifying the individual's name in addition to his or her former place of residence and/or an approximate date of birth.[2]

Not all individuals persecuted under the National Socialist regime registered, however. Estimates of the Jewish population of Austria before 1938 range from 200,000 to 300,000 individuals, many of whom do not figure in the preserved Asset Registration records. Several reasons explain this phenomenon. An average worker's income in the German Reich—where wages were a little higher than in Austria—amounted to 1,856 RM a year in 1937.[3] Therefore, one had to be relatively wealthy to "qualify." (Surprisingly, on the other hand, quite a number of individuals who certainly were exempt from the decree due to modest incomes also registered.) Many others left before submitting to a process that would eventually rob them of a large portion of their belongings and which, in addition, was so lengthy that in many instances

it was too late to leave once it was completed. Still others refused to register (though most of them eventually were discovered).[4] Therefore, though it is worth checking asset registrations, the absence of such a form cannot be construed as evidence that an individual was not persecuted.

A Database of 65,000 Austrian Victims of the Holocaust

The second most important list of individuals persecuted under the National Socialist regime in Austria is the database on Austria's Victims of the Holocaust maintained by the Dokumentationsarchiv des österreichischen Widerstandes (Documentation Center of Austrian Resistance). The Dokumentationsarchiv has compiled a list of roughly 65,000 names of individual victims of the Holocaust. The database includes people who were deported from Vienna; those who fled Austria, later were caught in another part of Europe, and taken to the camps; and those who were killed in "euthanasia" projects or died at the hands of the Gestapo. The database (accessible on the Internet at http://doew.at) includes many people who had registered with the Asset Registry in 1938, but it also contains names of victims who had not registered, most often because the value of their assets was below 5,000 RM.

It should also be noted that confiscation of property extended beyond individuals considered "Jewish" under the Nuremberg Laws.[5] A number of Austrian residents were subject to political persecution, declared "enemies of the state" or "enemy aliens," and had their property seized—most prominently, Prince Adolph Schwarzenberg and the Lanckoronski family. To find out whether an individual might have been subject to political persecution and his or her property subjected to confiscation, the researcher is advised to contact the Dokumentationsarchiv, which houses the largest collection of information on opponents of Austria's Nazi government.[6]

Historic Registration Records

Some former Austrian residents, particularly those who managed to escape, will appear in neither of the sources quoted above. However, the police and the government bureaucracy have held tight control over Austrian citizens and residents for centuries, and individuals have left traces in the resulting paper trails. Under the Meldegesetz (Bill on Registration), Austrian residents (then and now) must register with the local police within a few days of their arrival in the country or a move to a new address.[7] Although quite a few municipalities were bombed toward the end of the war and their historic registration records were lost, many other historic registration records have been preserved, in particular, those of the city of Vienna. An Auszug aus dem Melderegister (Registration Record) will contain the individual's date of birth, his or her spouse's name and date of birth, the names and birthdates of any children registered with them, and—in the historic records—their religious affiliation, if any. In addition, the records will list the period of time a person lived at (or was registered at) an address. If somebody left the country for good, the record will say so.

In Vienna, where most, though by no means all, Austrian art collectors lived, it is possible to retrieve such a record only by providing an address for the person in question. This is because the records are sorted by street address. A first step therefore would be to consult Vienna's historic address book, *Lehmanns Wohnungsanzeiger*. Somewhat like a telephone book, *Lehmanns Wohnungsanzeiger* listed owners and residents of every house in Vienna. Hardcover copies of the address book (which was published from the late 19th century until late into the 20th) are available at both the State and the City Archives.[8] The National Library (www.onb.ac.at) and the City Archives both own copies of *Lehmanns* on microfilm. Photocopies of individual pages are made for a charge.

Lehmanns was published yearly until 1942, suspended from 1943 through 1947, and resumed in 1948. Chances are high that someone who is listed in 1938 but not in 1942 emigrated or was deported. Very few Jewish citizens were still listed in 1942. Most of the Jewish residents of Vienna had been deported by mid-1943, having been forced to leave their original lodgings and move into overcrowded apartments much earlier. One must not forget that since most Austrian Jews lost the opportunity to work in a paid job very soon after the Nazis took power in 1938, many were forced to move within Austria for economic reasons well before emigrating. The Holocaust Victims' Information and Support Center—Anlaufstelle in German—at the Jewish Community in Vienna is in possession of a *Lehmanns* address book dating from 1938 and can help in individual cases (anlaufstelle@ikg-wien.at). With a corresponding address, Registration Records (dating before 1948) can be obtained from the City Archives in Vienna (post@ma08.magwien.gv.at).[9]

Works of Art Owned by Persecuted Individuals: Sources and Their Significance—Documentation on the Looting of Works of Art

Asset Registration Forms

Once one establishes that a provenance contains an owner with a name identical to someone who was persecuted in Austria, the search for traces of this individual's former property can begin. Again, Asset Registrations is the first—though not the most valuable—source to consult for documentation on works of art. Even though works of art theoretically had to be listed in the Asset Registrations and even be accompanied by an estimate, many of those persecuted failed to provide an exact list. Some who did gave only their own estimates for what they owned while others provided accurate assessments. Works of art considered "degenerate" are hardly ever listed since they had very little market value in the German Reich at the time (or so the owners thought it was worth trying to argue). The same goes for contemporary art.

Unfortunately, the department for works of art at the Asset Registry went out of business in 1943. After the department was abolished, its files vanished, along with many of the lists of estimates they contained. The most important surviving files on works of art belonging to persecuted individuals can be found in the archives of the Bundesdenkmalamt (Federal Monuments Office or Federal Office for the Protection of National Heritage).

The Federal Monuments Office: Documentation on Attempted Export

After the breakdown of the Austro-Hungarian Empire in 1918 and the end of World War I, all that was left of Austria was a tiny entity few thought would survive on its own. The economic heartland of the former empire, Bohemia, had been lost, and for many years the economic situation in Austria was strained. To prevent a drain of cultural heritage, the Art Preservation Act of 1923 was passed.[10] The original intent of the Preservation Act was to prohibit the export of objects of cultural value from Austria. The attempted export of any work created by an artist who had been dead 20 years or more had to be cleared with the Federal Monuments Office. When an individual moved to another country, taking his or her property along, applications for export permits had to be filed with the Monuments Office, which would clear the shipping crates (or block the export of individual items, for that matter). No exceptions were allowed, not even for refugees.[11]

The Archives of the Federal Monuments Office has preserved roughly 20,000 of these applications for export permits. They date from 1938 to 1941, with the number of applications reaching their peak in 1938. If individual objects were not cleared for export, a "Sperre" or block is stated on the application form. The Federal Monuments Office recently has undertaken the task of creating an indexed database of applications for export permits that will be

searchable by name. Unfortunately, in some instances the shipping company, rather than the owner, would apply for a license; such applications are close to impossible to find if one has only an individual owner's name.

Requests about whether an export application form exists in individual cases can be direct-ed to the Federal Monuments Office in Vienna, which also houses the offices of the Austrian Kommission für Provenienzforschung (Commission for Provenance Research)—provenienz forschung@bda.at. Since contemporary art did not fall under the Preservation Act, 20th-cen-tury paintings rarely are listed by title or artist; however, works by Gustav Klimt, who was already held in high esteem in 1938, are among the exceptions to this rule.

Not all the objects cleared with the Federal Monuments Office ultimately were exported. A stamp from Customs on the application form is the best indication that export actually occurred; in many cases, it never did. Even when objects made it out of Austria, many shipping crates got no farther than Trieste or Hamburg where they were confiscated and their contents sold. It is therefore important to check where the form was stamped; if the export stamp was applied on the Swiss border, one can assume the goods in question actually left Austria. In yet other cases, emigrants stored their crates with their shipping agents so they could be sent to a final destination that was unknown to the refugees at the time of their departure. Even though some refugees eventually reached such a safe destination, in thousands of cases their property did not.

Expropriation under the Eleventh Decree to the Reich Civil Code of 1941: The Vugesta

Individual confiscations started right after the Anschluss in 1938. In 1941, the Eleventh Decree to the Reich Civil Code was passed, which stripped anyone who had left the country—includ-ing deportees to camps outside the boundaries of the Reich—of their German citizenship and declared them enemies of the state. Shipping crates belonging to such individuals were sold by the Vugesta (a successor organization, Vugesta II or Möbelverwertungsstelle, later was created to sell separately the remaining property of those being deported from Vienna).[12] The Vugesta was a joint venture of shipping agents, who were eager to recover fees that had not been paid since 1938, and the Gestapo, which funneled the resulting profits to the State Revenue Authorities. The property of roughly 6,000 families was sold, including household goods, books, clothes, and thousands of works of art. In 2000, historians at the Holocaust Victims' Information and Support Center at the Jewish Community in Vienna were able to locate the card index of individual names of people whose property was sold off by the Vugesta. A list of the 6,000 names and their addresses subsequently was prepared.

Although the Vugesta's files have never been located and probably were destroyed in early 1945 after the agency's "mission" was completed, the State Archives possesses books that list how much each individual's property yielded at sale. It is estimated that the Vugesta grossed roughly 15 million RM, even though most goods were sold at roughly 10 percent of their actu-al value. The director of the Vugesta, Karl Herber, was tried as a war criminal in 1948, as was Bernhard Witke, who had "taken care" of the deportees' property. A glance at the files of their trials shows both men's role in the trade in confiscated goods that they helped to organize.[13] Requests to determine whether specific individuals were robbed through the Vugesta can be directed to the Federal Monuments Office, the State Archives, or the Holocaust Victims Information and Support Centre at the Jewish Community.[14] The State Archives has a policy of not making photocopies from books or any bound material; however, the Holocaust Victims Information and Support Centre has a complete copy of the records and can be contacted for details. Generally, expropriation under the Eleventh Decree to the Reich Civil Code of 1941 also will be listed in the Finanzlandesdirektionsakten (files of the Finance Authorities), which

deal with expropriation under the Eleventh Decree and restitutions by the federal government. Address requests for Finanzlandesdirektionsakten to the State Archives for the provinces of Vienna, Lower Austria, and Burgenland, and requests for former residents of other provinces to the provincial archives in question. Requests have to include both the owner's name and his or her approximate date of birth. Be aware, however, that works of art rarely appear in the files of the Finance Authorities, which mostly deal with real-estate issues.

A Database of Photographs

The Federal Monuments Office was and is the ultimate authority on the export of works of art from Austria. In addition to approving or denying export licenses, the office was put in charge of objects "safeguarded" at or confiscated from refugees' houses. It also housed the Zentraldepot für beschlagnahmte jüdische Kunst (Central Storage for Art Confiscated from Jewish Owners). Most of the objects in question were photographed so they could be "offered" to approved museums: first to the Führermuseum, Hitler's museum that was planned for Linz, and then to other museums. Thousands of photographs were preserved, and the Federal Monuments Office is in the process of digitizing the index books. Today, the photographs remain an extremely valuable source for provenance researchers. The historian should not expect to find plates featuring 20th-century art but rather Old Masters, works of art originating from Austria, and valuable objects such as glass, china, and sculptures.

Files on Individual Collectors

In addition to export applications and photographs, the archives of the Federal Monuments Office contain files on individual owners and their postwar efforts to claim restitution, as well as larger collections of material on significant collections of art such as the Rothschild family collection. Files on individuals provide valuable information concerning what claimants were looking for as well as hints concerning any other efforts, such as restitution requests filed in Germany. Generally all material in public archives that contains information on individuals falls under the Austrian Data Protection Act and is not accessible unless an applicant can prove that all the individuals in question either have already died or were born more than 110 years ago. (Exceptions are made for family members who can prove their relatives are deceased or, of course, the original victims themselves.)

One way for researchers to gain access to these files is to get permission from the descendants of the family in question. Regulations also differ from province to province. In Styria, for instance, it is not possible to access files that contain papers less than 50 years old; in other provinces or federal archives, the limit is 30 years. That said, the policy of the Federal Monuments Office and other public archives in Austria is to support provenance research. Requests for help are welcome as are applications for research permits from institutions or individuals who have suffered losses.

In addition to claims for lost property, the files on individuals document restitution of a few works of art by the federal authorities. All too often, however, the restituted pieces then were not cleared for export, so they had to be left behind in Austria for a second time.

Other Relevant Material on Individual Collectors and Official Looting

The Federal Monuments Office has preserved additional prewar material on Austrian collectors, namely the so-called Notariatsakten or notary's certificates. During the 1920s, collectors could profit from special regulations by opening their collections to the public for a limited amount of time each year. Asking for so-called Notariatsakten from the 1920s is worth the trouble. Although their number is very limited, they do occasionally provide more accurate details on prewar collections than do confiscation records or records provided by claimants filing for

Left: The wartime index book of the photograph department at the Zentralstelle für Denkmalschutz. Courtesy of the Leopold Museum.

Below: The dentist Heinrich Rieger had one of the most important modern collections in Vienna. The list in his *Notariatsakt* (notary certificate) is from 1921. Courtesy of the Leopold Museum.

34.	Schmutzer	:	Slovakin	
35.	Hampltz	:	Lebzeltherz	
36.	Lorenz	:	Landschaft	
37.	Laske	:	Orientmarkt	1919
38.	Laske	:	Salzburg	1919
39.	Blau Tina	:	ung. Dorfhaus	
40.	Borschke	:	Madonna I.	1918
41.	Borschke	:	Madonna II.	1918
42.	Kitt	:	Schwängere	1917
43.	Schile	:	Liebespaar	1918
44.	Kahrer	:	Landschaft	1916
45.	Pollak	:	Holländerin	
46.	Quittner	:	aus Paris	
47.	Oltjon	:	Bauernhaus	
48.	Parin	:	Interieur	
49.	Blau Tina	:	Landschaft	
50.	Epstein	:	Landschaft	1919
51.	Loffler	:	aus "Don Juan"	1915
52.	Leffler	:	aus "Fledermaus"	1915
53.	Harta	:	Brügge	
54.	Rojka	:	Piean'o	
55.	Hlavašek	:	Landschaft	
56.	Hamza	:	Interieur	
57.	Sternfeld	:	Brot	

postwar restitution. It is worth noting that most restitution claims were in vain, since a relatively small number of pieces had been sold off to museums and a disproportionately large number had vanished in private hands. Only today are some of these objects surfacing in the art market.

In addition to files on individual collectors and their collections' fates, the Federal Monuments Office provides general material on confiscation and "distribution" of looted art.[15] Other relevant material can be found in the correspondence of Hans Posse and his successor Hermann Voss, who were responsible for the acquisitions for Hitler's planned museum.

Postwar Restitution Efforts

The Third Restitution Act

Under the 3.Rueckstellungsgesetz (Third Restitution Act), claims could be filed for the recovery of property that was looted by private individuals or had ended up in the hands of private individuals.[16] Theoretically, all legal transactions that took place between March 13, 1938, and May 1945 were registered with the government. Very few actually were, though, and as a result former owners often did not know who had acquired their property—meaning that the Third Restitution Act was a dead end for most claimants. Many other claimants did not hear of the possibility of filing before the deadline for claims was long past.

The Vermögensentziehungsanmeldungen—the forms on which deprivation or acquisition of property had to be registered to start the procedures under the Third Restitution Act—have been preserved by the Archives of the City of Vienna. Unfortunately, the corresponding files were discarded by the archives a few years ago. To complete one's research it is worth checking into whether a Vermögensentziehungsanmeldung was filed under the Third Restitution Act by the owner in question. When inquiring with the archives, indicate a person's name and his or her residence on March 13, 1938. Few of these forms (which originally were filed with the municipal office) still exist in the provinces; inquire with the relevant provincial archives.

War- and Persecution-Related Material Damage Act

Restitution by the federal authorities was slow. The Federal Monuments Office was understaffed and not all of its employees were as motivated as they could have been. And of course, former owners had no possibility of claiming compensation for objects whose current whereabouts were not known. In 1958, the Kriegs- und Verfolgungssachschädengesetz (War- and Persecution-Related Material Damage Act) was passed.[17] Victims of persecution and victims of allied bombings were equally entitled to apply for compensation. However, only the original owner or a person who had lived in a household with the original owner could apply. All others were excluded, including surviving relatives who had not shared a household with the injured individual. On top of that, to qualify applicants had to prove they had a relatively low income. Due to the strong dollar during that era, almost no one who had emigrated to the United States qualified for compensation at all. Despite these exclusions, tens of thousands of applications from the provinces of Vienna, Lower Austria, and the Burgenland were filed and have survived in the basement of the Finanzlandesdirektion für Wien, Niederösterreich und Burgenland (Finance Revenue Authorities for Vienna, Lower Austria and Burgenland). They recently have been transported to the Austrian State Archives, where they will be available to those who provide the owner's name and his or her former address.

The First and Second Artistic and Cultural Assets Settlement Act

By 1960, the federal government of Austria was still in possession of thousands of unclaimed works of art that had not been restituted due either to lack of a claim or poor, if any, research on the original owners. After the better pieces were bought by the federal museums, a list of the works of art in question was published, and applicants were invited to file claims. The bill on which the process was based, the 1.Kunst- und Kulturbereinigungsgesetz (First Artistic and Cultural Assets Settlement Act), was hardly a success. Instead of doing research themselves by making use of existing files, the Austrian authorities demanded detailed proof from applicants, which few were able to provide. For the first time during the postwar era, residents from what were then East Block countries also were invited to apply, resulting in a number of applications from Hungary, Czechoslovakia, and the former Yugoslavia. Almost none of these had anything to do with the objects in question.

In 1985, the remaining objects were published again under the 2.Kunst- und Kutur-gutbere-inigungsgesetz (Second Artistic and Cultural Assets Settlement Act).[18] Applications for restitution only numbered a couple of hundred. The relevant files are now in the possession of the Austrian State Archives. Since the names of applicants and original owners have been digitized by the Federal Monuments Office and the Holocaust Victims' Information and Support Centre at the Jewish Community in Vienna, both institutions can provide help with the search for a particular name. The remaining pieces of art—many of which could have been restituted had proper research been conducted—were sold at auction in 1996, with the profits administered by the Jewish Community in Vienna to benefit needy victims of the Holocaust.[19]

Notes

1. www.oesta.gv.at/ Inquiries concerning "Asset Registrations" should be sent to adrpost@oesta.gv.at .

2. A contact address for respective archives in the province of Burgenland can be found at www.burgenland.at/landesarchiv/. For the Archives of the Province of Carinthia (Kärnten) go to www.landesarchiv.ktn.gv.at. For the Archives of the Province of Salzburg go to www.salzburg.gv.at/themen/se/salzburg/archive.htm. For the Provincial Archives of Lower Austria (Niederösterreich) go to www.noel.gv.at/service/k/k2/vermoegensanmeldungen.htm. For the Provincial Archives of Styria (Steiermark) go to www.verwaltung.stiermark.at/cms/beitrag/10001575/8581. For the Provincial Archives of Tyrol (Tirol) go to www.tirol.gv.at/themen/kultur/landesarchiv/index.shtml. For the provincial archives of Upper Austria (Oberösterreich) go to www.oberoesterreich.gv.at/cps/rde/xchng/ooe/hs.xsl/22750_DEU_HYTML.htm. A contact address for the archives of the Province of Vorarlberg is listed at www.vorarlberg.at/vorarlberg/bildung_schule/bildung/landesarchiv/start.htm.

3. Frank Bajohr, *Parvenüs und Profiteure. Korruption im Nationalsozialismus*, p. 235.

4. In several cases where people did not register the Vermögensverkehrsstelle tried to document their assets at a later point. Registrations filled out by the authorities and preserved in the State Archives usually have file numbers over 60,000; most of them are fragmentary.

5. "Jewish" is put between quotation marks in this context since many of the individuals in question no longer considered themselves members of the Jewish community in 1938. Some had no religious affiliation; others had converted to another religion of their own choice.

6. The database (accompanied by an excellent documentation) is also available on CD-ROM from http://doew.at.

7. Since 2002 registration has been taking place with the municipal authorities.

8. City Archives of Vienna: http://www.magwien.gv.at/ma08/m08_leit.htm.

9. For addresses in the provinces the researcher is advised to address the municipal authorities of the municipality in question. Addresses of Gemeindeämter "municipal authorities" can be found under http://herold.at. Type in "Gemeindeamt," meaning "municipal office," under "Name" and choose a province. The database will provide you with an alphabetical list of all Gemeindeämter. If the Gemeindeamt no longer possesses historic records, please contact the provincial archives in the Austrian province in question (see URLs above). Since there are only very few address books available for municipalities outside Vienna, a request for such a Auszug aus dem Melderegister registration form will be more successful if the researcher can provide any additional pieces of information, particularly names of spouses or children, approximate dates of birth, etc.

10. Austrian Federal Law of Jan. 25, 1923, amending the Law of Dec. 5, 1918, *State Law Gazette. No. 90*, Prohibiting the Export or Sale of Objects of Historical, Artistic or Cultural Value, *Federal Law Gazette No. 80/1923.*

11. See also Robert Holzbauer "The Austrian Federal Office for Heritage Protection: Assisting in the Looting during the War—Administering Restitution after the War," in *Religion Austria: Contemporary*

Austrian Studies 13, eds. Günter Bischof, Anton Pelinka, Hermann Denz (New Brunswick, London: Transaction Publishers, 2005), pp. 181-88.

12. On the Vugesta, see Robert Holzbauer, "Einziehung volks- und staatsfeindlichen Vermögen im Lande Österreich: die Vugesta—die Verwertungsstelle für jüdisches Umzugsgut der Gestapo," *Spurensuche*, nos. 1-2 (2000): pp. 38-50.

13. *Volksgerichtsakt Verfahren wegen §6 Kriegsverbrechergesetz gegen* Karl Herber, director of the Vugesta Vg 3c Vr 2272/38, and *Volksgerichtsakt Verfahren wegen §6 Kriegsverbrechergesetz gegen* Bernhard Witke, director of the "Möbelstelle Witke" et al. Vg 2b Vr 2331/45, *Landesgericht für Strafsachen Wien*, "Criminal Court of Vienna."

14. E-mail address: anlaufstelle@ikg-wien.at. See also www.ikg-wien.at; click on "Restitution."

15. Boxes 8 and 8/1 are of particular interest. Restitution Materials, "Federal Monuments Office," Vienna.

16. Third Restitution Act: Federal Law of Feb. 6, 1947, concerning the annulment of property seizure; *Federal Law Gazette* 1947/54.

17. War-and Persecution-Related Material Damage Act: Federal Law of June 25, 1958, concerning the award of compensation for damage to household equipment or occupational utensils incurred as a result of war or political persecution; *Federal Law Gazette* 1958/127.

18. Second Artistic and Cultural Assets Settlement Act: Federal Law of Dec. 13, 1985, concerning the release and disposal of formerly unclaimed works of art held by the Federal Government; *Federal Law Gazette* 1986/2.

19. *The Mauerbach Benefit Sale. Items Seized by the Nazis to Be Sold for the Benefit of the Victims of the Holocaust.* Christie's Auction 5638, Vienna, Oct. 29-30, 1996.

Judaica and Jewish Museums

Karen S. Franklin and Dorothee Lottmann-Kaeseler

IN 2001, a pewter Seder plate from 1755 was donated by Sylvia Hoffman to the Judaica Museum of the Hebrew Home for the Aged at Riverdale in Riverdale, N.Y. It arrived with a letter describing its provenance. The donor wrote that her husband had:

> an Aunt who was married to a gentile and he was able to protect her from the Nazis. . . . While [the aunt's] husband was still living, he went into these Jewish homes that were now vacated by the Nazis and tried to extract as many items as he could in a very short time frame. This Seder plate is one of the items he took from the home where a Jewish family had resided.

Ordinarily it would have been inappropriate for a museum to accept a gift with the knowledge it might have a tarnished history. We understood, however, that we were in a unique position to research the plate's history because of our good connections with the Jewish Museum of Wiesbaden, the area from which the plate had presumably come. When we accepted the gift, we made a commitment to the donor to study the history of the plate.

In the past three years we have conducted research throughout the United States, Germany, and Israel, contacting dozens of Hoffman family members, hundreds of genealogists, local historians, and regional and local archives.[1] This paper will summarize the sometimes surprising results of this research and outline the strategies we have employed, which can be replicated by others seeking to trace the history of Jewish family ceremonial objects.

Early History of the Hoffman Seder Plate

The Hoffman Seder plate is inscribed in Hebrew: "This belongs to the prominent man, Wolf, son of Mordechai, and the prominent woman, Meschacha, daughter of Rabbi Eliyahu (of?) Do(e)rnbach." Our basic research strategy was to explore the history of the plate by identifying the town of Dornbach and the plate's 18th-century owners, and then trying to move forward and learn more about the situation in Wiesbaden, where the plate supposedly ended up in 1942.

With the help of hundreds of experts participating in a German-Jewish genealogy listserv (gersig) on www.jewishgen.org, we soon identified seven German villages with the name Dornbach that might have had Jewish populations in the 18th century. It turned out that few did, and fewer still had surviving records. One detail tantalized us: one of the Dornbachs, Langendernbach, was a very short distance from the village of Frickhofen, the original home of the donor's family, then called Hoffmann (the second "n" was dropped by the American branch of the family). Could the Seder plate actually have been a Hoffmann family heirloom? Could the plate have been given to the Hoffmanns by a family friend for safekeeping during the war? Had it not been looted after all?

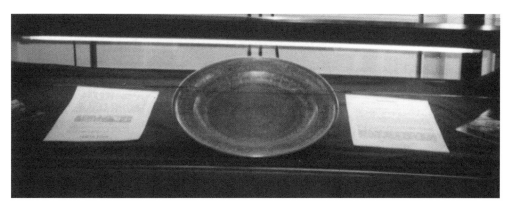

The Hoffman Seder Plate on display in Wiesbaden, Germany.

Focusing on this village of Langendernbach, we learned that sometime after 1717, the Jews of Frickhofen, Ellar, Langendernbach, Walddernbach, and a few other villages united to found the Jewish community of Ellar. A synagogue was located in Ellar, as was a newly established cemetery.[2] We found a local historian, Hubert Hecker of Frickhofen, who has researched the background of Jewish families in his area, going back to the late 18th century, using documents found in the archives of the diocese of Limburg. He was familiar with three generations of the Hoffmann family, and the archives contained the birth records for Cilly Hoffmann Jochims (the donor's aunt) and her brothers, parents, and grandparents. Making the connection to the generation of the individuals whose names are inscribed on the Seder plate, which requires going back one or two more generations, may require research in other sources.

Another local historian in the Langendernbach area, Dr. Mink, has undertaken an extraordinary amount of research on local families. Thus far he has not been able to trace the names inscribed on the Hoffman Seder plate but we are still hopeful that additional archival research on residents of surrounding villages may help to identify the original owners. Canvassing all descendants of the individuals who resided in the local villages also may yield information on both the original owners and those who owned it in more recent centuries.

Recent History of the Seder Plate

To research the plate's recent history, Dorothee looked in Wiesbaden sources and address books for Cilly Hoffmann Jochims and her husband, Willy, the donor's aunt and uncle. She was unable to find them in Wiesbaden during the period between 1938 and 1942. Hoping to gain more information about the case, Karen took the Seder plate to Wiesbaden in May 2004 and placed it on display in the Wiesbaden City Hall. The exhibition generated a large amount of publicity, and a woman named Marga Kolk stepped forward. She had known Cilly quite well from the 1950s until her death. Not only did she have a photo of Cilly with the Seder plate, she provided clues that have helped us move the research forward: she identified the name and address of cousins in Israel who would have more information.

Karen visited Cilly's 90-year-old niece in Israel in July 2004. The niece provided the information we needed: Cilly was not living in Wiesbaden in 1942 when the Seder plate was looted, but in Cologne! Contacts in Cologne, in Nuernburg where the couple had been married in 1930, and in Frickhofen provided further information. With this new information, Dorothee was able to find Willy's address in Cologne in the period prior to 1942. We also learned that Cilly's brothers, Albert and Ferdinand, had lived in Cologne until their deportation in July 1942. Both of them, with their wives, were murdered in Minsk.

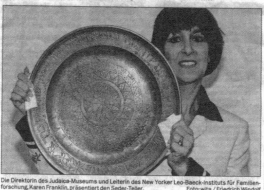

Rhein Main Presse Dienstag, 20. April 2004

Ein weit gereister Seder-Teller

Aus den USA nach Wiesbaden: Aktives Museum sucht Eigentümer

G.L. Der kleine Seitenraum des Rathaus-Foyers, der der Geschichte des Judentums in Wiesbaden dient, hat seit gestern in einer Vitrine einen Zinnteller aus dem Jahre 1755 „zu Gast", der über Jahrhunderte hinweg einer jüdischen Familie als Seder-Teller diente und unter anderem in hebräischer Schrift den Herkunftsort seiner einstigen Eigentümer mit „Doernbach" angibt. Einer von dort stammenden jüdischen Familie namens Jochims oder Joachims, die später in Wiesbaden lebte, gehörte der in der jüdischen Glaubenswelt beim Passah-Fest eine wichtige Rolle spielende Teller.

Der mit Blumenmotiven gravierte Zinnteller, der als selten schönes Exemplar gilt, kam mit der Direktorin des Judaica Museums und Leiterin des New Yorker Leo-Baeck-Instituts für Familienforschung, Karen Franklin, nach Wiesbaden und als Leihgabe in den Besitz des Aktiven Museums für Deutsch-Jüdische Geschichte, das ihn voller Stolz und in der Hoffnung präsentiert, mehr über seine genaue Herkunft zu erfahren.

Im Judaica-Museum in Riverdale, New Jersey, tauchte

der Teller 2001 als Geschenk von Sylvia Hoffmann auf, deren Mann Heinz vor drei Jahren verstorben war. Dessen in Wiesbaden lebende Tante Cilly war mit einem nicht-jüdischen Wiesbadener – Wilhelm Jochims oder Joachims – verheiratet und überlebte so die erste Verfolgungswelle der Hitlerzeit, konnte sogar noch in die Schweiz flüchten, um nach dem Krieg wieder nach Wiesbaden zurückzukehren. In ihrem Besitz befand sich dieser Zinnteller aus dem Jahre 1755, sowie eine ganze Reihe anderer Judaica, die möglicherweise von anderen jüdischen Familien vor ihrem Abtransport nach Auschwitz dorthin zur Aufbewahrung gegeben wurden.

Über ihren Neffen Fred Hoffmann gelangten sie nach 1981 in die USA und dort wiederum als Geschenk der dort lebenden Schwägerin des Fred Hoffmann, Sylvia Hoffmann, in das jüdische Museum in Riverdale. Das Wiesbadener Aktive Museum, das sich seit Jahren mit der Aufarbeitung der jüdischen Geschichte und des jüdischen Schicksals in Wiesbaden befasst, hofft nun, mehr und näheres zu erfahren, woher der Seder-Teller genau stammt

und durch welche Hände er ging, bevor er schließlich jenseits des Atlantik seine vorerst letzte Station erreichte, aus der er vorübergehend nach Wiesbaden zurückkehrte.

Der Seder-Teller wird am Vorabend des Passah-Festes benötigt. Jüdische Familien sitzen an einer festlich gedeckten Tafel zusammen und die uralte Passah-Haggada wird verlesen, die den Auszug des jüdischen Volkes aus der ägyptischen Sklaverei schildert. Auf dem Seder-Teller werden an diesem Abend außer drei Mazza-Scheiben, die an die drei Erzväter erinnern sollen, Gemüse als Symbol des Frühlings, bittere Kräuter (Meerrettich) zur Erinnerung an das bittere Leben der Israeliten in Ägypten, ein aus Nüssen, Äpfeln und Mandeln gestampfter Brei, der den Mörtel symbolisiert, mit dem die Juden ihre Häuser in Ägypten bauten, ein hartgekochtes Ei als Symbol des Festopfers und ein Lammknochen als Hinweis auf das Passah-Lamm serviert. Vier Becher Wein sollen dazu während der Verlesung der Haggada getrunken werden, ein fünfter bleibt unberührt und reserviert für den Messias.

Die Direktorin des Judaica-Museums und Leiterin des New Yorker Leo-Baeck-Instituts für Familienforschung, Karen Franklin, präsentiert den Seder-Teller. Foto: wita / Friedrich Windolf

Local coverage helped unearth more details about assets looted during the Nazi era. This newspaper article included a photograph of Karen Franklin, holding the Seder plate.

How did Cilly survive while her two brothers were deported? What do we now make of the explanation of the Seder plate's history in Sylvia Hoffman's donation letter—the story that the object was taken by Willy Jochims from a Jewish home in 1942? Is it possible that there is a connection between these two events?

Though we are still in the process of research, we have a theory. Jews living in a mixed marriage with a non-Jewish spouse were spared from deportation in 1942, but risked arrest later on. To save his wife, Willy may have collaborated with police or other municipal officials. It is possible that in return he became a recipient of plundered goods or part of the plundering procedure. We know that as Jews were moved from their homes in Cologne to Judenhaeuser (houses designated for Jews), their belongings were "redistributed." Local officials had some oversight of this redistribution. While the high officials took items of great value, there were certainly many items of lesser value that were divided among other officials. Willy Jochims, as a non-Jew, may have received some of this material. This theory, while not documented, certainly remains a possibility; it is especially intriguing because we know that the couple came to the United States in the early 1950s and attempted to sell a lift (large storage container) full of decorative objects, paintings, and artworks. When they didn't receive the prices they wanted, they returned to Germany with most of the items.

Despite this theory, we remain unconvinced that the Seder plate actually was taken with other stolen objects from Jewish homes. There remains the tantalizing possibility that it was a family heirloom, though Karen has contacted every family member possible and not a single individual remembers the plate as a family heirloom. Alternatively, the plate could have been given to the Jochims for safekeeping by a family from a neighboring village, which might explain Cilly's attachment to the object. Nonetheless, the research on the Seder plate has brought attention to other questionable activities of the Jochims.

Future Research

Additional research to identify the plate's original owners, determine its provenance throughout the centuries, and nail down what actually transpired in the 1940s will be facilitated by exhibiting the Seder plate in the village of Langendernbach, the plate's possible place of origin, and in Cologne, where it last changed hands. Exhibition in these venues also will bring attention to the general issues of our research. Collaborations between local historians and institutions like museums, banks, libraries, and the media during the exhibitions will increase their respective efforts to follow up on these issues.

Conclusion

To research the history of this Seder plate, we used three approaches that have been both effective and replicable. They are:

International collaboration. With partners in the United States and Germany, we have had broad access to archives and historians and few problems with language issues. Our differing research strategies and approaches, used in combination, were effective in tackling problems.

Genealogy. A particularly useful strategy for provenance research of family property like a Seder plate was the use of genealogists contacted through the Web. Partnering with the genealogists enhanced our ability to trace family members. We also engaged local German historians, who were quite helpful.

Display in Germany. Exhibition of the Seder plate in Germany enabled us to gain valuable research information. More important, these exhibitions raised awareness about the plundering of Jewish property, contested ownership of objects acquired during the Nazi period, and unsolved problems of restitution.

Notes

1. Wolfgang Fritzsche (Gustavsburg) Hubert Hecker (Frickhofen), Irene Corbach (Cologne), archives Nuernberg, Koeln, EL-DE Haus Koeln.

2. Paul Arnsberg, *Die Juedischen Gemeinden in Hessen*. Frankfurt/Main: Societätsverlag, 1971.

Identifying Owners of Books Held by the Jewish Museum in Prague

Michal Bušek

THE HOLDINGS of the library at the Jewish Museum in Prague (JMP) have been shaped by historical events, particularly World War II and the postwar situation in the Czech Republic. JMP was established in 1906 and is the third-oldest institution of its kind in Central Europe. (It was preceded by the Jewish museums in Vienna in 1895 and Frankfurt in 1897.) Its founding purpose was to preserve items in Prague synagogues, which were being destroyed during the early 20th-century urban renewal of Jewish ghetto areas. The task was to collect, preserve, and exhibit ceremonial artifacts, historical documents, manuscripts, and rare prints originating from Prague or Czech lands. The museum operated until the Nazi occupation in 1939, at which time the collections were placed under the administration of the Jewish community.

In autumn 1941, mass deportations of Jewish populations began. The Jewish community looked for a way to preserve various Jewish items from 153 communities in Bohemia and Moravia. In spring of 1942 community members formed a plan to establish a Jewish Central Museum (JCM) where the holdings of all the Jewish museums and communities could be collected. After lengthy negotiations with the Nazis, the project was approved and the JCM began to operate on Sept. 3, 1942. Thousands of items were gathered, sorted, catalogued, and recorded. The Nazis, unlike the museum staff, wanted to create a museum of an extinct race, and the museum staff was urged to prepare private exhibitions for Nazi leaders. The first of these was a Hebrew manuscripts and rare prints exhibit. Most of the museum employees were gradually sent to ghetto Theresienstadt and later to Auschwitz, where many of them perished.

The JCM's library holdings comprised mostly traditional literature from Jewish communities (rabbinic writings, prayer books, and fiction and nonfiction books by Jewish authors). Individual property was placed under the administration of the Treuhandstelle—an organization established in 1941 to take care of confiscated property. Confiscated books were cleaned and *ex libris* (references to their owners) removed. Many books had multiple copies. By March 17, 1943, there were 778,195 books under the administration of the Treuhandstelle; yet only half of the confiscated property had been processed. For purposes of owner identification, the central card catalogue, where every item was recorded, was very valuable.

After World War II the Jewish museum was restored. The original library of Prague's Jewish community (which was not processed for owner identification) became part of the museum library, so the holdings of JCM (approximately 46,000) now include books from the library of ghetto Theresienstadt, chateau Mimo, and other places. Zentralbuecherei Theresienstadt was founded in 1942 and contained approximately 250,000 books. The collection included books confiscated from deportees, but the largest number of books came from abolished German-Jewish organizations, Masonic lodges, or rabbinic seminaries in Berlin, Wroclaw, and others. In total, more than 100,000 books were transferred from Theresienstadt to the Jewish museum.

Beginning in 1944, all books and manuscripts confiscated from various European libraries

and organizations were gathered at chateau Mimo and other surrounding castles, including Novy Falkenburg, Novy Pernstejn, and Houska. The books from these places were transferred to the museum in 1947.

Between 1945 and 1950 some of the library holdings were loaned temporarily to approximately 52 reestablished Jewish communities in the Czech Republic. These loans were written off the museum inventory in 1950. Parts of the collection were donated to the American Jewish Joint Distribution Committee (JOINT, 34,900 books), the United Nations Relief and Rehabilitation Administration (UNRRA, 65,115 books), and the National and University Library in Jerusalem (40,000 books), while other books were subject to restitution claims. In total, 158,132 books were removed from the collection catalogue through these means.

In 1950, the Jewish museum and its collections came under the administration of the state. Ninety thousand books were donated to the National Recovery Foundation (which operated between 1945 and 1951 and provided temporary management and distribution of confiscated enemy property). Approximately 158,000 books were returned to their original owners or sent to other organizations. However, at the same time, more than 190,000 books were transferred to the Jewish museum from various places as war or after-war transfers.

Looking at all these changes of ownership, it is obvious that JMP's library collections include many books that belong to identifiable original owners. During the communist regime, this collection was largely unavailable for processing of any kind. The museum lacked adequate storage capacity and had no money to build state-of-the-art facilities where the books could be stored and processed. In 1994, the holdings of the State Jewish Museum in Prague were returned to the Federation of Jewish Communities in the Czech Republic. That same year, the Jewish Museum in Prague was established—in 2004 we celebrated our 10th anniversary—and director Dr. Leo Pavlát initiated the complex work of restoring collections and exhibits, including the construction of a new administration building with state-of-the-art facilities for the library collections. The book collections were moved at the beginning of 2001, the same year, library department staff started a comprehensive examination to determine their original owners.

Identification of the Books' Original Owners

Out of a total of 100,000 library holdings, library staff physically checked approximately 80,000 volumes, including periodicals and rare and old prints. JMP also administers approximately 34,000 books that are not included in the library holdings and have not yet been processed; most of these are originally from Theresienstadt. These books are stored in a temporary depository in Brandys nad Labem. Once their final storage place has been decided, the books will be recorded on an inventory list and their owners identified.

Pairs of library employees worked in shifts, checking the collections every day even while the library was fully operational. The work was carried out in the storage facilities, where there are optimal conditions for the books (temperature: 17-18 degrees Celsius, humidity: 50 percent). But in such an environment one can work comfortably for no more than 2 and 1/2 hours at a stretch. There were eight shifts each week; Friday was dedicated to checking questionable owners and problematic identifications, verifying similar or identical names, and database maintenance and administration.

The project was organized to allow one staff member to check the book itself while the other entered the information in a special database created by M. Vanicky, based on suggestions from library employees. Because of the time-consuming nature of the project, staff recorded included only the most essential information: inventory number, location number, and the owner's original record. This information included the abbreviation of an institution's or indi-

vidual's name; type of record (*ex libris*, card, stamp, written entry, signature, binding, etc.); and the text of stamps or cards containing the full name of the institution or, in case of individuals, address. A complete database entry also might contain information about the author of the book; its title, language, place and year of publication, publisher, and method of acquisition; and who had recorded the entry. Of course it was not always possible to fill in all the details completely, especially if the title page was missing.

We came across owner records in different languages; in addition to Czech and German, there was also Hebrew, Yiddish, Latin, Italian, Russian, Hungarian, and English. The biggest problem was reading and decoding owner records, especially handwritten names and signatures. It was impossible to determine some of the Hebrew and Yiddish names. Another problem was the appearance of more than one owner recorded in a single book. As the museum is not able to determine the chronology of each notation, all the information found was entered in the database.

The primary purpose of this database project is to identify the owners of the books, but there are other possible uses as well. Authors' dedications or mentions of significant personalities from Jewish communities are of great value for exhibition purposes. It is possible to find out what kinds of books were used during important life events such as bar mitzvahs, weddings, and so on. If a large numbers of books are identified as belonging to one individual, we can make assumptions about the nature of his personal library.

Continuing Efforts

From May 2001 to October 2003, museum staff examined 80,517 books. Thirty-four thousand contained owner records; these included books marked with the Theresienstadt library stamp or stamps from individuals. Only a small portion originally belonged to European Jewish organizations, which means that not all the books with owner records will be subject to eventual restitution demands. More than 5,000 owners—individuals and organizations—were identified. In some cases it was impossible to identify an owner conclusively from the record in the books; such owners were labeled "unidentified." The records were input using the Aleph database system, which the library has been using since 1996.

The only interruption to the processing was caused by floods in 2002. Damage in the basement of the administration building resulted in a long-term electrical shortage. During this down time (Aug. 13-Oct. 21, 2002), database maintenance was performed, and database entries were verified and updated. The database is fully searchable by owner name and place and can display a list of books containing a specified owner mark. Library holdings are continually processed into the Aleph database system, and when any change of book records occurs (call number change, etc.), the change is also recorded in the original owners database.

The original owners database project is time-consuming, and only the first stage has been completed. Our current plan is to check physically the books stored away from JMP's central facilities and document all owner-related information. JMP is willing to take part in similar international and bilateral projects, particularly since we presume that part of the original Library of the Jewish Community in Prague is situated today in Berlin and Vienna. Such international cooperation would improve our ability to determine the original contents of various European Jewish libraries.

JMP, of course, accepts restitution demands of all kinds, and our plan is to discuss returning some books to their original owners. Current regulations in the Czech Republic do not permit the return of property to organizations, only to individuals. Books from pre-war Czech and Moravian Jewish communities were placed under the administration of the Federation of Jewish Communities in the Czech Republic and are excluded from restitution demands of any kind.

Top: *Filled-out chart* from JMP's database.

Center: *Completely filled-out chart.*

Below: *Information about owner and list of owned books.*

Courtesy of Michal Busek.

Individual restitution demands will be judged by the restitution committee; organizational demands will be followed by negotiations and, we hope, an international project to determine the pre-war collections in Europe's Jewish libraries. Of course, a crucial condition for the above-mentioned restitution work and subsequent projects is the completion of the original owners database project.

Further information is available on the JMP Web site, www.jewishmuseum.cz.

Important Dates

1906	Establishment of the Jewish Museum in Prague
15.3.1939	Nazi occupation of Bohemia and Moravia
1939	Museum closed to the public
13.10.1941	Creation of Treuhandstelle
24.11.1941	First transport to Ghetto Theresienstadt
3.8.1942	Central Jewish Museum begins to operate
1942	Inception of Zentralbuecherei Theresienstadt
1945	The end of World War II
	Reestablishment of the Jewish Museum in Prague
1945-1947	Transfers of holdings from Theresienstadt and Mimo to the museum library
	Carried out some restitution demands and released books to reestablished Jewish Communities in Czechoslovakia
	Donation to JOINT, UNRRA, and Jewish National and University Library in Jerusalem
1950	Collections placed under administration of the state
	State Jewish Museum in Prague founded
1989	Collapse of the communist regime in Czechoslovakia
1.10.1994	Museum buildings and collections returned to the Jewish Community of Prague and the Federation of Jewish Communities in the Czech Republic
	Jewish Museum in Prague re-established
2001	Construction of JMP's new administrative building completed
	Books moved to new storage facilities
	Original owners database project begins
2003	First stage of database project ends

The Plunder of Jewish-Owned Books
and Libraries in Belgium

Daniel Dratwa

AS FOUNDING curator of the Jewish Museum of Belgium, I have watched private individuals bring us cardboard boxes full of books in foreign languages like Yiddish, Hebrew, and German for two decades now. Among the books included in these donations are some that surely originated in the public and private libraries of Jews in Belgium.

A few years ago, our interest in the field of the history of Jewish libraries and collectors of books in Belgium was aroused by the fact that Jacques Lust—the Belgian delegate of the Minister of Economic Affairs in charge of the restitution of looted cultural goods—discovered in the Ukraine documents on public and private libraries looted in Belgium by the Einsatzstab Reichsleiter Rosenberg (ERR). To find out if it was possible to further pursue this lead, he asked me to inquire about distinctive marks that appeared on the books owned by the different Jewish libraries and possibly the Jewish Museum of Belgium. As of today, we have found 118 different marks on the books owned by the museum.

Let us turn our attention now to the number of looted Jewish books. First, we will estimate losses from private families' collections of books. Historians estimate the Jewish population in Belgium around May 10, 1940, to have been between 65,000 and 70,000; from this we can hypothesize that about 15,000 families had at least some books. We know that roughly 8,000 households were seized during the Mobelaktion that started in January 1942. First, apartments that had been abandoned by Jews who had run away were seized; afterward, the dwellings of Jews deported to Auschwitz were taken. If we say that in each of these 8,000 households there were on average only 50 books, we are speaking of a minimum of 400,000 books stolen from Jewish private citizens.

Second, we will estimate losses from libraries and institutional collections. After investigating archival sources in Brussels or Antwerp as well as New York and Jerusalem, and without including libraries of religious books built by synagogues and oratories, we have counted 16 libraries created by Jewish institutions before May 10, 1940. We have not found the exact number of books in each of these institutions, but we know today with some precision the activities those libraries organized through the years to improve their collections. We have discovered that the most important pre-war library was created by the Agoudath Zion in Antwerp as early as 1906, and we know that it contained several thousand volumes in various languages but mostly in Yiddish, Hebrew, and German. The oldest library was that of the Alliance Israelite Universelle, founded at the end of the 19th century in the heart of the main Jewish community in Brussels. Another fine example is the library of the Tachkemoni school in Antwerp, assembled after 1925 by Rabbi Moshe Avigdor Amiel, who would become in 1936 the Great Rabbi of Tel-Aviv. In 1946 this institution compiled a filing for war damages describing precisely and accurately 4,000 works that were stolen.

We know from the documents found that those libraries were a main target of the ERR. The

report of the Buysse commission (July 2001, page 141) notes that "De octobre 1940 à février 1943, l'ERR Belgien envoya au quartier general de Berlin . . . 800 caisses contenant des livres et archives." ("From October 1940 until February 1943, the Belgium ERR sent to the Berlin head-quarters . . . 800 crates containing books and archives.") If we could reliably estimate the number of publications packed in one crate, it would permit a better understanding of the scope of the actions taken by the ERR. However, such an estimate is problematic because of the vary-ing ways the crates could be packed. For example, the library of Speyer, a Jewish senator, which contained 5,500 volumes, was arranged in 18 crates—305 books per crate. However, the ERR also stole from the house of Bernard Rothschild 220 publications that were put in two crates—110 books per crate.

If we assume, as does the official commission, that on average 150 books were contained in each crate, we can estimate the minimum number of books sent by the ERR to Berlin to have been 120,000 units. If we now take into account the fact that, of the 150 Belgian libraries loot-ed by the ERR from 1940 until 1943, two-thirds of them were of Jewish origin and that these two-thirds accounted for 47 percent of the total crates sent to Berlin, it means that 57,000 books were taken away from Jewish libraries and institutions in Belgium. Now if we add to that the earlier estimate of 400,000 books stolen from Jewish private citizens, we come to a total of *half a million* books looted from Belgian Jewish institutions and families.

The final question is, "How many books were found and given back after the war?" Here are a few examples, beginning with the most recent.

> In 2002 a single book was given back to a Jewish family from the collection of the Royal Library thanks to research made by the Buysse commission. This commission also found in the Sequestration Office 18 Hebrew books belonging to the Cerf family.

> In 1998 the Jewish Community of Antwerp gave to the Jewish Museum of Belgium 460 books in Yiddish from the library of the Agoudath-Zion in Antwerp with the stamp of the Centrale Anti-Juive pour la Wallonie et La Flandre, located on rue Philippe de Champagne in Brussels.

> Fifty years earlier, the Consistoire bought from the ORE Administration 565 books that had been found in the suburbs of Brussels. (L'Office de Récupération Economique [ORE] was established on Nov. 16, 1944, to research in Belgium or abroad all the goods that were neglected or taken by the Nazis; identify the owners of those goods; to recover their value.)

A few Jewish families were also lucky enough to recover some books, including the Errera family (214 books) and Stern family (124 books), which accounted for about 5 percent of their losses. In total we can say that a maximum of 5,000 books, or 1 percent of the looted books, has been returned during the last 60 years!

Left: A book from the collection;
note the Nazi stamp above the
stamp of the Jewish Library.
Courtesy of the Jewish Museum in
Belgium.

Below: The president of the
Sephardic Synagogue in Antwerp,
October 1944. Courtesy of the Jewish
Museum in Belgium.

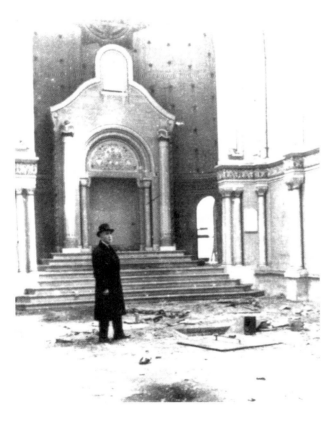

Case Studies: Part II

Peter Paul Rubens's Allegory of Eternity: A Provenance Research Case Study

Steven Kern

ON FEB. 18, 2000, the San Diego Museum of Art (SDMA) received a claim on behalf of the heirs of Jakob and Rosa Oppenheimer, Jewish owners of the Galerie van Diemen in Berlin, for the return of *Allegory of Eternity*, an oil sketch by Peter Paul Rubens.[1] An important work related to a series of tapestries at the convent of the Descalzes Reales in Madrid, the Rubens oil sketch has been in the museum's collection since 1947.[2]

The claim was filed by a Paris lawyer representing Oppenheimer heirs: one surviving daughter in Argentina, a grandchild and great-grandchild in France, and grandchildren in the United States (Florida and New Jersey). The lawyer informed the museum that Mr. and Mrs. Oppenheimer, the Jewish owners of a corporation of Berlin galleries, were forced by the Nazi government in 1935 "to throw on the market their jewelry, paintings, and other fine art objects." She asserted that the museum had bought the Rubens oil sketch "from the person or the successors of the person who spoliated [her] clients" and that this could be confirmed by the German administrations of restitution. The museum was requested to restitute the painting in conformity with the "Berlin declaration" of the German government, the Länder (German states), and the municipalities, in accordance with the 1998 Washington Conference on Holocaust-Era Assets.

The claim arrived just as SDMA was coming up to speed in the area of Nazi-era provenance research, which in 2000 was changing from an interesting, if daunting, topic into a new profession-wide initiative. A new position had only just been added in the Department of European art, an assistant curator whose workload eventually would be dominated by provenance work— 75 percent provenance research and 25 percent other duties.

Having received the claim, the very first thing SDMA did was to confirm the painting in question was, indeed, the work in its collection, which it clearly was. Its 1935 sale at the Graupe auction house in Berlin, for example, was documented in our own records. The museum also responded with a request "for information from the claimant in order to assist in determining the provenance of the object." Specifically, the museum requested evidence of ownership along with evidence of forced sale without appropriate compensation or restitution. Further, the museum requested evidence that the museum had purchased the painting from the "person or successors to the person who spoliated" the Oppenheimers, a claim apparently refuted by museum documentation.

In the meantime, the museum initiated its own research, reviewing the object file and correspondence and completing a physical examination of the painting's back. This yielded no new information. The European department also began a crash course in Nazi persecution of the Jews between 1933 and 1935, forced sales in Berlin, the Galerie van Diemen, and the Oppenheimers.

At the outset of research on the claim, the provenance listing for the oil sketch included

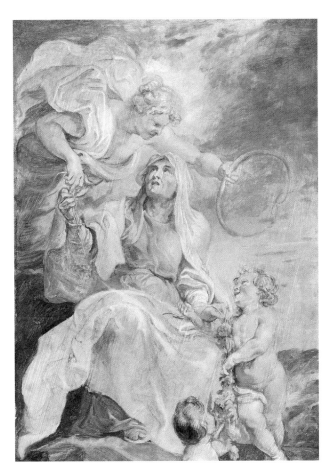

Allegory of Eternity, c. 1625-30, Sir Peter Paul Rubens, Flemish (1577-1640). San Diego Museum of Art (gift of Anne R. and Amy Putnam, 1947; funds for Nazi-era restitution settlement provided by the estate of Walter Fitch III, 2004).1947.8.

several significant gaps and problematic inconsistencies. Our original provenance read as follows:

> Hermitage Collection, St. Petersburg, Russia; Duke Vladimir Bariatinsky, Stroganoff Palace, St. Petersburg, Russia; (sold at) Rudolf Lepke auction house (Sammlung Stroganoff, no. 73), Berlin, Germany: May 12-13, 1931; van Diemen sale, Graupe, Berlin, Germany: January 25-26, 1935; Frederick A. Stern, 1942; (with) Jacob M. Heimann, New York, New York: 1946; Gift of Anne R. and Amy Putnam.

Julius Held's entry in the critical catalogue[3] added two additional bits of information: one, "in the possession of a printseller for sale, 1835"; and two, "liquidation sale," van Diemen and Co., Berlin.

What exactly were the questions, gaps, and concerns? Several are obvious. For example, where was the painting between the Stroganoff Sale in 1931 and the van Diemen sale in 1935? When and from whom had the Galerie van Diemen acquired the painting? What were the implications of a "liquidation sale" in Berlin in 1935, before Kristalnacht and the notorious, so-called "Jew sales" a couple of years later? Who benefited from the proceeds of the sale? Were all liquidations forced? While irrelevant to the claim, how and when did the painting get to the United States? Finally, prior to its time in Germany the painting appeared to have been nationalized by the Soviets and then sold in Berlin, adding another interesting layer to its history.

In 2001, still waiting for a response from the claimant, the museum continued its research using local and national resources such as the Getty Research Institute and the Frick Art Library. We also contacted colleagues for advice on the chance that someone might be able to contribute some insight into the situation. The Getty Research Institute was able to provide a copy of the Graupe catalogue for the van Diemen liquidation sale. The sale was an impressive one, indeed, covering scores of Old Masters, including several by Rubens; lot number 51 was the San Diego *Allegory*. With so many works liquidated in one sale, it was puzzling that more information wasn't immediately available about the Galerie van Diemen and the Oppenheimers. It also seemed strange that there was no word of other claims in the museum community concerning this gallery, family, and sale.

We gained deeper knowledge of issues surrounding Nazi-era provenance during sessions at the AAM annual meeting in St. Louis in 2001, when AAM's *Recommended Procedures for Providing Information to the Public about Objects Transferred in Europe during the Nazi Era* were introduced. Also making its debut at that same meeting was *The AAM Guide to Provenance Research* by Nancy H. Yeide, Konstantin Akinsha, and Amy L. Walsh. The sessions and the book gave us insight into the procedures and policies we needed to have in place at the museum. They also provided resources to accelerate research. Finally, the *Guide to Provenance Research* provided our first solid information on van Diemen and Co. Interestingly, the gallery had branches in Amsterdam and New York, where in the 1930s it had become affiliated with Karl Lilienfeld, which in turn later was acquired by Achim Moeller. Unfortunately, Achim Moeller does not have the old van Diemen files. There seemed to be no trace of the van Diemen files in the United States or Europe.

Now we knew a little about van Diemen and Co., but still almost nothing about the Oppenheimers. Then at the first AAM Provenance Research Seminar, held at the National Archives and Records Administration-II in College Park, Md., in December 2001, we finally connected with a colleague who had heard of the Oppenheimers and their connection to the Galerie van Diemen. This illustrates the importance of networking among provenance researchers. She directed us to a report prepared by a German researcher in response to a claim for two works by Rubens that appeared in the same liquidation sale as our painting, one in Karlsruhe and the other in Stuttgart.[4]

This report gave the museum its first understanding of who Jakob and Rosa Oppenheimer were. In a nutshell, they were among the most successful of Berlin's dealers, running the Margarf & Co., with its affiliates Dr. Benedict and Co., Dr. Otto Burchard & Co., Altkunst-Antiquitäten, and van Diemen and Co. Accused by the Nazis as being "Jewish capitalists," they fled on April 1, 1933, to avoid being apprehended by the Gestapo. Their businesses eventually were closed, and their stock liquidated. Both Oppenheimers ultimately lost their lives. Their family splintered.

More than two years passed before a communication from the claimants arrived in response to our October 2000 request for additional information. On Dec. 14, 2002, the Paris lawyer renewed her request for restitution of the painting in a new communication. The substance of the claim, however, was now very different. No longer was she simply representing the Oppenheimer estate on behalf of the heirs and requesting that the SDMA painting be returned to them. She now represented van Diemen and Co. as duly appointed liquidator. She requested the restitution of the painting to the company for the benefit of the stockholders—the Oppenheimer heirs listed in the first letter. The delay in responding to our request for information, she explained, was her desire "to create a precedent."

In fact she had two to bring forward. One was an agreement with the German government

for the return of Adriaen van de Velde's *Landscape with Shepherds, Horse, Cow and Sheep*, on deposit in a German provincial museum. The legal basis for this restitution was the 1991 Property Settlement Law and the 1999 Joint Declaration, covered elsewhere by Harald König. The second precedent was an agreement with "one of the most important American cultural institutions on the East Coast." Whereas the museum was provided with full citation of the German restitution, the agreement with the "important American cultural institution" was confidential—not a big help to us in determining how to resolve our case.

While the Paris attorney's first letter had been little more than a half-page with only two attachments, the second was two-and-one-half pages, with 17 attachments. Unfortunately, several were incomplete, virtually all were in German, and many were rendered illegible by the fax transmission. New copies, translations, and clarification of ideas were requested. For the following year, our legal counsel was engaged in regular correspondence—at times a bit adversarial—with Paris, attempting to explain the balance between collections stewardship, fiduciary responsibility, and the public trust, all legal and moral issues relating to Nazi-era provenance. As we stated in our very first response, "It is our intent and desire to resolve matters such as this in an equitable, appropriate, and mutually agreeable manner. We cannot do so without the facts." We were dogged by lack of proof of ownership: no files, no receipts. Did the Oppenheimers share interest in the painting with someone else? Was it on consignment? What was the relationship between the Berlin gallery and its branches, especially the one in New York? These questions took us back to the mystery of the painting's whereabouts between 1931 and the liquidation sale in 1935.

Soon after the receipt of the second letter, the museum decided to engage outside legal counsel (until then the museum had been represented *pro bono* by the law firm of our board president). Thad Stauber, then counsel at the Los Angeles County Museum of Art, came to our museum to advise us. He was not able to represent SDMA given his role in Los Angeles, but he recommended Tom Kline of Andrews Furth in Washington, D.C., who had worked on the case of the Art Institute of Chicago's Degas *Landscape with Smokestacks*. Tom consented to work with us, the first time he took a case representing an American museum rather than claimants. We also contacted Laurie Stein, as we were anxious to engage the services of a seasoned provenance researcher with experience in Germany. She was unable to work with us, but suggested Ilse von zur Mühlen, who was working with the Bayrische Staatsgemäldesammlungen. Through all these referrals, we were able to assemble an excellent team to work toward resolution of the claim.

Ilse did brilliant work, consulting many sources for us and helping us to build a clearer picture of the Oppenheimers and their affairs. She also tracked down all of our references in an attempt to flesh out the painting's history of ownership, especially the details of the van Diemen acquisition of the Rubens. She spent time in Berlin at the Restitution Offices, the Office of Commerce, the Bundesarchiv, the Berlin Document Center, and consulted the Reichskulturkammer records. She also surveyed the German literature for information on the Oppenheimers, van Diemen, and its gallery stock.

As a result of this work, by November 2002 the provenance record for the Rubens oil sketch had changed radically:

Anonymous printseller, London, 1835; Prince Vladimir Bariatinsky, Saint Petersburg, Russia, ca. 1864-ca. 1920; State Hermitage Museum, Saint Petersburg, ca. 1920–May 1931;[5] (through Rudolf Lepke Kunst-Auktions-Haus, Berlin, sold with the Stroganoff collection, May 12-13, 1931, cat. No. 2043, lot 73);[6] (with Leo Blumenreich, Berlin, May 1931);[7] (with Galerie van Diemen, Berlin, 1932-1935);[8] (through Paul Graupe auction house, liquidation

sale of Galerie van Diemen [Berlin branch], Berlin, January 25-26, 1935, lot 51); (with Arthur Goldschmidt/J.S. Goldschmidt, Berlin, 1935); Conrad Bareiss, Salach, Germany, ca. 1938-1939 (unspecified art dealer [U.S.A.?], 1940);[9] Frederick A. Stern, New York, 1942; Zinser Collection, New York, ca. 1946; (with Jacob M. Heimann, New York and Beverly Hills, 1946-1947); purchased by Anne R. and Amy Putnam for the Fine Arts Gallery (now SDMA), April 30, 1947.

In November we agreed to go to Berlin to review confidential files in the Berlin LAROV[10] and the Oberfinanzdirektion. We were to be accompanied by the Paris lawyer and an Oppenheimer grandson, who would represent all of the heirs. The trip took place in January 2003. Tom Kline, SDMA provenance researcher Claudia Leos, and I met with Ilse von zur Mühlen to review all records, documents, and outstanding questions. After three days of meetings with the Paris lawyer and her Berlin colleague (the heir had not come), we had a full understanding of the Oppenheimers, including their persecution and flight from Germany and attempts to continue operations from France and Switzerland, the closure and liquidation of their Berlin galleries (including van Diemen), Jakob's 1941 death in Nice following internment there, and Rosa's 1943 deportation, first to the concentration camp at Drancy and then in the 61st transport from France to Auschwitz, where she was killed on Nov. 2.

We knew, too, that the liquidation sale was well attended and that even though the prices were high, they still only represented about half of the works' estimated value. We knew that neither the Oppenheimers nor their heirs had benefited from the revenues of the 1935 sale; we knew that Jewish flight and property taxes had absorbed all assets. We knew that restitution paid to the heirs in 1957 had been the maximum allowed—75,000 marks—for an estimated value of approximately 500,000 marks, and that in the 2001 settlement with the German government, the restitution was not required to be paid back. We also knew that there was no evidence of further restitution or settlement for the San Diego painting.

But there were still questions: what exactly was the nature of the Oppenheimer dealings after their flight from Germany? What was the nature of the relationship of Oppenheimer with van Diemen, New York? How had the painting become part of the gallery stock or was it even part of the gallery stock? What are the implications of a painting purchased by a Jewish Berlin dealer from a Jewish liquidation sale?

We were convinced, however, that, while interesting, further research would have revealed little more relevant to this claim. The cost for additional research seemed unnecessary. Litigation was to be avoided for two reasons: cost and risk. Besides, if we entered into litigation, under whose law would the case be tried? (In California, we learned, the German laws probably would have applied.) Rather than litigate, we negotiated a settlement with the Paris lawyer and her Berlin colleague that would allow us to retain ownership of the painting. In the final agreement, which was accepted as just and fair by all parties, only the sum of the settlement is confidential. We wanted the rest of the story to remain public. It is important that we share the story and our process with colleagues, knowing that there will likely be future claims from the same sale and wishing that we had had the benefit of more information sooner.

The settlement was unanimously approved by the SDMA board of trustees at its March 2004 meeting and the painting's credit line was permanently changed: Gift of Anne R. and Amy Putnam, 1947; funds for Nazi-era restitution through settlement to Galerie van Diemen, Berlin, provided by the estate of Walter Fitch III.

Notes

1. Sir Peter Paul Rubens, Flemish, 1577-1640; *Allegory of Eternity*, c. 1625-30; oil on panel; 26 x 13 1/2

in. (66 x 34.3 cm). Gift of Anne R. and Amy Putnam, 1947; funds for Nazi-era restitution settlement provided by the estate of Walter Fitch III, 2004. 1947:8

2. The claim first had been sent via fax to the Timken Museum of Art, SDMA's next-door neighbor. The confusion as to the present owner and location was certainly due to a shared history of the two institutions; the founders of the Timken, sisters Anne and Amy Putnam, had been until 1950, the greatest benefactors of the San Diego Museum of Art, donating nearly 300 paintings beginning in 1927. SDMA had loaned the Rubens to the Timken for several years after its opening in the early 1950s and a catalogue, including the Rubens *Allegory*, was published in 1969. The entry for the painting in Julius Held's 1980 critical catalogue of Rubens oil sketches (see note 3) cited both institutions, the Timken as the present location and the SDMA as the owner. Further complicating the issue, the San Diego Museum of Art had changed its name from the Fine Arts Gallery in the early 1980s.

3. Julius S. Held, *The Oil Sketches of Peter Paul Rubens: A Critical Catalogue, Volume I* (Princeton University Press for the National Gallery of Art, 1980): cat. no. 114, p. 161; illus. pl. 118.

4. Rubens's *Marchesa Veronica Spinola Doria* at the Staatliche Kunsthalle Karlsruhe and *Marchesa Bianca Spinola Imperialis with Her Granddaughter* at the Stuttgart Staatsgalerie.

5. According to dealer Jacob Heimann (Heimann correspondence to Reginald Poland, SDMA Curatorial Files, Aug. 1, 1946), Vladimir Bariatinsky gave this painting to the Hermitage in Saint Petersburg. In light of historical circumstances it is probable that this painting was acquired by the Soviet government for the State Hermitage Museum from Prince Bariatinsky when Russian private collections were nationalized (1920-30). The painting also bore a label on the reverse that read in Russian "State Museum of Fine Arts."

6. From 1930 to 1933 the Soviet government authorized massive sales of art objects from Russian private collections and museums to be sold abroad. According to Robert C. Williams (*Russian Art and American Money*, Cambridge, Mass.: Harvard University Press, 1980, pp. 179, 182), the sale of the Stroganoff Collection, which had been nationalized by the Soviet government after the Russian Revolution, also included works of art that were not part of the Stroganoff collection but from the Hermitage Museum, such as Rubens's *Allegory*.

7. Art journals documenting the 1931 sale state that the painting was bought by "dealer Blumenreich of Berlin," who has been identified as Leo Blumenreich, a leading art dealer. Nora de Poorter, mentions the names of "Blumenreich and Benedict" as the 1931 buyers of the painting in *Corpus Rubenianum, Part II, "The Eucharist Series,"* vol. I (Brussels: Arcade Press, 1978), p. 388, without citing a source. The name "Benedict" could refer to well-known dealer Kurt Benedict, director of Dr. Benedict & Co., Berlin (a sister company to van Diemen). No further information has been found to confirm Benedict's involvement in the sale or in the painting's subsequent transfer to Galerie van Diemen.

8. The painting is documented as being in the New York branch of the van Diemen Gallery in 1932 in the photo archive of the Rijksburo voor Kunsthistorische Documentatie, the Hague, the Netherlands. It was lent to a Rubens exhibition at the Goudstikker gallery in Amsterdam in 1933. We presume van Diemen ownership although no lender information was given. In 1935, the Galerie van Diemen, Berlin was liquidated by order of the Nazi government. Its stock was sold through the Paul Graupe auction house in Berlin and dealer Arthur Goldschmidt bought *Allegory of Eternity* at the sale.

9. This painting was listed in the catalogue of "Masterpieces of Art," an exhibition at the 1940 New York World's Fair, as an anonymous loan. The works of art were lent by the following dealers: Mortimer Brandt Gallery, Buchholz Gallery, Demotte, Inc., Downtown Gallery, Paul Drey, Durand-Ruel Inc., Durlacher Brothers, Duveen Brothers, Inc., Ferargil Galleries, Marie Harriman Galleries, Jacob M. Heimann, Jacob Hirsch, F. Kleinberger & Company, M. Knoedler & Co., Inc., C. W. Kraushaar Art Galleries, Robert Lebel, Paris, Karl Loevenich, Milch Art Gallery, Newhouse Galleries, Inc., A. Seligman, Rey & Co., Inc., Jacques Seligmann & Co. Inc., Spanish Art Gallery, London, Frederic Stern, Brussels, Wildenstein & Co., Inc., Howard Young Galleries. The lender of *Allegory* is presumed to have been Frederick Stern, who owned the work in 1942.

10. The Berlin Landesamt zur Reglung offener Vermögensfragen (State Office of Open Assets Questions).

<div align="right">

Walter Westfeld (1889–1943?):
Art Dealer in Nazi Germany

</div>

Victoria S. Reed

CERTAIN art dealers in Nazi Germany are familiar to provenance researchers. We are attuned to red-flag names like Karl Haberstock, Gustav Rochlitz, and the Galerie Fischer, and paintings that were in their possession are scrutinized and featured on our museum websites. My purpose here, however, is to examine an almost unknown art dealer in Nazi Germany, Walter Westfeld, who did not profit in the Nazi era, but was instead one of its victims. Through the example of *Portrait of a Man and Woman in an Interior* by the 17th-century Dutch painter Eglon van der Neer, which passed through Westfeld's hands in the 1930s, I will describe a fascinating wartime provenance and outline the steps I took in conducting my research. In addition, this paper is a first step toward piecing together the story of the life and work of Walter Westfeld.[1]

When the Museum of Fine Arts (MFA) in Boston purchased van der Neer's signed *Portrait* from Silberman Galleries in New York in 1941, little was known of its history.[2] The painting had been included in two 19th-century sales, that of M. Meffre (Hôtel des Ventes, Paris, Feb. 25-26, 1845, lot 63) and that of Désiré van den Schrieck (Louvain, April 8-10, 1861, lot 68, to Laneuville). Beyond that, however, its provenance was unknown. In 1942 MFA curator W. G. Constable asked Abris Silberman about its provenance. The dealer responded that "the Eglon van der Neer painting was never in any collection in the United States. The painting was brought to this country by a refugee some time ago, and I wish I were able to supply you with more information."[3] It is not clear from this response whether Silberman was selling the painting on behalf of this unnamed "refugee" or another individual, how he had acquired it, or how long it had been in his possession.[4]

Despite this lack of information, Constable persisted in his research, and in 1943 was given further information about the painting by the art dealer Robert Lebel, formerly of Paris.[5] Constable placed a note in the curatorial file indicating that Lebel

> stated in interview Oct. 8, 1943, that c. 1937 he sold this picture to Walter Westfeld, then of Düsseldorf. Westfeld was arrested by Nazi [crossed out] German government in 1938, sent to a concentration camp, and his property seized. This was sold by the German govt. through Lempertz, auctioneer, of Cologne, some time before the fall of France. Whether the picture had previously been sold by Westfeld, or was in the sale, Lebel did not know.[6]

Recognizing that *Portrait* might have been among the objects seized and included in a forced sale of Walter Westfeld's possessions in Nazi-occupied Germany, the MFA identified the van der Neer as one of seven paintings of high priority for ongoing provenance research when the museum's provenance Web page was launched in 2000. The press release issued at the time drew media attention to its history, and the picture was featured in articles in the *Boston Herald* and on the website of the news channel CNN.[7]

Attempts to identify the painting in Lempertz auctions were unsuccessful, due in part to the

Left: *Portrait of a Man and Woman in an Interior*, c. 1666, Eglon van der Neer, Dutch (1634-1703). Museum of Fine Arts, Boston. Seth K. Sweetser Fund. 41.935. Photograph © 2005, Museum of Fine Arts, Boston.

incomplete runs of their catalogues at most libraries. Lempertz itself was unable to supply any information, with its staff stating that their archives had burned during World War II and that they had no documentation from before 1944.

In the fall of 2003, shortly after my arrival at the MFA, I took up research on the painting's history. An examination of the reverse yielded little information about its previous owners. No customs stamps are legible. The frame bears labels from loans that postdate its acquisition by the MFA, along with an unidentified, red-bordered label numbered 2729. The reverse of the panel itself is marked by an illegible red seal.

Through an online search I discovered that in October 1920 a Galerie Walter Westfeld opened at Haufe Wall 14 in Elberfeld (today, Wuppertal, about 20 miles east of Düsseldorf).[8] Announcements in German periodicals from the 1920s indicate that the gallery featured paintings by Rhenish artists, especially of the Düsseldorf school. The gallery also dealt in paintings by Dutch, Italian, and French artists from the 17th to the 19th centuries.[9]

In October 2003 the MFA's online provenance of *Portrait of a Man and Woman* was updated to reflect Walter Westfeld's connection to the Elberfeld art market, and the search for a descendant began in earnest. With the assistance of the Art Loss Register, we determined that Westfeld was born in 1889, that he had been expelled from the Reichskulturkammer (chamber for arts and culture) on the grounds that he was Jewish, and that he had been declared missing at Auschwitz. The Düsseldorf city archive was contacted, but was unable to share further infor-

mation—at least concerning restitution claims—without the power of attorney from Westfeld's heirs.

On May 23, 2004, the MFA received an e-mail from a relative of Walter Westfeld living in the United States, who had found the provenance of the *Portrait* on the MFA's website. He remembered seeing Westfeld last at his 12th birthday party in Essen, just days before Kristallnacht in 1938 and confirmed that Westfeld had operated galleries in Elberfeld and, later, Düsseldorf. Unwilling to leave Nazi-governed Germany, Westfeld secretly continued to operate as a dealer. He relied upon a woman named Emilie Scheulen to manage his business matters; after his death, she was declared to be his wife and took the name Westfeld.[10] None of the members of the family possessed any of his works of art.

On Nov. 12, 2004, I received copies of documents left by Westfeld's brother, including correspondence that sheds further light on his career and even the history of the van der Neer. Most important is a letter from the brother to the MFA (Feb. 6, 1944).[11] The brother cites a letter he received from Robert Lebel in the fall of 1943, that is, at the same time Constable recorded his interview with the dealer. Lebel wrote: "The Museum has purchased a painting which I sold to Walter around 1935-36. . . . You might remember it. Walter had it at the Kleucker Gallery, and also, at a time, in Amsterdam." In this letter to the museum, it is explained that Westfeld ran art galleries at Elberfeld and Düsseldorf until about 1936 or '37, when he was forced by the Nazis to discontinue his occupation on account of his Jewish descent.[12] "From that time on . . . my brother kept his valuable art objects as a private art lover and at the same time put his employee, Mr. Kleucker, in charge of selling part of his possessions under the name of 'Gallery Kleucker' at Düsseldorf."

Two exhibition catalogues published by the Galerie Kleucker give a fuller picture of its stock in 1937-38.[13] It is not clear, however, that Westfeld controlled the operations of the gallery through Kleucker; rather, he may have simply consigned objects to him.[14] Two paintings included in the loan exhibition "Spitzweg: Sonder-Ausstellung" (April 1938), identified in the catalogue as belonging to "Sammlung W. in Düsseldorf" and "Sammlung W. in Wuppertal-Elberfeld" were, according to the 1960 catalogue raisonné of Spitzweg's paintings, lent by "W. Westfeld."[15] The paintings depict monks in outdoor settings and are the only objects from Westfeld's collection (in addition to van der Neer's *Portrait*) that I have succeeded in identifying.[16] That other objects exhibited at the Galerie Kleucker also belonged to Westfeld is probable, but without further information they cannot be identified at this time.

The letter to the MFA continues, "In November 1938 my brother was arrested by the Nazi authorities and put in prison. The [Nazis] seized and sold by auction all of his fortune of which they could get possession." Walter Westfeld was sentenced on July 2, 1940, convicted of violating foreign exchange restrictions, and fined 300,000 Reichsmarks (RM) to be obtained from the sale of his works of art.[17] "The public sale of what was finally left, held by the art firm Lepke [*sic*] in Cologne, yielded a return of more than RM 300,000." The sale of Walter Westfeld's possessions was in fact held at Lempertz, Cologne, Dec. 12-13, 1939.[18] The title page of the auction catalogue advertises it as a Zwangsversteigerung, a forced sale. The van der Neer *Portrait* was not included.

Finally the brother writes in his 1944 letter: "Besides [the Galerie Kleucker] my brother kept in Amsterdam and Paris a number of works of art which are likely to have been seized by the Nazis later, after the invasion of Holland and France." Whether he bought and sold works of art abroad after he discontinued the Galerie Westfeld is unknown, but as late as 1939 he had some paintings safeguarded at the Rotterdamse Wisselbank in Amsterdam.[19] These are said to have been taken and sold by a Mr. van Haastert, with the assistance of a furniture dealer, dur-

ing the war.[20] Though it is not known which paintings were kept at the bank, it is a possibility that the van der Neer *Portrait* was among them, since Lebel wrote that Westfeld had it "at a time, in Amsterdam." To my knowledge these works of art were dispersed and remain untraced.

Lebel himself had been entrusted with a valuable part of Walter Westfeld's painting collection.[21] In 1941 he reported that he had two of Westfeld's paintings in North America: a landscape by Georges Michel, in Canada, and a garden scene by Adolphe Monticelli, in New York.[22] At that time, according to Lebel, all of the other works of art—his own, and those given to him by Westfeld—were in Paris. Subsequently Lebel learned that nearly all of his possessions in France had been seized by Nazi forces during the war. The van der Neer *Portrait* could not have been among these, as it was on the New York art market by June 1941. By 1946 Lebel had recovered many of Westfeld's paintings in France, but what happened to them is not known.

The last time his brother heard from Walter Westfeld was on Nov. 16, 1941, in a letter written from a German prison. After serving his sentence at Lüttringhausen, Westfeld was examined again by the Gestapo, deported to Theresienstadt in 1942, and in 1943 sent to his death at Auschwitz.[23]

Although we still do not know where and when the Eglon van der Neer painting left his possession, through correspondence we recently have learned much more about the life of Walter Westfeld. The importance of providing detailed provenance information, not only in a setting like the International Provenance Research Colloquium, but also on a museum website, has been proved by the serendipitous communication initiated last spring by Westfeld's relative. I hope that others will come forward with facts to fill in the gaps in the story of this painting and, more important, the story of Walter Westfeld. With a fuller picture of his activities as an art dealer, it may be possible to reconstruct his career and honor properly the memory of a man whose life ended so anonymously during the Nazi era.

Author's note: I would like to extend my deep thanks to the family of Walter Westfeld for their generous assistance with the research and the writing of this article. I also thank my colleague Frederick Ilchman, for his help with the development of ideas and with editing, and Jörg Wünschel for his help with translations.

Notes

1. Since this paper was first presented in November 2004, the results of important archival research on the trial of Walter Westfeld have been published by Herbert Schmidt, *Der Elendsweg der Düsseldorfer Juden: Chronologie des Schreckens 1933-1945* (Düsseldorf: Droste, 2005), 273-78.

2. Eglon van der Neer (Dutch, 1634-1703), *Portrait of a Man and Woman in an Interior*, about 1666, oil on panel, 73.9 x 67.6 cm (29 1/8 x 26 5/8 in.), signed, lower right: E. vander Neer f. Museum of Fine Arts, Boston, Seth K. Sweetser Fund, 41.935. When the painting was acquired, the picture over the mantel appeared as a landscape. In 1963 it was cleaned, and the picture was revealed to depict Venus and Cupid. The overpaint existed by 1861, when the picture was described in the Schrieck sale catalogue as "un paysage de Ruisdael."

3. Letter from A[bris] Silberman to W. G. Constable, June 3, 1942, in MFA curatorial file.

4. The archives of Silberman Galleries have been destroyed, so it has not yet been possible to discover where and when the gallery acquired the painting. The earliest mention of it among Silberman's correspondence with the MFA is in a letter to W. G. Constable, June 3, 1941, in MFA Archives, in which the painting is referred to as a "recent acquisition."

5. Robert Lebel (1901-86) of Paris was an art historian, art expert, and dealer, best known for his work on the art of Marcel Duchamp. He fled Nazi Europe around 1940-41 and went to New York,

where he worked as an independent dealer. He returned to Paris after World War II.

6. Handwritten note, Oct. 8, 1943, in MFA curatorial file.

7. Mary Jo Palumbo, "MFA Names Suspect Works," *Boston Herald*, April 11, 2000, p. 47; "Boston museum says Web site art may be Nazi loot," http://archives.cnn.com/2000/STYLE/arts/04/11/holocaust. art.reut/.

8. On the opening of the gallery, see *Kunstchronik und Kunstmarkt 56*, no. 9 (Nov. 26, 1920): 182.

9. For announcements of exhibitions at the Galerie Walter Westfeld during the 1920s, see *Kunstchronik und Kunstmarkt 32*, no. 34 (May 20, 1921): 650; 33, no. 2 (Oct. 7, 1921): 26; 33, nos. 42-43 (July 14-21, 1922): 709; 34, no. 10 (Dec. 8, 1922): 189-90; 34, no. 21 (Feb. 23, 1923): 411; 34, nos. 35-36 (June 1-8, 1923): 661; *Der Cicerone 13*, no. 6 (1921): 190; 17, 1 (January 1925): 48-49; 20, no. 18 (September 1928): 612; and 22, nos. 21-22 (November 1930): 565-66. On the retrospective exhibition of Heinrich Hermanns held there, see Hans-Peter Bühle, "Hermanns, Heinrich," in *Lexikon der Düsseldorfer Malerschule 1819–1918*, vol. 2 (Munich: Bruckmann, 1998), p. 86. Several paintings by Carl Spitzweg were exhibited at the gallery; see Günther Roennefahrt, *Carl Spitzweg. Beschreibendes Verzeichnis seiner Gemälde, Ölstudien und Aquarelle* (Munich: Bruckmann, 1960), p. 203, cat. nos. 666, 668-70, p. 204, cat. no. 677, and p. 264, cat. no. 1159.

10. For further on Westfeld's relationship to Ms. Scheulen, see Schmidt, *Elendsweg*, 273-274, 277. Her marriage to Westfeld was recorded retroactively on May 30, 1956, and she was declared his sole heir.

11. Letter to the director of the Museum of Fine Arts, Boston, Feb. 6, 1944; reproduction in MFA curatorial file.

12. The business actually closed in May, 1936; see Schmidt, *Elendsweg*, p. 274.

13. "Meisterwerke der Malerei des 18. Jahrhunderts" (Düsseldorf, Galerie August Kleucker, September 1937) and "Spitzweg, Sonder-Ausstellung: Katalog mit 16 Abbildungen und 1 Farbendruck auf dem Umschlag und einer Einführung" (Düsseldorf: Galerie August Kleucker, April 1938). Both were loan exhibitions, and several paintings in each were owned by the gallery itself.

14. According to correspondence from August Kleucker (Jan. 31, 1947), all of his records were destroyed.

15. *Spitzweg, Sonder-Ausstellung*, p. 8, cat. 1, *Monch am Meer*, 25 x 36 cm., panel and p. 13, cat. 28, *Mönch vor seiner Behausung, lesend*, 19 x 13.4 cm., panel; see Roennefahrt, *Carl Spitzweg*, 259-260, cat. no. 1117, and 270, cat. no. 1210.

16. The immediate postwar provenance of the two paintings has not been established. See Siegfried Wichmann, *Carl Spitzweg, Verzeichnis der Werke: Gemälde und Aquarelle* (Stuttgart: Belser, 2002), p. 157, cat. no. 171 (Switzerland, private collection; in 1949 Hermann Uhde-Bernays gave an expert opinion of the work) and pp. 361-62, cat. no. 821 (private collection; this appeared in the auction Alte Kunst, Lempertz, Cologne, sale no. 567, Nov. 23-25, 1978, lot 562, as *Monch vor seiner Klause*. No provenance is given in the catalogue).

17. According to Westfeld's relative; e-mail correspondence, Nov. 11, 2004, in MFA curatorial file. See also Schmidt, *Elendsweg*, pp. 274-75. Emilie Scheulen was sentenced at the same time to six months in prison and fined 1,000 RM for aiding in foreign exchange violations.

18. "Zwangsversteigerung von Zirka 700 Ölgemälden neuzeitlicher Meister und einigen Gemälden alter Meister," cat. 404, Lempertz, Cologne, Dec. 12-13, 1939.

19. According to Westfeld's relative; e-mail correspondence, Nov. 11, 2004.

20. According to communication from Albert Salomon (Aug. 6, 1946), a Dutch banker who emigrated to the United States in 1939, Mr. W. K. S. van Haastert, a lawyer, took Salomon's belongings as well as Westfeld's paintings. Van Haastert claimed that the Gestapo had seized them but, according to Salomon, it was later discovered that he had taken them himself and sold them.

21. The following information about Robert Lebel is taken from correspondence supplied by the family of Walter Westfeld.

22. The Michel painting was seized by the Canadian government since it had been shipped from a Nazi-occupied country. Other paintings said to have been entrusted to Lebel include the *Earl of Pembroke* by Anthony van Dyck (about 100 x 120 cm) and a painting of putti by François Boucher (about 40 x 60 cm).

23. On his examination and deportation, see Schmidt, *Elendsweg*, p. 275. Westfeld was declared deceased at the end of the war, though the date of his death is not known.

Art Trade

The Development of the Art Market
in Berlin between 1939 and 1945

Angelika Görnandt

PRICES for works of art remained relatively stable during the first years of the Nazi regime. But that changed after 1939, when prices hit inflationary heights. The unprecedented price of 270,000 marks, for example, was paid in April 1943 at the auction house H. W. Lange for a painting by Arnold Böcklin titled *Honeymoon*.

During the early years of the regime, there was a relatively small supply of outstanding works of art in circulation. There were several reasons for this. Most art collections on the market had been formed between the end of World War I and the German inflationary period (1919-23). These collections were composed of lesser qualities of work, as the best examples had already been bought by collectors from abroad. German collectors simply could not afford the higher prices. In addition, beginning in the mid 1930s many collectors sold their master works not through auctions but privately. Such sales were not published; therefore we cannot use them to evaluate the art market. In Berlin, for example, there was a disproportionally large number of works by 17th-century Dutch masters and 19th-century German artists on the market. Prices for both were similiar.

My analysis of the art market is based on contemporary reports from the periodical *Weltkunst*, auction catalogues, and auction records from the State Archive of Berlin. To put matters into perspective I created the following categories for Dutch and German paintings sold between 1933 and 1939: prices over 1,000 marks are considered high, over 5,000 marks steep, and over 10,000 marks exorbitant. In addition to supply and demand, the prices depended on the quality of the individual piece. As far I can see, prices surprisingly were not affected by whether the works came from Jewish or non-Jewish collections. Moreover, the high reserve prices in auction catalogues for art from Jewish owners demonstrate that works of such provenance were not necessarily auctioned for unreasonably low prices. However I must point out that the high prices for such art should not be confused with the artworks sold by auction houses specializing in household effects. The kind of art sold there was often of inferior quality or by unknown artists, and the auction prices seldom exceeded 50 marks. Interestingly, inquiries at the State Archive in Berlin have revealed that the household properties of non-Jewish owners were sold for very low prices as well.[1]

Despite the fact that many Jews were forced to sell their art collections before they left the country, the art market was not inundated. Moreover this is not confirmed in any of the sources I have mentioned above. I suspect that many collectors sold their works privately; or placed them in storage, expecting to ship them abroad; or gave them to friends in Germany for safekeeping. The works simply did not appear on the official market.

During World War II the art market changed dramatically. While at the beginning of the war fear and reservation kept prices down, that changed early in 1940 when the rich started to invest in art again. One reason was the lack of luxury goods; the Germans went on a shopping

spree, leading to rising prices throughout the war years. Sales over 20,000 marks were no longer a rarity. These prices reflected the shortage of artworks on the market. The regime was highly concerned about this situation, as they did not want to repeat the inflationary years. Consequently in the fall of 1940, a limit was placed on prices payable for works of art. However this mandate was ignored, and prices continued to climb.

In 1941 works by Dutch masters and 19th-century German paintings were sold for record sums, more than 50,000 marks. Owing to the steady surge, other artworks were bought for ever higher prices. For this reason I had to reset the standards for prices in 1941 and 1942 for what is to be considered high (10,000 marks), steep (30,000 marks), and exorbitant (50,000 marks).

In the fall of 1941 there was a price explosion when French impressionist paintings came on the German art market. The stratospheric price of 148,000 marks was paid for the painting *Lady on a Terrace* by Gustave Courbet from the collection of the Jewish bank owner Jakob Goldschmidt.[2] Furthermore, most of these paintings sold for more than twice or triple the prices suggested by the auction houses. In other words, these extraordinarily high sums were paid for artworks from a Jewish collection. The determining factors for these prices were quality and rarity on the Berlin art market. In essence, the provenance of an artwork from a Jewish collection had little relevance to the prices. To demonstrate how important quality was, many paintings in the Goldschmidt collection were on the Nazi's list of valuable works of art not allowed to leave the country.

It is important to bear in mind that Jewish sellers received only a tiny percentage of the proceeds from these sale. Even that tiny percentage ended on Dec. 3, 1938, when the Nazi regime prohibited Jewish people from receiving any proceeds from the sales.

While the official media remained silent over the high prices paid on the art market, the Secret Service made note of them in a confidential memo. They expressed with astonishment and anxiety that sales of artworks from Jewish property often got double or more of their estimated prices.[3] They worried that wealthy buyers were purchasing art merely as investment.[4] The government compared these prices to the inflation of the 1920s. Publications like the country's leading art magazine *Weltkunst* tried to calm sentiments by calling the sales anomalies.[5]

As the war progressed, the quantity of artworks sold in auctions declined considerably in Berlin and other German cities. Berlin and Munich were no longer the most important art markets in the German Reich; that title now belonged to Vienna. Many German art dealers, including Lange, moved to Vienna. As a result of the drastic decline of auctions and the undiminished demand for works of art, prices skyrocketed once again. At the beginning of the 1940s the high sums had been fueled by the quality of a work; later on it was driven exclusively by the intense demand for art in general. For many Germans, investing money in art seemed better than putting it in the bank. Moreover, this haven kept their money out of the reach of the Nazis, who overtaxed people's savings to finance the war.[6]

Hence, it was not altogether surprising that in 1943 vertiginous prices were paid for Dutch Old Masters and 19th-century German paintings. In April 1943, for example, landscape pieces by Dutch painters were bought for up to 125,000 marks.[7] In addition, at the same auction paintings by 19th-century artists like Monet and Courbet went for 126,000 marks and even as high as 178,000 marks. These prices, which represented a new inflationary period for art, doubled within the span of a year. At this point, prices were influenced not by the quality of the work but by the insecurity caused by the war. Here I must point out that the state was heavily involved in the price explosions. At auctions in Berlin, the most expensive paintings often were bought by officials for the planned Hitler Museum in Linz. Among these artworks

Summary Price Categories on the Berlin Art Market

Price Categories	1933-39 Market	1940 Market	1941–42 Market	1943-44 Market
Exorbitant	over $10,000	over $20,000	over $50,000	over $100,000
Steep	over $5,000	over $10,000	over $30,000	over $40,00
High	over $1,000	over $5,000	over $10,000	over $20,00

Source: Own calculations

was the painting titled *Honeymoon* by Böcklin, which became the costliest work ever sold at an auction in Berlin during the Nazi era.

Until 1944 buyers continued unabatedly to pay high sums for paintings. Sales no longer took place in auction houses, but exclusively at certain galleries, like Lange's. Although he had moved his auction house to Vienna, he continued to sell artworks in Berlin. Among his numerous sales of 1944 was one painting by François Boucher, which sold for 250,000 marks.[8] This and other high priced paintings were bought by the Nazi regime. But while officials were spending enormous sums for art, in summer 1944 the regime implemented money-saving measures. As a result prices for consumer goods, services of all sorts, and cultural properties were regulated.[9] The regime once again was attempting to reign in sales of art. The measures however, were unnecessary because the art trade came to a screeching halt in September 1944. By this time the German Reich was destroyed, and people were struggling to stay alive. Consequently the art trade was no longer of any importance.

In summary, art prices in Berlin grew to inflationary heights during the war years, as a result of a huge demand for and the dwindling supply of works of art. Though the Nazis passed laws in an attempt to restrain the art market, they also contributed to the inflationary prices. At first quality was extremely important; later works of low quality also got high prices. People were buying whatever they could get their hands on.

Notes

1. For example, see the records of the auction house Gerhard Harms. See Landesarchiv Berlin (State Archive Berlin), A Rep. 243-04, Nr. 17-21.

2. Catalogue: *Gemälde und Kunstgewerbe aus der ehemaligen Sammlung J. G.*, Berlin, H. W. Lange, Sept. 25,1941.

3. *Meldungen aus dem Reich (MADR) 1938-1945* 4, no. 92 (May 30, 1940), p. 1,195.

4. *MADR 1938-1945* 10, no. 293 (June 22, 1942), pp. 3,854-856.

5. Werner R. Deusch, "Der Kunstmarkt im Kriege," *Kunstpreis-Verzeichnis 1939/1940* 1 (Berlin, Paris 1941), p. 10.

6. Willi A. Boelcke, "Die Finanzpolitik des Dritten Reiches. Eine Darstellung in Grundzügen," i *Karl-Dietrich Bracher, Manfred Funke, Hans-Adolf Jacobsen (Hg.), Deutschland 1933-1945*. Neue Studien zur nationalsozialistischen Herrschaft, Bonn 1993, p. 112.

7. Catalogue: *Verschiedener deutscher Kunstbesitz*, H.W. Lange, April 16-17,1943.

8. The sale took place on July 21, 1944. See Bundesarchiv Koblenz (State Archive Koblenz), B323/153, LF XXVII/38/204.

9. Anonymus, "Kriegsverpflichtete Preisstellung," in *Weltkunst* 18, no. 8 (Aug. 15, 1944), p. 2.

Hildebrand Gurlitt and the
Art Trade during the Nazi Period

Katja Terlau

WHILE conducting a research project on acquisitions made at the Wallraf-Richartz-Museum/Fondation Corboud in Cologne during the years 1933 to 1945, I came across the name Dr. Hildebrand Gurlitt (1895-1956).[1] Through Gurlitt's single-handed efforts, the Wallraf-Richartz-Museum (WRM) procured 32 major works of art, sculptures as well as paintings, from 1941 through 1944. These new additions came from France, almost all from former private collections in Paris. The name of the previous owner was noticeable on only a few examples. Most were returned to France after the Second World War; however, a few remain in the museum and their origins remain unknown.

While I was conducting this research at the Wallraf-Richartz-Museum, there were several cases in the Federal Republic of Germany—in which art dealer Hildebrand Gurlitt had played a role—involving return of artworks to their rightful heirs. Here are three examples from Cologne.

The painting *Zwei weibliche Halbakte* (Two Female Half Acts) by Otto Mueller, 1919, was confiscated by the Gestapo from the collection of Ismar Littmann in Breslau. This painting, then labeled as "degenerate," did not sell at the Galerie Fischer auction in Lucerne in 1939. It made its way back to Germany in 1940 and into the hands of Hildebrand Gurlitt. He sold it to Cologne collector Josef Haubrich who donated his collection to the Wallraf-Richartz-Museum in 1946. The Museum Ludwig in Cologne returned the painting to the rightful owner's heirs in 1999.

The painting *Landschaft mit zerborstener Brücke* (Landscape with Broken Bridge) by Meindert Hobbema was sold to the Wallraf-Richartz-Museum by Gurlitt for 125,000 Reichsmarks (RM) in 1941. It came to Gurlitt following a forced sale from the collection of Frederico Gentili di Guiseppe in Paris. The painting was returned to the rightful owner's heirs in 2000.

The picture *Die Weintraube* (La Grappa de Raisin) by Louis Marcoussis, 1920, was on loan from the Küppers-Lissitzky Collection to the Provinzial Museum in Hanover. In 1937, the work was confiscated from the museum and fell into Gurlitt's hands. Later, the painting was bought by the collector Haubrich and given as a gift to the city of Cologne in 1950. After the true origin of the painting was discovered in 1999, it was restored to its rightful owner, Jen Lissitzky.

These restitutions of paintings handled by Gurlitt raise a number of questions: Who was this dealer? Where did he acquire the artworks that landed in the Wallraf-Richartz-Museum? Was his acquisition of these works harmless and irrelevant, as he claimed after the war? Or was it the result of seizure and forced sale?

During my research, a colleague at the museum came into contact with a history teacher in Wesseling, near Cologne, who has a file with various business documents from Hildebrand Gurlitt from 1943-44. He had acquired the documents from his 80-year-old uncle, a freelance artist living in Düsseldorf, who recovered the files in 1966 or 1967 from the former home of the Düsseldorfer Kunsthalle museum, one day before it was demolished. Touring the building, he spotted the documents in a locked room. With only enough clearance to fit his hand, he reached in and grabbed a small stack of papers. He took the dusty documents and read them the very same evening and decided to return and recover additional documents. But when he returned to the museum the next day he found only rubble. He is certain that the rest of the documents in the room were destroyed. This interesting tale provided me with an additional motive to further acquaint myself with Hildebrand Gurlitt.

This paper will summarize the results of my investigations to date into Gurlitt's art-dealing activities. I will not revisit the frequently remarked-upon theme of "degenerate art," but rather will bring to light Gurlitt's connections to France in the early 1940s and his work as an art dealer and special emissary for Linz.

Early Biography

Hildebrand Paul Theodor Ludwig Gurlitt was born on Sept. 15, 1895 in Dresden.[2] He was the second and youngest son of the art historian Dr. Cornelius Gurlitt (1850-1939) and a cousin of the equally well-known Berlin art dealer Wolfgang Gurlitt (1888-1965), whose collection is located today in Linz.[3] In National Socialist (NS) racial terminology, both Wolfgang and Hildebrand were dubbed "second-degree mixed Jews" or "quarter Jews."[4]

After his military service (1914-18), Hildebrand Gurlitt began his studies in music and the fine arts in Berlin, Frankfurt, Dresden, and Heidelberg. He completed his course work in Frankfurt-Main with a doctoral thesis on architecture in Saxony. In the early 1920s he worked as an assistant at the Provincial Conservatory in Brandenburg and wrote critiques for various periodicals, including *Voss*, *Deutsche Allgemeine*, *Frankfurter Zeitung*, and several newspapers in Dresden. From 1922 to 1925 he was assistant for the architecture collection and for the art history institute at the Technical University of Dresden.

In 1923 Hildebrand Gurlitt married Helene Hanke, a dancer from Dresden, who later gave birth to a son and a daughter. He became director of the König-Albert Museum in Zwickau in 1925, and took over the business dealings of the Zwickau Art Society the following year. Through his initiative a new museum was opened in Zwickau that same year. With a modern sensibility, Gurlitt patronized artists such as Pechstein, Klee, Kollwitz, Barlach, Nolde, and Schmidt-Rottluff. Due to growing political pressure against collecting and exhibiting modern art, he was forced to resign his post, ostensibly because of the poor financial situation of the city of Zwickau. He took a temporary position teaching at the Kunstgewerbeakademie (Applied Arts Academy) in Dresden, 1929-30.

In 1930 Gurlitt became director and chairman of the Kunstverein (Arts Society) in Hamburg, but he was again relieved of his post by the NS party in 1933. The connoisseur and patron of modern art had to settle for working as an art dealer in Hamburg. Gurlitt was one of only four dealers commissioned to trade in "degenerate art" (along with Bernhard A. Boehmer, Karl Buchholz, and Ferdinand Möller).[5] He got access to the Berliner Reichslager (storage facility) for confiscated art from which legitimate drawings, watercolors, paintings, and sculptures were sold to various collectors after 1937. It is worth noting that Hildebrand Gurlitt was never an NS party member.

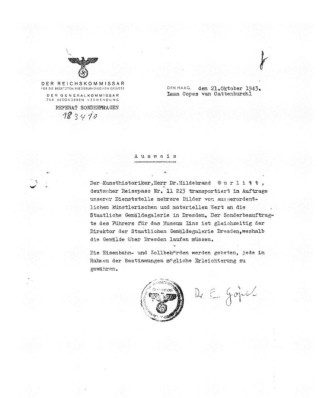

Above: Hildebrand Gurlitt.
Reproduced with permission from *Kunst in der Krise* by Maike Bruhns (Hamburg, 2001)

Left: Hildebrand Gurlitt's identification card, 1943. Private collection.

The 1940s

After German forces invaded and occupied France in 1940, Gurlitt began practicing his trade as an art dealer there. He purchased works of art around France, but especially in Paris, for various German museums. Several travel documents dating from the summer of 1941 point to this fact. Another travel document from Jan. 20, 1942, reads: "Reichs-German Dr. Gurlitt is purchasing artworks of great artistic and material value, commissioned by major German museums in France." All such documents bear the signature of Mr. Geringk. In all probability, this is the signature of musicologist Dr. Heribert Geringh. He was head of the Sonderstrab Musik (special music unit) in France as of 1940.

In spring 1942 Gurlitt closed his gallery in Hamburg (Alte Rebenstrasse 6), but continued conducting business from his hometown of Dresden (Kaitzerstrasse 26). Sometime after relocating his business to Dresden, Gurlitt entered into a business arrangement with Herman Voss of the Staatliche Gemäldegalerie (State Gallery of Paintings).

Voss and Gurlitt were close friends. The two men shared similar fortunes; both had to resign from previous positions as a result of political pressure. Their friendship turned into a very important working relationship in March 1943 when Voss was called upon to direct the Staatliche Gemäldegalerie Dresden as well as to work as the special agent (Sonderbeauftragter des Führers) of the Führermuseum Linz project. Among the first decisions Voss made was to stop any more purchases from Karl Haberstock. Instead, Voss named his trusted friend Gurlitt his accredited buyer in 1943. From that time on Gurlitt was, next to a flock of up to 50 art dealers who bought for Hitler, the most important supplier to the Linz Museum. His cousin Wolfgang Gurlitt also was commissioned by Voss for a time as a buyer for the Linz collection, although he was not quite as successful or active as Hildebrand.

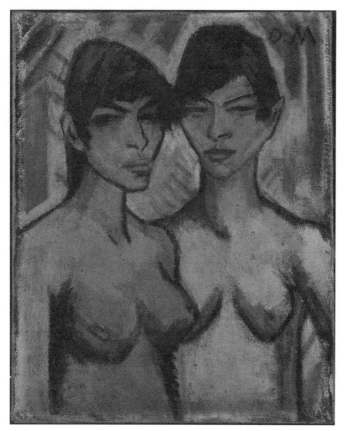

Two Female Half Acts, 1919, Otto Müller, Museum Ludwig, Cologne. Reprinted with permission from Reinisches Bildarchiv Köln.

According to my previous research into his dealings, Gurlitt bought mainly from other art dealers and very rarely from private collectors. After the war, he maintained that he never dealt in art that was not voluntarily put up for sale. As a dealer he had contacts with numerous trusted middlemen, beginning with his own family. His business contacts ultimately included numerous museums and dealers. In France, Gurlitt had contacts with Hugo Engel, Theo Hermsen, Etienne Ader, and Gustav Rochlitz, among others.

After the war, the Art Looting Investigation Unit (ALIU) concluded that Gurlitt was of no particular importance as a buyer. According to S. Lane Faison's *Consolidated Interrogation Report No. 4: Linz Hitler's Museum and Library*, "The importance of Gurlitt as an agent for Linz seems to have been exaggerated in previous reports. The quantity of his purchase is not very large, and his name does not appear in Reger's register."[6] Many subsequent publications support the report.

Birgit Schwarz's recent publication, *Hitler's Museum: The Photo Album of the Linz Art Gallery*, sheds new light on the exact details of Gurlitt's purchases for the Führermuseum in Linz. According to Schwarz, Gurlitt took part in at least 24 purchases of paintings for the Linz gallery. Almost all of these paintings originated from private collections in France, as did many of his purchases for the Wallraf-Richartz-Museum. The first and last of the purchases for Linz were on Sept. 3, 1943, and June 28, 1944, respectively. The Gurlitt correspondence found in Düsseldorf covers precisely this time period (1943-44) and provides information about purchases for museums and collectors, bank transactions, currency dealings by the exchange control office (Dresdner Bank, Dresden/Paris and Crédit Lyonnais, Paris), other agents, and art dealers.

Voss's papers reveal that five other works were all "acquired from [H.G.] for the Führer's purposes," as Voss noted in a letter written to Gurlitt in Dresden on Sept. 4, 1944. These five included four paintings and a plaster bust by Houdon.[7] Apart from a few leads about the regional origins of the artworks, the documents include almost no information on the previous owners. As in Cologne, most of the works were returned to France after the war.

Purchases for Museums

The Düsseldorf documents include evidence of business transactions with numerous museums. These include the Städelsches Kunstinstitut, Frankfurt; Museum für Kunst und Kulturgeschichte (Museum for Art and Cultural History), Dortmund; Bayerische Staatsgemäldesammlungen (Bavarian State Collection of Art), Munich; Kunsthalle und Museum für Hamburgische Geschichte, Hamburg; Herzogliche Anstalten für Kunst und Wissenschaft (Ducal Institution for Art and Science), Gotha; Museum der Bildenden Künste (Museum of the Fine Arts), Leipzig; Städtische Museen, Cologne; Nationalgalerie, Berlin; and, of course, the Staatliche Gemäldegalerie (State Gallery of Paintings), Dresden. As the head office of the Dresdner Bank in Berlin noted in 1944, "Dr. Gurlitt works mainly with leading city and national museums. It is especially to be noted that substantial contracts are currently being finalized with the special emissaries of the Führer in Linz at the State Gallery of Paintings in Dresden."[8] Works traded to these museums include those of well-known artists such as Monet, Boucher, Courbet, Corot, Denis, Maillol, Murillo, Rodin, Tiepolo, Spranger, van Dyck, Thoma, and Rayski.

Apart from sales to museums, Gurlitt also dealt important works of art to Hans Lange, Hermann (F.) Reemtsma, Josef Haubrich, Carl Neumann, Margit and Bernhard Sprengel, and Joseph Goebbels, among others. In July 1943 he received an order stating that, as a result of new currency control regulations, "it is required that these imported paintings and drawings are solely to be used for purposes pertaining to state and local museums or other facilities. Private sales are prohibited."[9]

Bank Transactions

By early 1943 Gurlitt's banking was carried out through a newly created account with the Dresdner Bank in Dresden.[10] Currency authorizations for the purchases in France also were calculated at this bank. Reviewing a request from Gurlitt for a loan in February 1944, the Dresdner Bank noted that he was "in possession of great personal means." It is also noted that not long after the account was opened over 3.7 million RM already had passed through the account. The loan was authorized for 100,000 RM and permission for more than this was granted for a short time. Numerous statements from the Dresdner Bank document Gurlitt's active trading of art during this time. During a few months in the summer of 1944 he traded or arranged sales or purchases of works of art worth several million Reichsmarks, earning a commission from each transaction. As a result of these transactions, Gurlitt managed to amass a remarkable wartime fortune.

In addition to his account with Dresdner Bank, Gurlitt also banked with the Bankhaus Wilhelm Rée in Hamburg, where he kept a large deposit and enjoyed a healthy credit line of 200,000 RM.

The Postwar Years

In March 1945 Gurlitt fled with his family from Dresden to the castle of Baron von Pöllnitz in Aschberg, near Bamberg. Baron von Pöllnitz, a Luftwaffe officer, was considered the representative of the Paris art dealers. At this time the art dealer Karl Haberstock, another friend of the

baron, temporarily resided in Aschberg.

Gurlitt remained at the Aschberg castle under house arrest during the Allied occupation, and gave a sworn statement to representatives of Judge Advocate Section, 3rd U.S. Army, in June 1945. His statement "included an itemized list of more than 20 boxes of works of art transported from Dresden, which he states are his own. Some of these are heirlooms, but many were bought during the war in Paris or Amsterdam. The boxes are at Aschbach." I have not been able to determine the contents of these 20 boxes or the present location of the objects they contained. Gurlitt's 1956 obituary, however, refers to his splendid private collection, which contained watercolors by modern and German expressionist painters. It is believed that he acquired these works during the National Socialist years. The collection was exhibited several times internationally and even toured the United States in 1955.[11]

Hildebrand Gurlitt remained in Aschbach-Oberfranken until 1947. In the summer of that year he asked Prof. Otto H. Förster—the former director of the Wallraf-Richartz-Museum, who had been relieved of his duties in 1945—to give a sworn statement in connection with a public lawsuit against him. Förster already had been helping Gurlitt find new work. The former museum director now confirmed that he had helped Gurlitt obtain a French visa. The following grounds were given by Gurlitt: "1) because you knew me as an expert of the field who truly understood your anti-Nazi museum plans. 2) because you knew, that as an anti-fascist and a mixed Jew, that I would behave in a tactful manner in France. 3) because you knew that, as a mixed Jew, I was in extreme danger and hardship and could keep myself hidden much easier in France." Gurlitt arranged for Förster to give this deposition to prove that he went to France not as a result of his Nazi contacts, but as one who was against the Nazis and persecuted by them. The court case in which the deposition was to be given also concerned Karl Haberstock; notably, Haberstock claimed in his defense that Gurlitt and he were the same.[12]

At the end of 1947, Gurlitt was appointed director of the Society of the Arts for the Rhineland and Westfalia in Düsseldorf. Otto H. Förster was instrumental in securing this appointment.[13] In 1953 Gurlitt made great efforts to organize restitutions to France from the Wallraf-Richartz-Museum in Cologne.[14] On Nov. 9, 1956, he passed away at the age of 61 after a serious automobile accident. In his obituaries and subsequent biographies, his activities during the Nazi era were largely omitted. His obituary in the *Düsseldorfer Nachrichten* (Düsseldorf News) stated: "Gurlitt weathered the years of darkness through his humble work as an art dealer." At the end of the 1950s, a street in the old town of Düsseldorf was named after the "beloved" Hildebrand Gurlitt.

Summary

Hildebrand Gurlitt was one of the most important and active art dealers during the Nazi era. Nonetheless, his activities in France at the beginning of the 1940s have yet to be closely examined, perhaps because the magnitude of his dealings for museums and private customers has long been underestimated. The inventory of objects that passed through Gurlitt to Germany beginning in the early 1940s also requires thorough investigation. In addition to the numerous paintings and sculptures he traded, it is yet to be determined how many drawings and graphic arts objects also passed through his hands. That said, we can certainly conclude that Hildebrand Gurlitt not only dealt in "degenerate art" but also in looted art on a large scale. More works of art are now believed to have made their way from France to Germany through his activities than was previously thought. For this reason, all works that were been procured by him should be treated with the utmost attention, particularly with regard to the conditions of their procurement, and should be researched for evidence of forced sales.

Notes

1. Katja Terlau, "Das Wallraf-Richartz-Museum between 1933-1945," *Museen im Zwielicht*, Magdeburg 2002, pp. 21-39.

2. Exhibition Catalogue Zwickau 1999: *Hildebrand Gurlitt*.

3. See also www.linz.at/archuv/gurlitt/inhalt.htm.

4. See www.linz.at/archuv/gurlitt/probleme.htm.

5. Eugen Blume and Dieter Scholz, *Überbrückt, Ästhetische Moderne und Nationalsozialismus—Kunsthistoriker und Künstler 1925-1937*, Cologne 1999, p. 281; Zuschlag, Christoph, *Entartete Kunst*. Worms 1995, pp. 215-16.

6. S. Lane Faison, *Consolidated Interrogation Report No. 4: Linz. Hitler's Museum and Library*. OSS Report, Washington, D.C., Dec. 15, 1945, p. 51.

7. Joseph Vernet, *Nächtliche Hafenszene*, RM 40.000; A. L. Girodet-Trioson, *Bildnis der Königin Hortense*, RM 25.000; Willem van Dies, *Seeschlacht*; RM 25.000; Österreichischer Meister um 1850, *Junges Mädchen mit Liebhaber*, RM 10.000; Houdon, *Gipsbüste des Prinzen von Preussen*, RM 17.500. The painting by Vernet later found itself at WRM.

8. Filialbüro Dresden A-G, Historical Archive of Dresdner Bank, Dresdner Bank A.G., Frankfurt am Main, Document of Berliner Direktion der Dresdner Bank vom 5.2.1944.

9. Business Correspondence Files of Gurlitt, Private, Correspondence Dresdner Bank, Paris, from July 12, 1943 to Dr. Gurlitt.

10. Branch office Dresden A-G, Historic Archive of the Dresdner Bank, Dresdner Bank A.G. Frankfurt am Main, Statement of Berliner director of Dresdner Bank from 5.2.1944.

11. *Rheinische Post*, Nov., 10, 1956.

12. Historic Archives of the City of Cologne, Best. 1232 Nr. 71, Bl., Letter Dr. H. Gurlitt to Förster from June 12, 1947.

13. ". . . Otto Helmut Förster . . . let it be known that Dr. Hildebrand Gurlitt, former director of the Hamburg Society of the arts, is seeking work." From the file "Gurlitt," Düsseldorf Society of the Arts.

14. Correspondence from Oct., 27, 1953, Prof. Dr. Reidemeister to the Administration for the Arts and Culture of the City of Cologne, file "Restitutions to France–General Correspondence," p. 205, WRM Archive.

Contributors

BETTINA BOURESH is an historian at the Rheinisches Archiv- und Museumsamt, Pulheim (near Cologne), where she researches the provenance of pictures in the Rheinisches Landesmuseum Bonn. Bouresh is an active member of ICOM Germany, serving on the board of its International Committee of Memorial Museums for the Remembrance of Victims of Public Crimes.

MICHAL BUSEK works as a Judaist researcher in the library of the Jewish Museum in Prague (JMP), where he oversees the "original owners of the books" list and database in JMP's library and works to identify the original owners. He joined JMP in July 2001 as a volunteer and has worked in the library department since January 2003. He studied at Charles University, Prague, and has an M.A. in Biblical and Jewish studies; his thesis was titled Problems of Shoa in Judaism.

KAREN D. DALY has been a museum registrar at Virginia Museum of Fine Arts (VMFA) since 1996. In 2003, she assumed an additional role as VMFA's administrator of Nazi-era provenance research, serving as the museum's contact person for information related to Nazi-era provenance and as its coordinator of provenance research. Previously, Daly taught art history courses as an adjunct instructor in colleges in the Richmond area. She holds a master of arts degree in art historical studies from Virginia Commonwealth University and a bachelor of arts degree in philosophy/religious studies from Louisiana State University.

DANIEL DRATWA has served as founding and chief curator of the Jewish Museum of Belgium since 1980. He studied Jewish art and political science of the Jews of Belgium at Paris X University, and has curated dozens of exhibitions over the years. Dratwa has written two books and numerous articles on this subject for Encyclopaedia Judaica, Encyclopedia of Zionism, and Neues Leksikon des Judentums. Since 1998 he has conducted research on looted art from Jewish collections and has lectured on this subject in Vilnius (OSCE), Philadelphia (AAM), New York (CAJM), and Austria. He is president of the Association of European Jewish Museums, board member of the Brussels Council of Museums, and member of the Belgium Study Commission of Jewish Goods.

KAREN S. FRANKLIN is director of The Judaica Museum of The Hebrew Home for the Aged at Riverdale and director of the Family Research Program at the Leo Baeck Institute. She currently serves on the AAM/ICOM board and is a former AAM board member. A past president of the Council of American Jewish Museums, Franklin is currently CAJM's international liaison. She also has served as a president of the International Association of Jewish Genealogical Societies and is now co-chair of the Board of Governors of Jewishgen, Inc.

MICHAEL FRANZ is director of the Koordinierungsstelle für Kulturgutverluste, the Coordination Office for Lost Cultural Assets, which operates www.lostart.de—Germany's central and publicly accessible database for looted and trophy art. Previously, Franz worked as a lawyer and as an expert for the Ministry of the Interior on Internet-Databases on looted art. He specializes in legal questions on looted art and trophy art. He passed his First and his Second State Examination on Law (1994 and 1997) and wrote his doctoral thesis on legal problems with regard to the loan of cultural objects (1995). He has directed the Koordinierungsstelle since 1999.

ANGELIKA GÖRNANDT is a provenance researcher at the Office of the Regulation of Private Estate Matters (Bundesamt zur Regelung offener Vermögensfragen) in Berlin. She has been

involved in provenance research in accordance with the Washington Principles on Nazi-looted artworks since December 2002. Her work includes research on artworks reclaimed by the Jewish Claims Conference (JCC), the valuation of looted and destroyed works, and the search for heirs. She is an active member of the working committee Provenance Research and organized its December 2003 meeting in Berlin. Prior to that Görnandt worked for two years at the State Gallery in Stuttgart as a press assistant. She is writing her doctoral dissertation on the art trade in Berlin before and during the Nazi period, focusing on the fate of the Robert Graetz Collection.

MICHAEL HALL read history and history of art at University College London, followed by a post-graduate degree in art history at the Courtauld Institute. He is currently completing his Ph.D. on Baron Lionel de Rothschild as a collector of pictures, also at the Courtauld Institute. For the past 20 years he has been curator to Edmund de Rothschild, at Exbury in Hampshire, with a stint as decorative arts editor of the Macmillan-Grove Dictionary of Art.

UTE HAUG is a provenance researcher at the Hamburger Kunsthalle and a co-founder of the Arbeitskreis Provenienzforschung, founded in November 2000. In February 2001 she conceived and organized the international conference Die eigene GESCHICHTE: Provenienzforschung an den deutschen Kunstmuseen im internationalen Vergleich (Our Own History: Provenance Research in German Art Museums, an International Comparison) at the Hamburger Kunsthalle. More recently, she organized the exhibition "Parcours: Die Rücken der Bilder" ("Parcours: The Backs of Pictures"), October 2004-April 2005. Prior to her work in Hamburg, Haug was a researcher in Depot Administration and Inventory at the Stiftung Museum Schloss Moyland–Sammlung van der Grinten–Joseph Beuys Archiv des Landes Nordrhein-Westfalen, Bedburg-Hau, and assisted in the conception and organization of numerous exhibitions. Her 1998 dissertation in art history, completed at the Rheinisch-Westfälische Technische Hochschule, Aachen (Germany) is titled Der Kölnische Kunstverein im Nationalsozialismus—Struktur und Entwicklung einer Kunstinstitution in der kulturpolitischen Landschaft des "Dritten Reichs" (The Kölnische Kunstverein under National Socialism: Structure and Development of a Cultural Institution in the Cultural-Political Landscape of the "Third Reich").

MARK HENDERSON is a reference librarian for special collections and visual resources at the Getty Research Institute in Los Angeles. He is the primary subject specialist for the Research Library's important collection of dealer archives as well as for art market, Holocaust era, and provenance-related resources. He co-curated the GRI exhibition "The Business of Art: Evidence from the Art Market," which highlighted some of the library's most important art market-related materials, including a number of Holocaust-era items from the Cramer archive.

ROBERT HOLZBAUER has been head of provenance research at the Leopold Museum Private Foundation in Vienna since October 2003, where his tasks include reorganizing documentation and research (library, archives, provenance research, audiovisual documentation and coordination of external research). From 1998 to 2003, he worked as a historian at the Archives of Austrian Federal Monuments Office (Bundesdenkmalamt) at the offices of the Austrian Commission for Provenance Research, of which he continues to be a member. Holzbauer conducted research for the lawsuits Altmann v. Republic of Austria (the Bloch-Bauer-case), U.S. v. Portrait of Wally, and similar cases. He has participated in numerous publications and historical research projects on political and economic history,

research documentation, audiovisual media, and military history. He received a Ph.D. from Vienna University in modern and Austrian history/social and economic history (1992).

STEVEN KERN has been curator of European art at the San Diego Museum of Art since 1997. He previously held curatorial positions at the Sterling and Francine Clark Art Institute, Williamstown, Mass., from 1988 to 1997, and the Museum of Fine Arts/George Walter Vincent Smith Art Museum, Springfield, Mass., from 1983 through 1988.

URSULA KÖHN is a referent for provenance research at the State Art Collections Dresden (SKD). She joined SKD in December 2000 after leaving the Saxony Ministry of Science and Art, where she has been a referent for museums and heritages. During her nine years there, she gained experience in possession and property, cultural patronage, methods of subvention, and sponsoring. Previously she arranged contracts between artists and production and agricultural companies, organized symposiums and exhibitions, and was authorized by Bezirkskunstzentrum Karl-Marx-Stadt (Chemnitz) to buy art objects. After her studies she was a scientific assistant in Town Art Collection Karl-Marx-Stadt (Chemnitz). Köhn finished her studies in history of art at the University of Leipzig in 1973.

HARALD KÖNIG works at the Federal Office for the Regulation of Private Estate Questions (Bundesamt zur Regelung offener Vermögensfragen) in Berlin, Germany. He is in charge of a research group concerned with the restitution of cultural assets dispossessed or looted in Germany during the Nazi era. In particular, König conducts research on works of art in public ownership of the Federal Republic of Germany (a number of objects once belonged to the so-called Linz collection) and handles claims for restitution. In addition, he is responsible for the implementation of the Property Settlement Act of 1990 (Gesetz zur Regelung offener Vermögensfragen) as far as works of art are concerned. From 1995 to 2003 he worked in various positions for the Regional Fiscal Agency of Berlin (Oberfinanzdirektion Berlin). After he finished his degree in law in Berlin in 1993, he worked as a lawyer for two years. In May 2004, König received an LL.M. (European Union Law) from Northumbria University, Newcastle upon Tyne, United Kingdom.

MADELEINE KORN, PH.D., works as an independent expert in provenance research. She has conducted research for the Tate Gallery, London, and the Musée national d'art moderne, Paris, among others. She specializes in collectors and exhibitions of modern foreign art in Britain before the Second World War. She recently was awarded a three-month Neil MacGregor Scholarship at the National Gallery, London, which was part of the National Inventory Project. She is also a member of the Permanent Collections Committee of the Ben Uri Art Gallery—The London Jewish Museum of Art.

DOROTHEE LOTTMANN-KAESELER cofounded the Active Museum of German Jewish History in Wiesbaden (1988) and has served as its director since 1998. She was awarded the "Culture Prize" from the city of Wiesbaden and the Obermayer German Jewish History Award 2004. She also is a board member of Association for the State of Hessen Memorial Sites, member of State of Hessen Research Commission For Jewish History, and active in "German Jewish Collections" Conventions, Association of European Jewish Museums, and the Council of American Jewish Museums.

SOPHIE LILLIE is an independent provenance researcher in Vienna, Austria, and author of Was einmal war (Vienna: Czernin Verlag, 2003), a handbook of art collections looted in Vienna. After earning a master's degree in art history (Columbia University, 1995), Lillie spent six

years working on restitution issues for the Federation of Jewish Communities in Austria, serving as director of the Holocaust Victims' Information and Support Center until 2001. She currently works on behalf of a number of families seeking to recover looted art. *Was einmal war* received a Bruno Kreisky Award for Political Books in 2004.

MARINA MIXON is a specialist historical researcher. Since 2001 she has been a spoliation research advisor, appointed by the National Museums Directors' Conference through the support of the Museums, Libraries and Archives Council to coordinate provenance research on potentially spoliated works of art for the period 1933-45 in non-national galleries and museums in the United Kingdom. From 1999-2000, as a spoliation researcher for the British Library in the Department of Special Collections, she researched Western and Oriental manuscripts, rare books, and incunabula for items potentially subject to spoliation during World War II. Her research located the Benevento Missal. Prior to this she worked at the British Library for the Department of Western Manuscripts and in Exhibitions for the Oriental and India Office Collections. She also has held positions at the National Trust and at the Society of Antiquaries in London.

ANNA PANKIEWICZ, PH.D., holds an M.A. in law and in applied linguistics from Warsaw University. She joined the foreign service in 2000 and has served as second secretary for political and legal affairs at the Embassy of Poland in Washington, D.C., since 2001.

RUTH PLEYER has been a provenance researcher since 1998 when she first worked with Hubertus Czernin on the family history of the Bloch–Bauers (the restitution case currently pending as Altmann v. Austria.) From 1999-2002 she worked at the Holocaust Victims' Information and Support Centre at the Jewish Community in Vienna, where she built up the division of provenance research and represented the Jewish Community in the Austrian Commission for Provenance Research. She has studied Arabic and Oriental studies at the University of Vienna and is currently doing research on the Zuckerkandl family's former collection of art.

VICTORIA S. REED is research fellow for provenance in the Department of the Art of Europe, Museum of Fine Arts, Boston. She received her B.A. from Sarah Lawrence College and her M.A. and Ph.D. from Rutgers University. She worked for several years at the Metropolitan Museum of Art as a research assistant and a gallery lecturer. Before joining the staff of the MFA in 2003, she spent two years as curatorial research associate at the Princeton University Art Museum, where she worked chiefly on provenance and curated the exhibition "In Pursuit of the Past: Provenance Research at the Princeton University Art Museum" (2003).

BIRGIT SCHWARZ is the author of Hitler's Museum. She graduated from the University of Mainz in Germany with a thesis on the stained-glass artist Johannes Schreiter (b. 1931). In 1985 and 1986, she served as a curatorial assistant at the Staatliche Kunsthalle Karlsruhe, Germany. From 1987 to 1989 she lived in Rome, Italy. In 1989 she began work as a freelance art historian in Freiburg, Germany, and later in Trier, Germany. During this period she curated many exhibitions on contemporary art, worked as lecturer at the University of Trier, and was chairperson of the Art Society Trier (1997-98). Since 1998 she has been living in Vienna, Austria. Her research has centered around 20th-century German painting, including the Dada period (1919-22) of Otto Dix, and the Führermuseum Linz.

LAURIE A. STEIN has over 20 years of wide-ranging experience in museums, archives, and private collections in the United States and Germany. She earned a bachelor's degree in

European history and art history from Tufts University and a master's degree in art history from the University of Chicago, where she is currently completing her doctorate. Stein specializes in 20th-century German fine arts, design, and architecture, and in research on issues of World War II provenance and restitution. She has held curatorial positions at the Art Institute of Chicago (1986-89), the Saint Louis Art Museum (1989-91), and the Museum der Dinge/Werkbund-Archiv in Berlin (1991-2001). She was founding director of the Pulitzer Foundation for the Arts in St. Louis (2001-02), midwest director for Christie's (2003-04), and has participated in numerous exhibitions and scholarly publications. She has served as a consultant to many institutions, including the Art Institute of Chicago, Wallraf-Richartz-Museum in Cologne, Kaiser Wilhelm Museum in Krefeld, Milwaukee Art Museum, and the Yale University Art Gallery. She was one of the four original members of the Arbeitskreis Provenienzforschung in Germany.

STEPHANIE TASCH currently works as a provenance researcher for Christie's in Berlin. She was born and raised in Hanover, Germany; read art history, English and philosophy at the universities of Bochum, North-Rhine Westfalia, Germany, and Vienna, Austria; had extended stays in London (Paul Mellon Centre for Studies in British Art); and conducted research for her dissertation project, "Studies in English Allegorical Portraits of Women from van Dyck to Reynolds" (published), under the supervision of Werner Busch (Freie Universität Berlin). As a freelance art critic, she is a frequent contributor to various German-language publications, including texte zur kunst magazine, mainly on contemporary art, with a focus on East Asia/China. Tasch is a member of the Arbeitskreis Provenienzforschung and regularly participates in national and international conferences and seminars on looted art and provenance research issues.

KATJA TERLAU is a freelance provenance researcher and art consultant. Previously she led a provenance-research project on the history of museums in Cologne, particularly the Wallraf-Richartz-Museum in the years 1933 to 1945, after she joined the museum as an assistant in 1998. She also was a coordinator at the Federation of German Industries (BDI); and research assistant, Westfälischen Museum für Archäologie, Münster. In 2001, she drafted and organized the exhibition "Museeen im Zwielicht: Ankaufspolitik 1933-1945," at the Wallraf-Richartz-Museum. She holds a Ph.D. in art history (1998) and a master's in art history, archaeology, and prehistory (1995).

PATRICIA A. TETER is senior research editor at the Getty Project for the Study of Collecting and Provenance (formerly the Provenance Index), where she manages the 18th- and early 19th-century Belgian and French Sales Projects. During her years in the department, she has overseen the artist research in the inventory and sales projects as well as in related publications. Previously, she worked at the Los Angeles County Museum of Art as an exhibition coordinator. Recently, Teter was production editor for The Houses and Collections of the Marquis de Marigny by Alden R. Gordon. She is writing an article on two early 19th-century collections acquired during the Napoleonic wars.

ESTHER TISA FRANCINI is a historian based in Zurich, Switzerland. As a scientific assiociate she has been involved since 2002 with a project assigned by the Independent Commission of Historians Liechtenstein Second World War. The result is her forthcoming book, Liechtenstein und der internationale Kunstmarkt 1933–1945: Ein Bericht auf den Spuren von Sammlungen und Provenienzen im Spannungsfeld von Flucht, Raub und Restitution (Liechtenstein and the International Art Market between 1933-1945: A Report about

Collections and Provenances in the Context of Flight, Loot and Restitution). From 1998 until 2001 she was a scientific contributor and project member of the Independent Commission of Experts Switzerland—Second World War. With Anja Heuss and Georg Kreis, she published the report Fluchtgut–Raubgut: Der Transfer von Kulturgütern in und über die Schweiz 1933–1945 und die Frage der Restitution (Flight Assets–Looted Assets: The Transfer of Cultural Goods into and via Switzerland 1933-1945 and the Issue of Restitution). From 1992 until 1998 she studied history and French literature in Zurich and Paris.

VANESSA-MARIA VOIGT has been researching the history of the Margrit and Bernhard Sprengel Collection, 1934-45 within the framework of a doctoral scholarship from the Sprengel Museum Hannover since August 2001. Her work is focused primarily on research into the provenance of the works in this collection. Voigt has a master's degree in art history, classical archeology, and ethnology from the University of Münster (February 2001).

HELEN J. WECHSLER currently serves as director, Strategic Initiatives and Special Projects, at the American Association of Museums, where she has worked since 1990. She provides overall management, leadership, and support in the planning, development, and implementation of projects that address the emerging needs of the museum community and enhance its ability to serve the public. As AAM's director of International and Ethics Programs from 1997 to 2005, her responsibilities included directing an international museum partnership program funded by the U.S. Department of State, administering the U.S. National Committee of the International Council of Museums, serving as point person for AAM on issues of international cultural property, staffing AAM's ethics committee, and overseeing the development of ethics guidelines for the museum field.

FRIEDEGUND WEIDEMANN is curator at the Museum of the Present, National Gallery in the Hamburger Bahnhof, Berlin. Since 2003 she has been responsible for provenance research at the National Gallery, where she worked for over 30 years in the Department of the 20th Century. From 1982 to 1990 she managed the department of the National Gallery in the Otto-Nagel-Haus, Berlin. In 1983 she completed a Ph.D. at the Humboldt-University, where she had studied history of art and theatre science from 1961 to 1966.

BOGUSAW W. WINID, has served as deputy ambassador from Poland to the United States since 2001. He holds a Ph.D. in history from Warsaw University (1991). He also studied at Indiana University, Bloomington, and completed the Diplomatic Training Program at the Hoover Institution, Stanford. Winid joined the foreign service in 1991. In his present capacity, he coordinates Polish restitution efforts in the United States, among his other responsibilities.

NANCY H. YEIDE holds a master of arts from American University and has been head of the Department of Curatorial Records at the National Gallery of Art (NGA) since 1990. Her primary interest is in the history of collecting, particularly during the 19th and 20th centuries, a topic on which she has published regularly in such journals as Apollo, Archives of American Art Journal, and Museum News. Since 1997 she has conducted World War II-era provenance research on the National Gallery of Art's collection and has spoken and written widely on the subject. In 2001 she co-authored The AAM Guide to Provenance Research. She was NGA's Ailsa Mellon Bruce Sabbatical Curatorial Fellow for 2002-03, during which time she researched the art collection of Reichsmarschall Hermann Goering for her forthcoming catalogue raisonné.

Index